Realism, Writing, Disfiguration

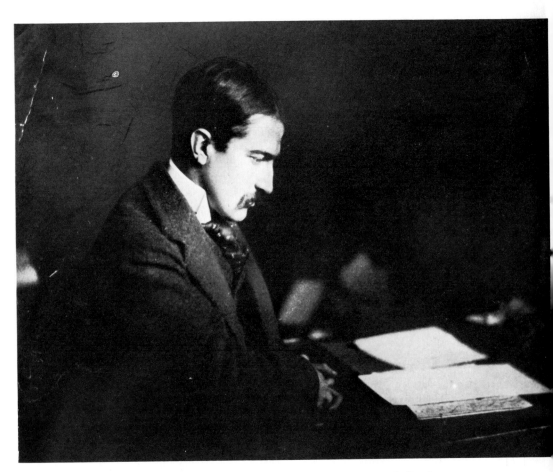

Stephen Crane at Brede Place, 1899. Stephen Crane Collection,
Clifton Waller Barrett Library, University of Virginia Library.

Michael Fried

REALISM, WRITING, DISFIGURATION

ON

Thomas Eakins

AND

Stephen Crane

The University of Chicago Press · Chicago and London

The University of Chicago Press, Chicago 60637
The University of Chicago Press, Ltd., London

© 1987 by Michael Fried
All rights reserved. Published 1987
Printed in the United States of America

96 95 94 93 92 91 90 89 88 87 5 4 3 2 1

An earlier version of chapter 1 was first published in *Representations*,
no. 9 (Spring 1985). © 1985 Michael Fried.

Library of Congress Cataloging-in-Publication Data

Fried, Michael.
Realism, writing, disfiguration.
Bibliography: p.
Includes index.
1. Eakins, Thomas, 1844–1916. Gross Clinic.
2. Crane, Stephen, 1871–1900. Upturned faces.
3. Realism in art. 4. Realism in literature. I. Title.
ND237.E15A64 1987 759.13 86-16478
ISBN 0-226-26210-3
ISBN 0-226-26211-1 (pbk.)

MICHAEL FRIED is professor of humanities and the his-
tory of art and director of the Humanities Center at The
Johns Hopkins University. He has published widely on
modern art and art criticism and is the author of *Morris
Louis* and *Absorption and Theatricality: Painting and
Beholder in the Age of Diderot*. The latter was awarded the
Louis Gottschalk Prize of the American Society for
Eighteenth-Century Studies as the outstanding book of
its year on an eighteenth-century subject.

To Stanley Cavell

Contents

List of Illustrations

Frontispiece: Stephen Crane at Brede Place, 1899.

FIGURES

COLOR PLATES (following page 80)

Preface

This book consists of two long essays, the first on the American paint-
er Thomas Eakins (1844–1916) and the second on the American
writer Stephen Crane (1871–1900). The Crane essay in particular
came as a surprise: although my interest in him predates by many years
my involvement with Eakins, it was only in the course of working on
The Gross Clinic that I began to see what might be made of a series of
texts by Crane, culminating in "The Upturned Face," that I had al-
ways hoped to be able to do something with. The two essays go to-
gether, then, not only in their concern with intricately analogous
issues, but also because, as if accounting for a prior fascination, the
first irresistibly gave rise to the second.

As for the issues themselves, they may at first appear to be inscribed
(up to a point they are inscribed) within the by now familiar topic of a
thematics of writing.[1] What ultimately is at stake in both essays,
however, is not a thematics of writing in general but more particularly
a problematic of the *materiality* of writing as that materiality enters
into Eakins's paintings and Crane's prose. The case of Eakins is almost
straightforward compared with that of Crane. That is, for Eakins it is
precisely writing's materiality—hence its visibility—that allows it to
be painted, though my analysis of the respective systems of what I call
writing/drawing and painting in Eakins's art mainly emphasizes the
tensions that result from his attempt to subsume the first system with-
in the second. (Among the most acute of those tensions is that between
the horizontally oriented "space" of writing/drawing and the ver-
tically oriented "space" of painting, a distinction I trace back to a
specific pedagogy that prevailed in Eakins's Philadelphia during his

formative years.) In Crane's prose, on the other hand, the materiality of writing turns out to be simultaneously elicited and repressed: elicited because, under ordinary circumstances, the materiality precisely doesn't call attention to itself—in fact we might say it effaces itself—in the intimately connected acts of writing and reading; and repressed because, were that materiality allowed to come unimpededly to the surface, not only would the very possibility of narrative continuity be lost, the writing in question would cease to *be* writing and would become mere mark. (More than just its materiality is required in order for a signifier to be a signifier.) The consequences of this complex dynamic include Crane's obsession with a distinctive cluster of motifs (e.g., upturned faces, corpses, fires, snakes); his resort to an entire armory of literary devices that have always been recognized as fundamental to his style (e.g., onomatopoeia, alliteration, animism, dialect); and his pursuit of effects of sensory, chiefly visual, immediacy, which from the first has led to his being characterized as an "impressionist," a term I both take seriously and radically reinterpret in the second of these essays. Put another way, the essay on Eakins is largely concerned with what it means for writing, as part of a historically specific network of cultural practices, to be something that can be painted, while the essay on Crane grapples with the more tortuous question of what it means for writing *in writing* to be an object that can be seen and hence represented, an object (to go still further, as I do) the actual inscribing of which on the page can be seen and represented as it takes place (but must also be repressed, made unrecognizable, if inscription and representation are to be of writing). That these issues and questions can be shown to be central to the work of the greatest American painter and (except for Theodore Dreiser, whose literary career proper began the year Crane died) American writer of their respective generations is obviously a matter of some significance.[2]

I will only add that the two essays are somewhat different in attack, the first centering on a single painting (though at the same time ranging widely within Eakins's oeuvre) and giving weight to biographical considerations, the second deploying a large number of often extensive quotations from a broad selection of writings and minimizing biography (though toward the end appealing to eyewitness accounts of Crane at work).

I am grateful to the National Endowment for the Humanities for a fellowship that, along with support from The Johns Hopkins University, made possible the writing of this book. To the Endowment I owe further thanks for sponsoring an Institute on American Realism, conducted jointly by Walter Benn Michaels and myself at the University of California, Berkeley, during the summer of 1985, at which I presented my Eakins and Crane material to an ideal audience of engaged Americanists.

Among the friends and colleagues who have commented helpfully on one or both parts of this book, I want particularly to thank Stanley Cavell (who read the Eakins essay in its penultimate draft) and Walter Benn Michaels (who talked through with me the argument of the Crane essay at a decisive moment), and then Sharon Cameron, Jonathan Crewe, Frances Ferguson, Debra Fried, Neil Hertz, Ruth Leys, Peter Sacks, Mark Seltzer, and Edward Snow. To Walter Benn Michaels and Michael Rogin I am further indebted for inviting me to contribute an essay on Eakins (the present one minus certain revisions and additions) to a special issue of *Representations* devoted to American culture between the Civil War and World War I. Finally, I am grateful to John Wilmerding of the National Gallery of Art and Darrel Sewell of the Philadelphia Museum of Art for their assistance in locating works by Eakins in private collections.

I have performed many operations, and flatter myself that I possess at least some of the qualities of a good operator—a steady hand, an unflinching eye, perfect self-control, and a thorough knowledge of relative anatomy. I have rarely failed to accomplish what I had set out to do. The sight of blood, as I have said, was very disagreeable to me in early life; but it never appalled me in any of my great operations, and I do not believe that I ever trembled three times in my life when I had a knife in my hand. My hand and eye, so thoroughly trained in pitching quoits and pennies and practising with the bow and arrow in early boyhood, never failed me. I believe that I was always a safe operator, and if I ever committed any great mistake I am not aware of it. My knife was always guided by a thorough knowledge of the case, and, I have reason to believe, by sound judgment, strengthened and sobered by the light of experience and the dictates of common sense. I can say what few men, extensively engaged in practice, can say: "I have never lost a patient upon the table from shock or loss of blood."

It has been generally supposed, from the fact that I am a rather voluminous author, that I am fond of writing. Nothing is more true, and I should be very ungrateful if I denied it. Not only am I fond of writing, but writing has been one of the greatest solaces of my life. Many of my happiest days and nights have been spent with my pen, in the silence of my study, dead as it were to all the world around me, only enlivened by my own thoughts and reflections, in the midst of my books, the silent companions of my lonely hours, and the witnesses of my earnest efforts to contribute something that might be worthy of my profession.

Autobiography of Samuel D. Gross, M.D.

1

Realism, Writing, and Disfiguration in Thomas Eakins's *The Gross Clinic*

I

When Thomas Eakins in March or early April 1875 began work on *The Gross Clinic* he was thirty years old and had reached a stage in his early career when for the first time he was prepared to attempt a painting of major artistic and intellectual scope (Fig. 1, Pl. 1).[1] The circumstances must have seemed propitious: in 1876 an international art exhibition was scheduled to be held as part of a vast Centennial exhibition in his native city of Philadelphia and, along with other American painters and sculptors of his generation, Eakins doubtless welcomed the chance it would provide to establish his reputation. Furthermore, he was already a figure of modest note in Philadelphia painting circles. Between 1862 and 1865 he had been a student at the Pennsylvania Academy of the Fine Arts; in the fall of 1866 he had sailed for Paris, where he had studied at the Ecole des Beaux-Arts with Jean-Léon Gérôme and had worked briefly with the portraitist Léon Bonnat and the sculptor Augustin-Alexandre Dumont; and following his return from abroad in the summer of 1870 he had begun to be recognized as an extraordinary teacher in his own right. He had exhibited pictures in the Paris Salon of 1875, a matter of some distinction for a young American, as well as in New York and Philadelphia. Among his art student friends in Paris had been William Sartain, whose father, John Sartain, an influential figure in Philadelphia's cultural life, was soon to be appointed Superintendent of the Centennial art exhibition. In August 1875 the elder Sartain, after visiting Eakins's studio, wrote to his daughter in Paris that Eakins's unfinished picture of Dr. Gross "bids fair to be a capital work." Sartain is known to have issued private assurances to several artists that their

3

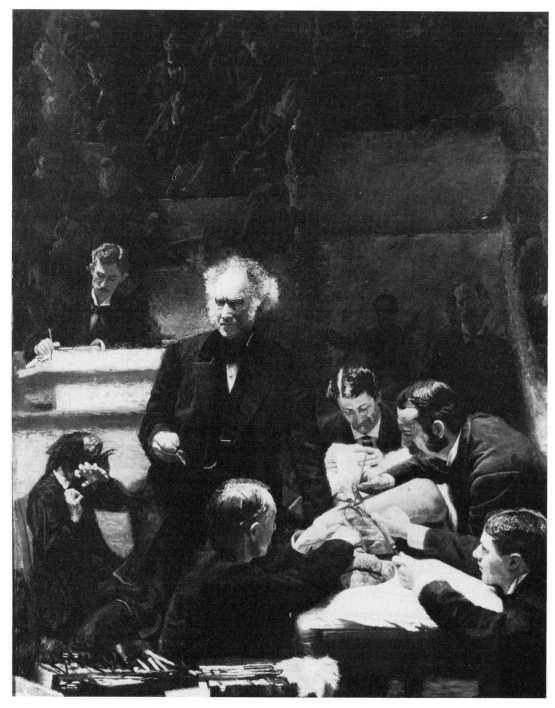

1. THOMAS EAKINS, *The Gross Clinic,* 1875. Jefferson Medical College,
Thomas Jefferson University, Philadelphia.

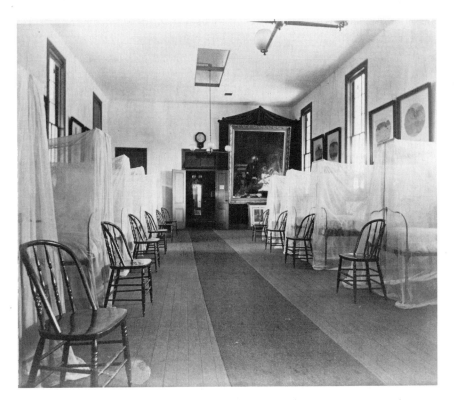

2. Ward in Model U.S. Army Post Hospital, Medical Department, Philadelphia
Centennial Exposition, photograph, 1876. Photograph courtesy
of the Library of Congress.

works would be accepted for exhibition at the Centennial, bypassing the
jury that was charged with the task of selection. Although he didn't
extend this privilege to Eakins, the young painter would have had
ample reason to expect the best.

As things turned out, Eakins had five works accepted for exhibition
in the art galleries but *The Gross Clinic* wasn't among them. It was
rejected by the selection committee, a conservative group, though as a
portrait of a leading doctor who had written a manual of military
surgery it was allowed to hang among medical exhibits in the prefabri-
cated U.S. Army Post Hospital that was also part of the Centennial
exhibition (Fig. 2). Before that, however, Eakins placed it on show at
the Haseltine Galleries, where it received a rave review from his friend
William Clark, art critic for the Philadelphia *Evening Telegraph*. The
rest of *The Gross Clinic*'s early exhibition history is quickly summa-

5

rized. In March 1879, on the occasion of the recently formed Society of American Artists' second annual exhibition in New York, Eakins borrowed *The Gross Clinic* from Jefferson Medical College, which had bought it for two hundred dollars the year before. Accepted by the jury, it provoked a violent reaction among the New York critics, who acknowledged its power and indeed its technical distinction but almost without exception were appalled by its choice and treatment of subject. Following that exhibition, which had been much noticed, the directors of the Pennsylvania Academy of the Fine Arts invited the Society of American Artists to send to Philadelphia as many of the works as could be kept together. But when those works were hung in Philadelphia, *The Gross Clinic* was segregated from the other oil paintings while a canvas by a Philadelphia artist that had been rejected by the New York jury was given pride of place. As Eakins was by then a mainstay of the Pennsylvania Academy art school, this further evidence of the unacceptableness of his masterpiece must have been galling. Thereafter *The Gross Clinic* returned to Jefferson Medical College, where it has remained; its modern fame as "the greatest painting in American art"[2] is the issue of developments after Eakins's death.

Owing to the labors of scholars from Lloyd Goodrich to Elizabeth Johns, we know almost everything that could be known about the scene Eakins chose to depict. Its central figure, Dr. Samuel David Gross (1805–84), Professor of Surgery at Jefferson Medical College since 1856, was one of the leading surgeons and teachers of surgery of his day. As Johns explains in her chapter on *The Gross Clinic,* the operation being performed is consistent with Gross's advocacy of "conservative" surgery, the aims of which were to avoid amputation and more generally to cooperate with the gradual healing processes of nature, and with his distaste for the theatricalism with which earlier teacher-surgeons had practiced their art and that in 1875 was not yet wholly a thing of the past.[3] Specifically, the patient, a young man, is being operated on for the removal of a piece of dead bone from his thigh, a treatment for osteomyelitis that Gross had brought to a high level of refinement. The moment depicted is one at which, the incision having been made by Gross, an assisting surgeon probes the wound; two other assistants, one of whom is almost entirely obscured behind Gross, hold the incision open with metal retractors; a fourth assistant, his profile largely turned away from the beholder, grips the patient's legs; while at the far end of the table an anesthesiologist holds in his

hands a mass of chloroform-soaked gauze and gazes down at the patient's face, which, along with the rest of the body above the hips, is lost to view. Behind Gross and to his right (our left), a woman in black, traditionally characterized as the patient's mother, cringes in her chair and covers her eyes. Above her, seated at a lectern, another physician records the proceedings. In the right-hand portion of the painting two standing figures, the nearer one of whom is Gross's son (also a surgeon), are framed by the doorway to the amphitheater. The rest of the audience comprises twenty-one figures including Eakins himself, who sits hunched forward immediately to the right of the entrance ramp with notebook and pencil in hand.[4] (His identity is much plainer in the black-and-white watercolor Eakins made after *The Gross Clinic* than in the painting itself [Fig. 3].)

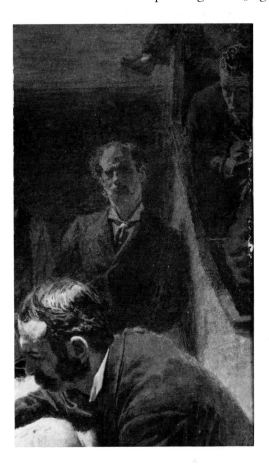

3. THOMAS EAKINS,
The Gross Clinic, 1875,
India ink wash on cardboard,
detail of Eakins.
The Metropolitan Museum
of Art, New York.
Rogers Fund, 1923. (23.94)

The scene would have been a familiar one to Eakins long before he thought of basing a painting upon it. As Johns and others have emphasized, Eakins had studied human anatomy in high school; starting in 1862, when he made the decision to become an artist, he had pursued further study with surgeons, first at the Pennsylvania Academy and then at Jefferson Medical College, where the students were called upon to dissect; he had continued to dissect and to attend surgical classes during his years in Paris; and back in Philadelphia he had returned to Jefferson for at least one more round of lectures and dissection. "There his apprenticeship ended," Johns writes. "He had earned the credentials to paint the surgery in [*The Gross Clinic*] in 1875; to become the chief preparator/demonstrator in 1876 for the surgeon W. W. Keen, M.D. in Keen's lectures on anatomy at the Pennsylvania Academy of the Fine Arts; and to teach anatomy and dissection himself over many of the next years."[5]

Regarding the more strictly pictorial aspects of *The Gross Clinic*, commentators have mostly drawn attention to its uncompromising realism, its atmosphere of subdued but intense drama—a function both of the actions of the figures and of the strongly contrastive chiaroscuro lighting—and what they have taken to be its relation to various historical precedents, notably Rembrandt's *The Anatomy Lesson of Dr. Nicolas Tulp* (1632; Fig. 4) and, a more recent proposal, François-Nicolas-Augustin Feyen-Perrin's *The Anatomy Lesson of Dr. Velpeau* (Fig. 5), exhibited in the Paris Salon of 1864 and possibly seen by Eakins after his arrival in Paris two years later.[6] In addition, Johns has suggested that there may be a kinship between Gross's pose in Eakins's picture and that of the sculptor Martinez Montañés in Velázquez's portrait of the latter in the Prado,[7] while Parry, who describes *The Gross Clinic* as a "total image of a man engaged in his profession," would place it in "a long tradition of full-length portraits of men at their work, including such local examples as John Neagle's *Pat Lyon at the Forge* (Pennsylvania Academy of the Fine Arts)."[8] Some of these connections are more convincing than others—I am doubtful, for instance, about the relevance of Feyen-Perrin's canvas, the location of

4. (opposite, top) REMBRANDT VAN RIJN, *The Anatomy Lesson of Dr. Nicolas Tulp*. 1632. Mauritshuis, The Hague.

5. (opposite) F.-N.-A. FEYEN-PERRIN, *The Anatomy Lesson of Dr. Velpeau*, 1864. Musée des Beaux-Arts, Tours. Photograph courtesy of Bulloz.

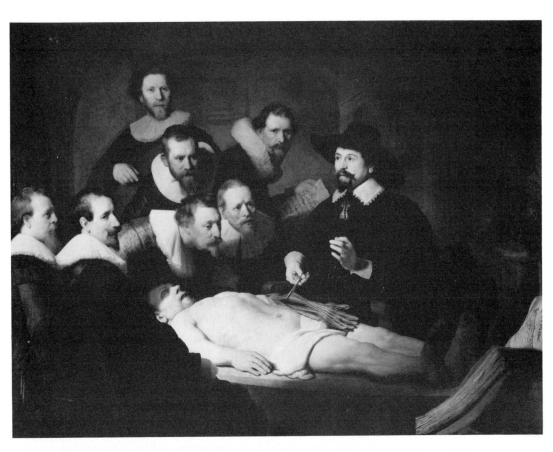

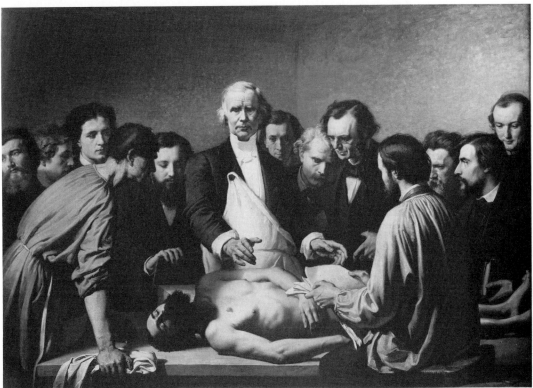

which in the later 1860s remains unknown—but all of them together serve to normalize *The Gross Clinic,* to stabilize it generically, and in the end to suppress the challenge it presents to traditional categories of art-historical comprehension. By this I don't mean to imply that Eakins's picture bears no significant relation to previous painting: on the contrary, it might be said almost to sum up the mainstream realist tradition from Caravaggio on. But it does so in a way that invites us to rethink the nature of that tradition, and to the extent that we accept the invitation we shall find the usual techniques of art-historical inquiry to be of little use.

In other respects too the pressures of a normalizing discourse have kept interpretation under the tightest of reins. For example, a few writers, most importantly Goodrich, have noted an obdurate obscurity at the heart of Eakins's composition. "With all its clarity," Goodrich observes, *"The Gross Clinic* is not easily read at first glance; it has elements of enigma. The center of the action, the patient, is almost hidden; his face is covered by the anesthetist's cloth, and all that is visible of his body is his left buttock and thigh and his sock-covered feet; it takes a little time before one realizes what the doctors are working on. Also there is a half-hidden figure behind Dr. Gross [i.e., the third assistant mentioned above]; at the latter's left appears a hand holding a retractor in the incision, and on the surgeon's right are the elbow, thigh, and knee of this figure. These enigmatic features are part of Eakins' realism; a more superficial painter would have made things obvious, but Eakins knew that in an actual operation, involving six participants, everything is not clearly visible."[9] As Johns puts the same argument, Eakins "had to show the thigh of the patient in order to demonstrate this type of operation; he had to put a surgeon behind Dr. Gross who would logically reciprocate the work of Dr. Appel [the second assistant] in the right foreground; and he had to show the location of every hand involved in the surgery. Eakins eclipsed nothing—indeed, even exaggerated the knee of the surgeon behind Gross: the demands of a real situation took precedence over design, material over grace."[10] Similar reasoning has been advanced to justify the shocking portrayal of the operation and the blood on Gross's right hand: the wound and blood are shown, it is claimed, because they were there to be seen and because Eakins's artistic principles demanded that he be faithful to the facts of perception.[11]

But to argue in these terms is to posit an original scene that in effect

demanded its own exact transcription, a notion that divests the painter of all but the barest responsibility for his painting even as it testifies to the success of a kind of ontological illusion that Eakins doubtless aspired to bring off. Put another way, what this tautological argument from reality characteristically ignores is that consciously or otherwise Eakins *chose* to obscure the disposition of the patient's body, to almost wholly eclipse the assistant behind Gross, and to assault the viewer twice over—with the open wound from which blood oozes and, more stunning in its impact because an even starker violation of decorum, with Gross's bloody right hand holding a scalpel—or three times, if we include the figure of the cringing mother unable to look at what is taking place, and that each of these choices could have been modified without sacrificing the painting's overall realism of effect. So we are entitled to regard them as calling for further commentary if not explanation, and in general to suspect that we haven't yet begun to come to grips with *The Gross Clinic* with anything like the energy of imagination and complexity of purpose that it displays toward us.

A few words about my approach are in order. First, I believe that crucial aspects of the significance of *The Gross Clinic* can be brought out only by bracketing its supposed dependence upon the scene it claims to represent and by comparing it instead with a considerable number of other works in Eakins's oeuvre, with particular emphasis on the 1870s and early 1880s. This will lead to a distribution of emphasis that may seem surprising, and it also means that the title of this essay is something of a misnomer, since the scope of my argument extends far beyond *The Gross Clinic* itself. Second, although I shall be centrally concerned with the question of the nature of Eakins's realism, I should acknowledge at the start that I shall have little to say explicitly about the body of work that many esteem as his crowning achievement as a realist painter, the portraits of the 1890s and after. But I am convinced that the argument I shall be developing holds good for his portraits generally, and in any event I stand squarely opposed to the views of those scholars who see the later work as paradigmatic for his entire production and therefore insist that Eakins was from the outset basically a portraitist.[12] As will become clear, to engage his paintings and drawings of the 1870s and 1880s with this assumption in place would be to simplify them drastically, which in turn would have depressing consequences for our understanding of his achievement as a whole. Finally, I should also acknowledge that my reading of Eakins

has in part been shaped by my investigations into the relation between painting and beholder in French art and art criticism between Chardin and Manet, and in particular by my studies of the major French realist of the mid-nineteenth century, Gustave Courbet.[13] Not that the issues I shall be pursuing here involve the problematic of theatricality and antitheatricality that has been the gist of my interpretations of French developments. On the contrary, coming to Eakins from that prior involvement has had the virtue of forcing me to register important differences between his art and that of the French masters who have been the focus of my research until now. But it has also helped me to discover terms with which to express those differences, and although I mostly refrain from juxtaposing Courbet and Eakins, a comparison between their respective enterprises is tacitly at work throughout this essay.

<div align="center">II</div>

For some time now it has been recognized, as I have already mentioned, that Eakins represented himself in *The Gross Clinic* attending closely to what is taking place and either sketching the scene or making notes on it (or both) in a sketchbook or notebook that rests on his knee. Such an act of self-portrayal in a multifigure composition was by no means unprecedented and in itself might not seem to require further discussion. But there are several reasons why Eakins's inclusion of himself in the most ambitious of his early paintings is of interest.

In the first place, there are other instances of the sort in Eakins's work. For example, in the earliest and most renowned of his pictures of rowers on the Schuylkill River, *The Champion Single Sculls* (or *Max Schmitt in a Single Scull* as it has come to be called), Eakins has portrayed himself rowing vigorously in the middle distance with the name and date "EAKINS 1871" on the stern of his scull (Pl. 2, Fig. 6; unfortunately, both name and date are all but invisible in black-and-white reproduction). He also appears seated in a distant stake boat signaling with an upraised arm in another rowing picture, *The Biglin Brothers Turning the Stake* (1873; Fig. 35); and in still another canvas of the first half of the seventies, *The Artist and His Father Hunting Reed Birds* (ca. 1874; Fig. 7), he is shown standing in the stern of a small boat and poling it along as his father stands in the bow with rifle at the

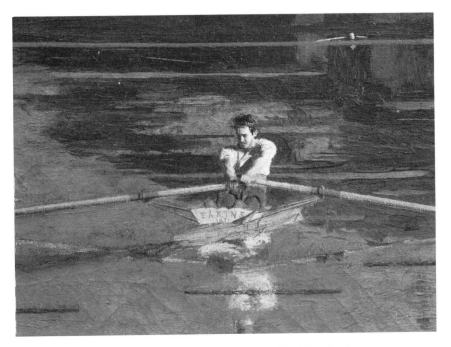

6. THOMAS EAKINS, *Max Schmitt in a Single Scull*, 1871,
detail of scull in middle distance. The Metropolitan Museum of Art, New York.
Purchase, 1934, Alfred N. Punnett Fund and Gift of George D. Pratt. (34.92)

ready waiting for a bird to break cover.[14] In an important picture of
the next decade, *The Swimming Hole* (1883–85; Fig. 8), Eakins turns
up in the right foreground swimming toward the group of naked fig-
ures on the rocks. And in a large-scale work that casts the subject
matter of a surgical operation in a new format, *The Agnew Clinic* (1889;
Fig. 9), Eakins is there once more among the onlookers (he is the
standing figure at the extreme right), his image supposedly having
been painted by his wife, Susan Macdowell Eakins. This tendency to
include himself in his paintings is all the more striking in that only
two "pure" self-portraits by him have come down to us, both dating
from a later moment in his career.

A second reason for paying close attention to Eakins's portrayal of
himself in *The Gross Clinic* is that variants of what he is shown doing—
concentratedly sketching and/or writing, in any case wielding a pen-
cil-like implement—recur elsewhere in the picture: (1) in the actions
of the recording physician who transcribes the proceedings; (2) in

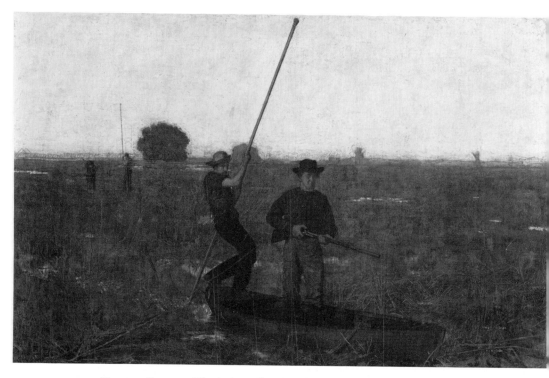

7. THOMAS EAKINS, *The Artist and His Father Hunting Reed Birds*, ca. 1874.
Virginia Museum of Fine Arts, The Paul Mellon Collection.

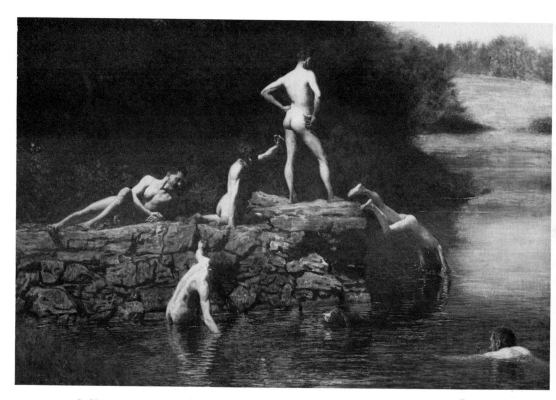

8. THOMAS EAKINS, *The Swimming Hole*, 1883–85. The Fort Worth Art Museum,
Fort Worth. Purchased by the Friends of Art. Photograph by David Wharton.

those of Gross's principal assistant probing the open wound; and (3) in the position of Gross's right hand holding the scalpel much as one might hold a pencil or pen (or for that matter a paintbrush). The figure of Eakins, so obscure and marginal, thus turns out to be closely linked with the dominant foci of the composition and his actions to be keyed to those of its leading personages.

A third reason takes the implication of these last remarks a step further by suggesting that Gross's stance and demeanor may be seen as analogous to those of a painter who, brush in hand and concentrating hard, has momentarily stepped back or turned partly away from a canvas on which he has been working. In this connection the startlingly illusionistic depiction of the bright red blood on Gross's right hand may be taken as alluding to—almost as representing—the actual crimson paint that was a primary means of that illusion, as if blood and paint were tokens of one another, natural equivalents whose special relationship is here foregrounded with unprecedented vividness.[15] Viewed in these terms, *The Gross Clinic* begins to emerge not simply as a uniquely impressive memorial portrait or a powerfully dramatic image of a masterly human intelligence at work but also as an indirect or

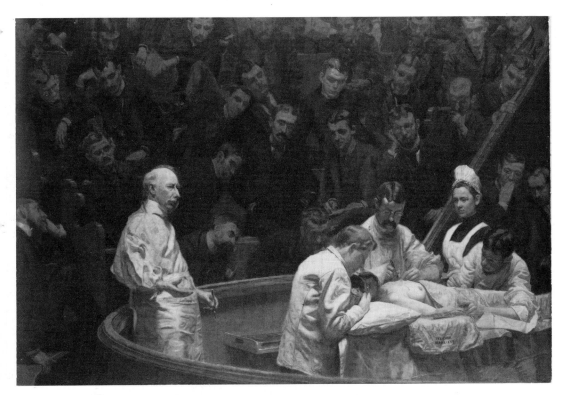

9. THOMAS EAKINS, *The Agnew Clinic*, 1889. University of Pennsylvania School of Medicine. Photograph courtesy of University of Pennsylvania Archives.

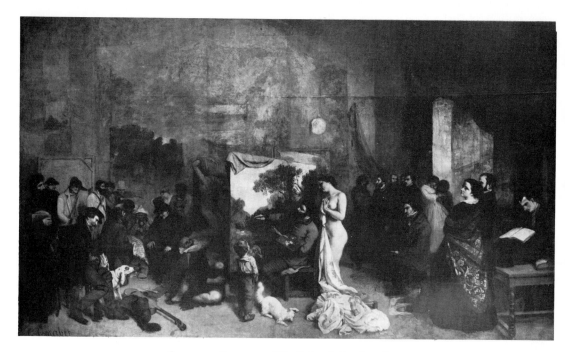

10. GUSTAVE COURBET, *The Painter's Studio*, 1854–55.
Musée du Louvre, Paris. Photograph courtesy of Réunion des musées
nationaux, Paris.

metaphorical representation of the enterprise of painting, comparable
in significance to Courbet's monumental *Painter's Studio* (1854–55;
Fig. 10), a picture Eakins couldn't have seen, or the seventeenth-
century masterpiece that Eakins did see at the Prado in 1869–70,
Velázquez's *Las Meninas* (1656; Fig. 11). *The Gross Clinic*'s relation to
the latter is especially intriguing. On the one hand, the two composi-
tions differ significantly from one another, and the value structure and
overall tonality of *The Gross Clinic* are far closer to Rembrandt than to
Velázquez. (They are closer still to Caravaggio, a point I shall return to
presently.) On the other hand, I am haunted by what seems to me a
partial affinity between the figures of Gross and Velázquez as well as
between the rearmost of the two men standing in the doorway to the
amphitheater in the American work and the figure silhouetted in the
doorway drawing back a curtain at the rear of *Las Meninas*. There is
also a suggestive resemblance between the pose of the nearer of the two
men in the doorway in *The Gross Clinic* and the standing male servant
in the right-hand portion of the Spanish picture. Eakins's admiration
for Velázquez both on the occasion of his visit to Madrid and through-
out the years that followed is well documented, though it seems to
have been the principal figure in the right foreground of *Las Hilanderas*

16

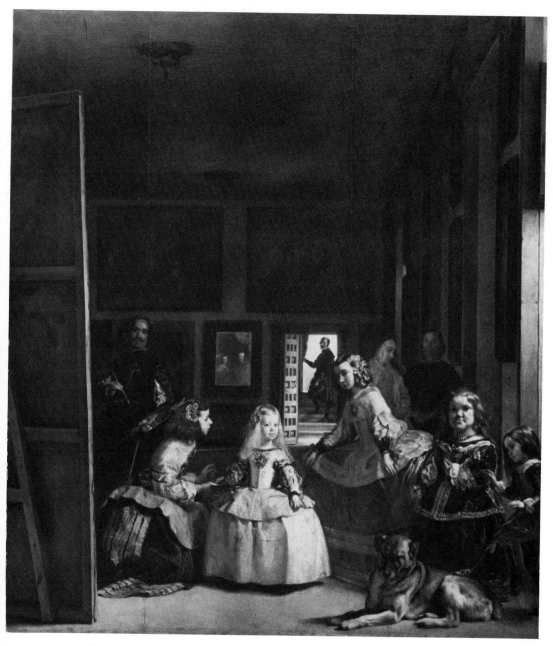

11. DIEGO VELÁZQUEZ, *Las Meninas,* 1656. Museo Nacional del Prado, Madrid.

(1657[?]; Fig. 12), a seated woman seen partly from the rear, that he singled out for special notice in 1870.[16] In fact it is tempting to connect the team of assistants gathered around the operating table in *The Gross Clinic* with the (admittedly far more loosely grouped) trio of women in the right-hand portion of *Las Hilanderas*. Finally, however, all these associations are at best tentative: suggestive as they may be, they fall short of providing compelling evidence for the reading of *The Gross Clinic* as a "real allegory" of Eakins's enterprise that I have begun to sketch.[17]

To strengthen my case, let me introduce in this context a painting Eakins appears to have started or at least conceived of around the time he began work on *The Gross Clinic,* although it wasn't completed until two years later—*William Rush Carving His Allegorical Figure of the Schuylkill River* (1876–77; Pl. 3). The chief personage in that picture, William Rush (1756–1833), had been a ship's carver and a sculptor in wood and terra-cotta who had lived and worked in Philadelphia in the early decades of the republic.[18] Eakins's picture represents Rush carving a fountain sculpture, which became famous in its time, of a lightly draped water nymph holding a local shore bird called a bittern on her shoulder. After completion the sculpture was painted white to simulate marble and in August 1809 was installed in Centre Square, then the heart of a water distribution system designed by Benjamin Latrobe. The accepted interpretation of *William Rush* emphasizes Eakins's desire to commemorate Rush's achievement as a Philadelphia artist and, more important, to strike a blow for the academic study of the nude as the basis for all ambitious art. (A young woman of good family was said to have served Rush as a model; in Eakins's painting she is shown posing unclothed in the company of a chaperone.) The theme of the nude had particular relevance to Eakins, not only because it expressed one of his most profound artistic convictions but also because, as David Sellin has shown, the years 1876–77 marked the first phase of a controversy over the use of naked models at the Pennsylvania Academy of the Fine Arts art school that was to climax in Eakins's dismissal from the school in 1886.[19] We might note too that Johns has linked Rush's "gentlemanly dress" and "graceful bearing" in Eakins's picture with "the aristocratic tradition of Velázquez in his studio paintings at the Prado,"[20] though at least as pertinent as that aspect of *Las Meninas* is the resemblance between the figure Eakins most admired in *Las Hilanderas* and the seated chaperone absorbed in

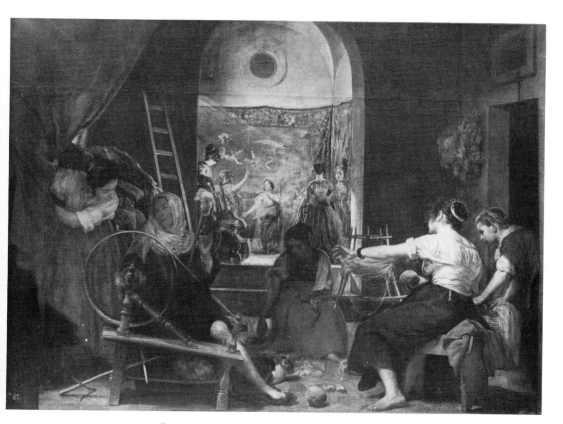

12. Diego Velázquez, *Las Hilanderas*, 1657(?).
Museo Nacional del Prado, Madrid.

her knitting in *William Rush*. But what I find particularly significant about the temporal conjunction of *The Gross Clinic* and *William Rush* is that it establishes that during these years Eakins was explicitly concerned with a scene of artistic representation that bore a strong if indirect relation to his own situation and beliefs. And this helps prepare the ground for the extension of such a description to *The Gross Clinic* itself.

Moreover, there is a further tie between *The Gross Clinic* and *William Rush* that carries surprising implications for our understanding of both. I have remarked in passing that Rush was a ship's carver and a sculptor; actually he was the new republic's foremost ship's carver before he began sculpting independent busts and figures, which is to say that much of his career was spent designing and carving figureheads and ornamental scrolls for vessels. Drawings for two such scrolls as well as working notes, presumably in Rush's handwriting, appear on the wall of his studio toward the right-hand edge of Eakins's paint-

ing, and two finished scrolls in wood rest on the floor in the left foreground.[21] As Johns has observed, there is in this regard a parallel between Rush and Eakins, who was trained and for a short time practiced as a writing master—his father's profession—before deciding to become a painter. Where I part company with Johns is over her interpretation of that parallel in terms of a fundamental difference between artisanship and high art. Thus she sees Eakins in *William Rush* as having "created a sculptor who was no mere ship's figurehead carver, but in his very workshop identity an important citizen," and characterizes the likeness between Rush's and Eakins's careers by saying that "just as Rush had moved beyond shipcarving into the more demanding realm of sculpture, so Eakins had moved on after several years of writing and teaching ornamental script to become a professional artist."[22] But the designs for scrolls on the studio wall, not to mention the finished scrolls on the floor, plainly declare that the creator of *Water Nymph and Bittern* was *still* actively engaged in ship carving, which in turn strongly suggests that Eakins wished to call attention precisely to the *continuity* between vocations that modern scholars are inclined to regard as essentially distinct. In the same spirit, Eakins began one of two verbal glosses on his painting with the deceptively simple statement, "William Rush, the Ship Carver, was one of the earliest and one of the best American sculptors"—a sentence that manages both syntactically and typographically to insist on the primacy of Rush's supposedly merely artisanal activity.[23]

If we ask what significance this way of construing Rush's career has for the view of Eakins's enterprise that is implicit in *William Rush,* the answer would seem to be that the picture presents Eakins's training and practice as a writing master as directly relevant to—as inextricably bound up with—his work as a painter. (The handwritten notes on the wall in Rush's studio are a further, more emphatic indication of this.) And if armed with this notion we now turn again to *The Gross Clinic,* it is impossible not to be impressed by the crucial role that writing and writinglike activities assume in that painting. I refer not simply to the figure of the doctor seated at a lectern and recording the proceedings but also to the actions of the figures of Gross, the chief assisting surgeon, and Eakins himself, all of whom, as we have seen, are represented engaged in tasks that require the use of a pencil- or penlike instrument. Indeed the proliferation of figures engaged in tasks of that nature militates against reading the figure of Gross sim-

ply as a version of the painter at work on his painting; especially in view of Eakins's portrayal of himself in Gross's audience sketching and/or writing, it seems preferable to think of all four personages as collectively thematizing a manner of working—of coordinating eye and hand, of articulating a portion of the world, of representing oneself to others—that finds its most general expression in the enterprise of writing. This immediately and inevitably raises further questions. For example, what in Eakins's formation as person and artist accounts for the implicit thematization of writing in both *William Rush* and *The Gross Clinic?* How are we to understand the relationship—at once a distinction and a sliding—between writing and painting that *The Gross Clinic* in particular allegorizes and embodies? And what if any are the implications of our findings for the interpretation of other works in Eakins's oeuvre?

III

Part of the answer to the first of these questions is cultural: in Philadelphia high schools of the mid-nineteenth century, writing and drawing not only were considered essential skills but were taught as different aspects of a single *master* skill of eye and hand working in concert. The key textbook was Rembrandt Peale's *Graphics* (1834), which in a later edition was in use at Central High School during the years Eakins studied there (1857–61).[24] Strongly influenced by the ideas of the Swiss educational theorist Johann Heinrich Pestalozzi, Peale maintained that "writing is little else than drawing the forms of letters [just as] drawing is little more than writing the forms of objects," and went on to provide a graded series of exercises that would lead the beginner from the drawing of simple lines and curves through Roman capital letters, Arabic numerals, designs "taken from the pattern of Furniture Scrolls" (not unlike the drawings of scrolls in *William Rush*), various objects such as an urn, a sarcophagus, an antique ax, and a saucebowl, the Old English alphabet, the features of the human face with special attention to the ear as an almost abstract pattern of curving lines, the Old German alphabet, and the modern English alphabet in script, both upright and oblique.[25] Other textbooks in use at the school would have reinforced Peale's approach, so that by the time Eakins graduated he had gained a high degree of competence

both in fine penmanship and in the elements of drawing, including perspective, and, equally important, he had been thoroughly indoctrinated in a set of practices and a way of thinking that barely if at all distinguished one from the other. When the professorship of drawing and writing at Central High School fell open in September 1862, Eakins, then only eighteen, was one of four candidates who competed for the position; he didn't win it and soon afterward began studying to be a painter at the Pennsylvania Academy of the Fine Arts. But this involved not a change of direction so much as the pursuit of a career that his early mastery of writing and drawing had made seem an attractive possibility.[26]

It is therefore not surprising that representations of writing in several languages—more broadly, of graphic notational systems of all kinds—turn up repeatedly in Eakins's art, though it is perhaps more than a little surprising that this has never been noticed. For example, in *Street Scene in Seville* (1870; Fig. 13), his earliest attempt at a true painting (what the French would call a *tableau*) as distinct from a study of a head or a figure, three street musicians are shown performing in front of a stuccoed wall into which various graffiti have been scratched, mainly words in Spanish (both in script and in sticklike capitals) and a childlike drawing of a matador confronting a bull. Three paintings made during the first years after his return to Philadelphia, *Frances Eakins* (1870; Fig. 14), *Home Scene* (ca. 1871; Fig. 15), and *At the Piano* (1872), so clearly depict the sheet music from which his sisters Frances and Margaret have been playing that individual notes can be glimpsed, and *Home Scene* also represents his youngest sister, Caroline, sprawled on the floor drawing with chalk on a framed slate. Other works of the 1870s that contain images of writing in a broad sense include *Max Schmitt in a Single Scull* (Pl. 2; not just Eakins's signature and the date but also the name "Josie" in slanting capitals along the side of Schmitt's scull); *Sailboats Racing on the Delaware* (1874; Fig. 16), which depicts near the top of each sail numerals in red (the nearest boat is number 25); *William Rush* and a study for it, *Interior of a Woodcarver's Shop* (1876–77; Fig. 17), in both of which patterns for letters and numbers can be seen hanging on the far wall; the marvelous *Baby at Play* (1876; Fig. 18), which portrays Eakins's niece Ella Crowell playing with blocks the faces of which bear capital letters that have been painted—drawn with the brush—with a precision worthy of his education;[27] and a superb portrait, *Dr. John H. Brinton* (1876;

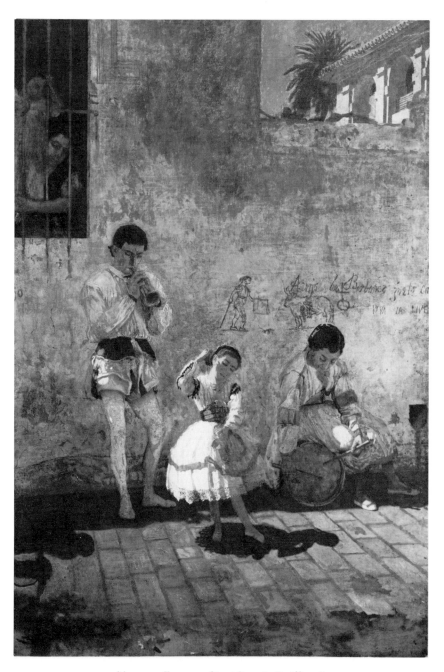

13. THOMAS EAKINS, *Street Scene in Seville*, 1870.
Photograph courtesy of Christie's.

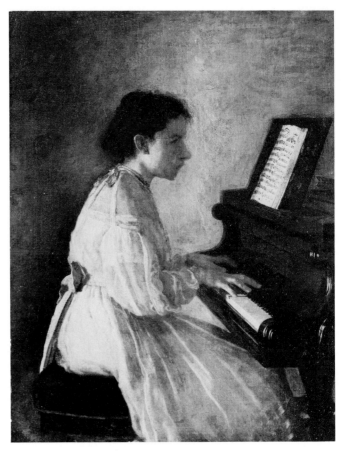

14. (above) THOMAS EAKINS, *Frances Eakins,* 1870.
The Nelson-Atkins Museum of Art,
Kansas City, Missouri (Nelson Fund).

15. (opposite, top) THOMAS EAKINS, *Home Scene,* ca. 1871.
The Brooklyn Museum, New York. Gift of George A. Hearn,
Frederick Loeser Art Fund, Dick S. Ramsay Fund,
Gift of Charles A. Schieren.

16. (opposite, bottom) THOMAS EAKINS, *Sailboats Racing
on the Delaware,* 1874. Philadelphia Museum of Art. Given by
Mrs. Thomas Eakins and Miss Mary Adeline Williams.

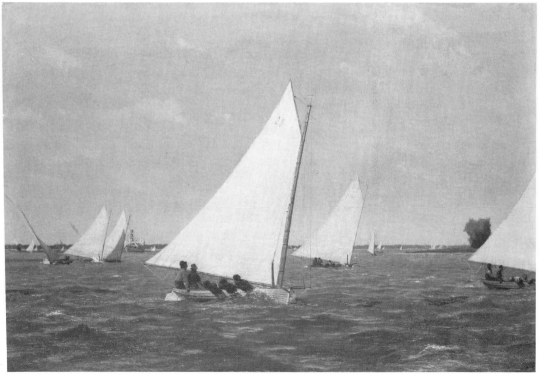

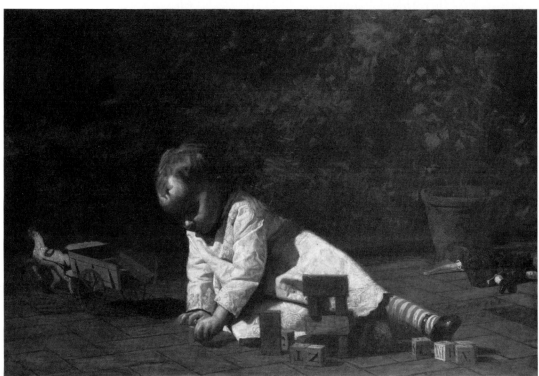

17. (top) THOMAS EAKINS, *Interior of a Woodcarver's Shop*, 1876–77.
Philadelphia Museum of Art. Given by Charles Bregler.

18. (above) THOMAS EAKINS, *Baby at Play*, 1876. National Gallery of Art,
Washington, D.C. John Hay Whitney Collection.

Figs. 19, 20), in which we find, all but lost in shadow beneath the desk at the left, a tall ceramic(?) vase decorated just below the rim with the sitter's name. (Note also the stamped envelope protruding above the rim.)

A more imposing instance of Eakins's fascination with different alphabets and handwritings is his severe, naturalistic *Crucifixion* (1880; Fig. 21): the whole upper portion of the cross, from the top of the painting to below the crossing, is obscured by a large parchment or papyrus covered with writing—the traditional derisive identification of Jesus of Nazareth as king of the Jews—both in Greek script and in Roman capitals.[28] The prominence and legibility of that writing in contrast to the deeply shadowed and almost wholly unreadable features of the figure on the cross implies an unusual order of priorities. Another canvas of the early 1880s, *The Writing Master* (1882; Fig. 22), portrays the painter's father engrossing a document, the upper portion of which—a mixture of letters and flourishes—occupies the near left foreground of the image. In *The Agnew Clinic* from the end of the decade, a towel hanging down from the table on which a woman is being operated on for breast cancer bears upside down the stenciled words "UNIVERSITY HOSPITAL" (Fig. 23). Two later boxing pictures, *Taking the Count* (1898) and *Between Rounds* (1899; Fig. 24), depict brightly lettered posters and, in the latter, smaller signs indicating the press box and the round. Indeed *Between Rounds* is of even greater interest than this suggests: not only is the press box full of men writing, it also contains (to the right of the numeral "2") a sketch artist, who thus fulfills a role analogous to that of the figure of Eakins in *The Gross Clinic;* furthermore, the figure of the seated timekeeper concentrating on his watch, the face of which we can barely glimpse (though we know it to bear tiny marks and numbers), may be compared to that of the chief assisting surgeon peering into a wound only partly open to our gaze in the earlier painting.

Among the later portraits that involve motifs of writing are *Frank Jay St. John* (1900; Fig. 25), with its mysterious gridlike piece of ship's equipment leaning against the wall to the left and bearing in small characters along its edge the legend "S. S. ORION ORDER M. 926"; *Monsignor James P. Turner* (ca. 1906; Fig. 26), in which the letter "M" forms part of the ornamental grillwork to the prelate's right (note too the precisely drawn cross on the cover of the Bible cradled in his arms); and, one of Eakins's final masterpieces, *Professor William*

19. THOMAS EAKINS, *Dr. John H. Brinton*, 1876. Medical Museum of the
Armed Forces Institute of Pathology; on loan to the National Gallery of Art,
Washington, D.C.

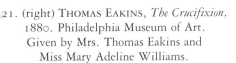

20. THOMAS EAKINS, *Dr. John H. Brinton*.
1876, detail of ceramic(?) vase.
Medical Museum of the Armed Forces Institute
of Pathology; on loan to the National
Gallery of Art, Washington, D.C.

21. (right) THOMAS EAKINS, *The Crucifixion*,
1880. Philadelphia Museum of Art.
Given by Mrs. Thomas Eakins and
Miss Mary Adeline Williams.

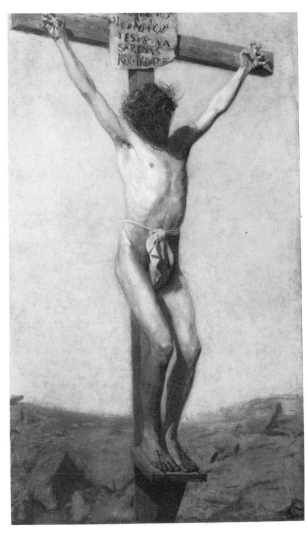

22. (overleaf) THOMAS EAKINS, *The Writing Master*,
1882. The Metropolitan Museum of Art, New York.
Kennedy Fund, 1917. (17.173)

23. (overleaf) THOMAS EAKINS, *The Agnew Clinic*, 1889,
detail of operating table. University of Pennsylvania School
of Medicine. Photograph courtesy of University
of Pennsylvania Archives.

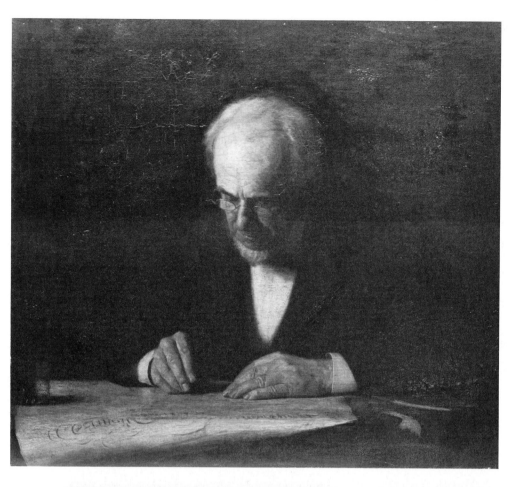

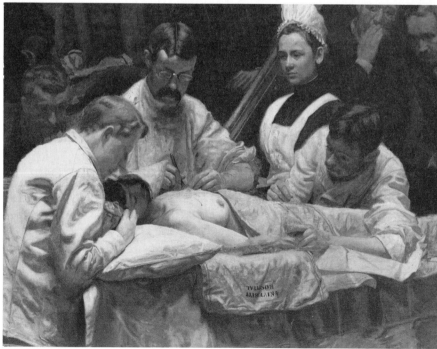

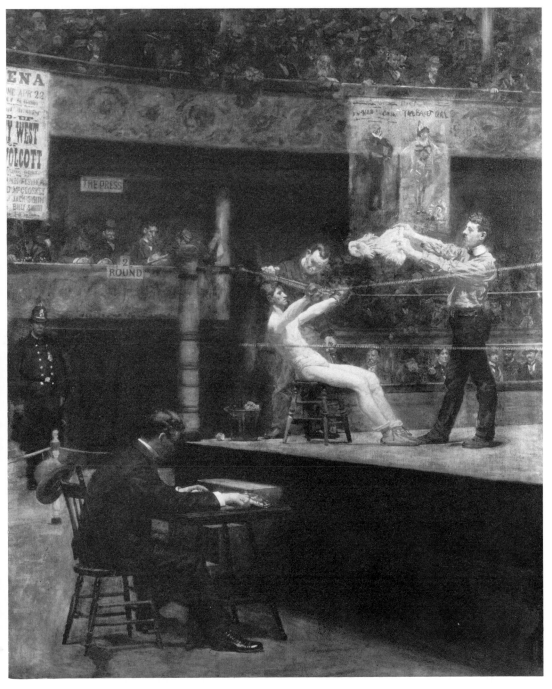

24. THOMAS EAKINS, *Between Rounds*, 1899.
Philadelphia Museum of Art. Given by Mrs. Thomas Eakins and
Miss Mary Adeline Williams.

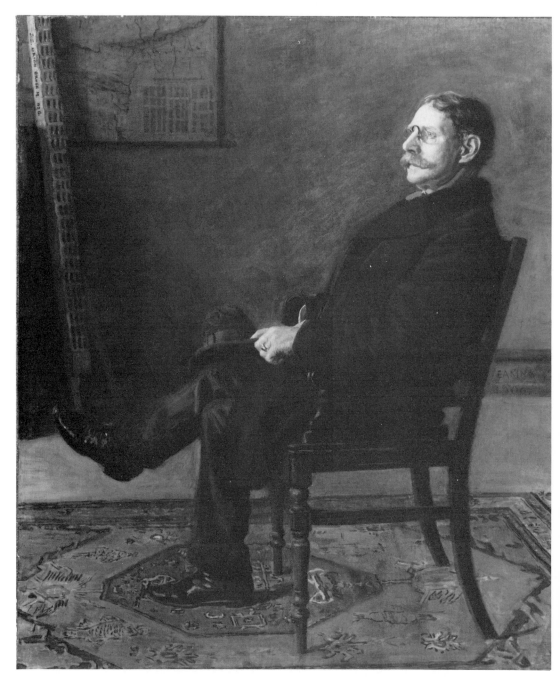

25. THOMAS EAKINS, *Frank Jay St. John,* 1900.
The Fine Arts Museums of San Francisco. Gift of
Mr. and Mrs. John D. Rockefeller 3rd.

26. (opposite) THOMAS EAKINS, *Monsignor James P. Turner,* ca. 1906.
The Nelson-Atkins Museum of Art, Kansas City, Missouri (Nelson Fund).

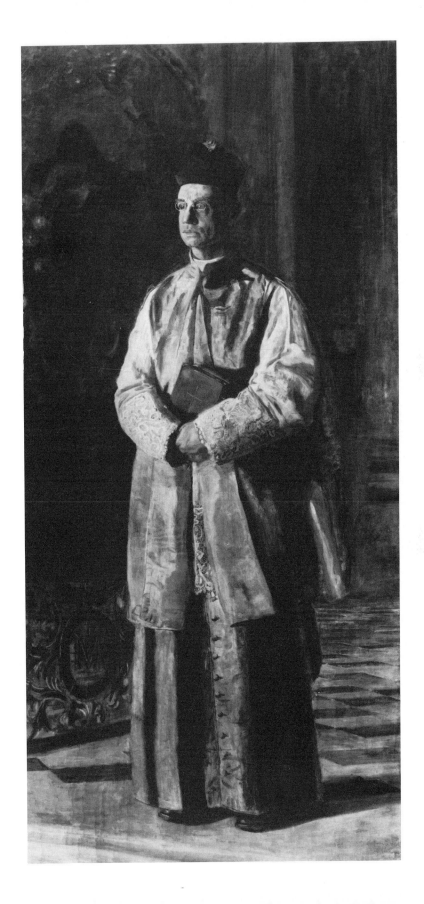

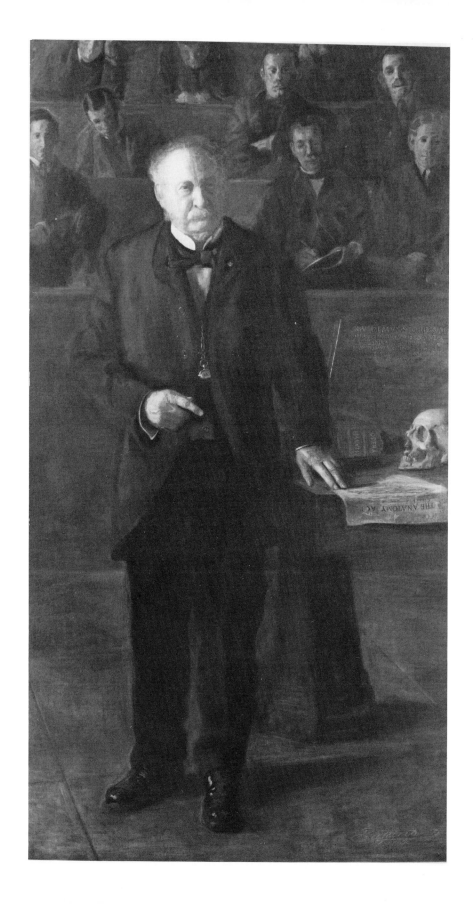

Smith Forbes (1905; Fig. 27), which comprises a range of graphic imagery including a document at the top of which we can read the inverted heading "The Anatomy Act," a Latin text carved into the wooden wall separating Forbes from the students taking notes behind him, an ancient book titled "OPERA/HARVEY" on the spine, and a bright watch-fob bearing the minute numerals "1883."[29] Eakins's obsession with writing also can be seen in the seventeen instances in which, utilizing the full resources of his early training, he projected his signature in flowing script into the perspective structure of the painting in such a way as to make the signature appear to coincide with the ground plane.[30] (See for example the signatures at the lower right of the *Brinton* and *Forbes* portraits; I shall have more to say about this device further on.) And the sheer persistence of the obsession can be gauged from the fact that a late version of *William Rush* (1908; Figs. 28, 29) depicts the naked model standing on a cylindrical block of wood on which two letters, either a "c" or a "b" and an "r," have been stenciled upside down (the recurrence of inverted motifs of this sort invites speculation), while Eakins's last name and the date appear in bold red lettering on the carved scroll that rests on the studio floor immediately to the model's right.

But perhaps the most unexpected manifestations of Eakins's involvement with writing are several *frames* that he designed for important paintings. Two in particular deserve special notice: that for *The Concert Singer* (1890–92; Fig. 30) has carved into its bottom segment the opening bars of Mendelssohn's "Rest in the Lord," the aria from *Elijah* that Weda Cook is represented as singing; and the broad gilt frame for *Professor Henry A. Rowland* (1897; Pl. 4) is entirely covered with scientific formulae, graphs, diagrams, drawings of spectra, and the like, all in an imitation of Rowland's hand.[31] (Here as in *William Rush,* and in a sense in *Street Scene in Seville* and *The Crucifixion,* Eakins seems to have taken pleasure in reproducing someone else's handwriting.) The tendency of images of writing in Eakins's art not only to invest the representational field but also to transgress or extend its physical limits is tantamount to treating the frame as the typically blank but by no means inviolable margin of a page. And the fact that *The Concert Singer* depicts at its left-hand edge part of a single palm

27. (opposite) THOMAS EAKINS, *Professor William Smith Forbes,* 1905. Jefferson Medical College, Thomas Jefferson University, Philadelphia.

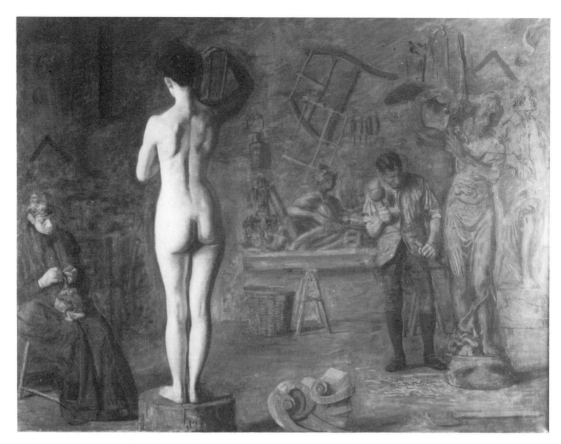

28. THOMAS EAKINS, *William Rush Carving His Allegorical Figure of the Schuylkill River,* 1908. The Brooklyn Museum, New York. Dick S. Ramsay Fund.

29. THOMAS EAKINS, *William Rush Carving His Allegorical Figure of the Schuylkill River,* 1908, detail of wooden block and carved scroll. The Brooklyn Museum, New York. Dick S. Ramsay Fund.

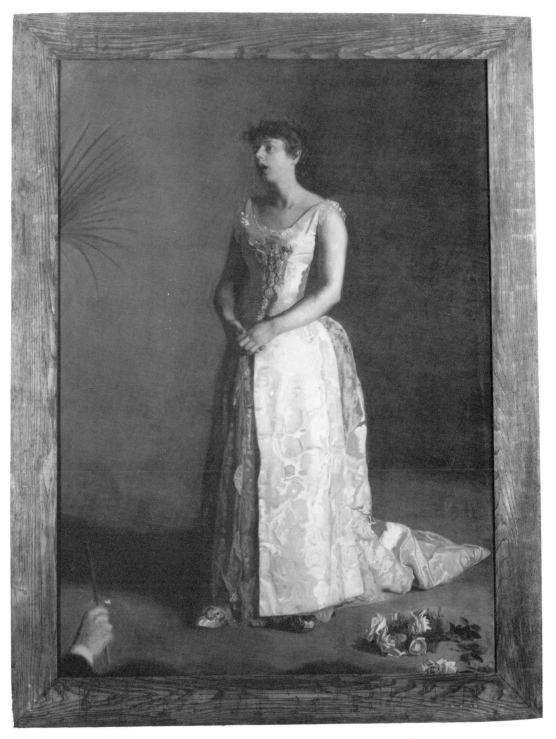

30. THOMAS EAKINS, *The Concert Singer,* 1890–92, with frame.
Philadelphia Museum of Art. Given by Mrs. Thomas Eakins and Miss Mary
Adeline Williams.

frond and, in the bottom left corner of the canvas, the right hand of a conductor holding a baton strongly suggests that at least in this instance a lack of certainty about the status of the limits of the canvas is given expression within the painting itself.[32]

A second, equally important, and not unrelated factor contributing to the thematization of writing in Eakins's paintings was personal: Eakins's father, Benjamin Eakins, was himself a writing master—he taught fine penmanship and engrossed documents in a beautiful, ornamental hand—and the relations between father and son appear to have been extremely close. Benjamin, a self-made man of means, fully supported his son's choice of vocation, initially by subsidizing his training in Philadelphia and Paris and, after Thomas's return from abroad in 1870, by allowing him to live and paint in the family's home on Mount Vernon Street and moreover by relieving him of all financial necessity. "You learn to paint the best you can, Tom," he is reported to have told his son, "you'll never have to earn your own living."[33] This continued backing from his father enabled Eakins to pursue his course as a painter without having to depend on sales, which throughout his career were sporadic at best. For his part, Eakins clearly esteemed his father highly and perhaps viewed his own career as in part an extension of the older man's. Both *The Artist and His Father Hunting Reed Birds* (Fig. 7) and another picture, *The Chess Players* (1876; Fig. 31), in which Benjamin is depicted watching two other men play chess, bear the inscription "BENJAMINI EAKINS FILIUS PINXIT," testimony to the closeness between father and son. It is also true that Benjamin Eakins appears to have been a severe and perhaps somewhat forbidding character: thus meals in his presence are described as having been markedly subdued affairs;[34] and in a picture already mentioned, *The Writing Master* (Fig. 22), Eakins portrayed his father at close range sitting with head bent over a document on which he is working in a manner that at once memorializes the sitter's professional skills and, uncharacteristically for this painter, guards the secret of his personality. (A later portrait of Benjamin Eakins is less obviously reticent.) In his fine catalog of the Eakins collection at the Philadelphia Museum of Art, the late Theodor Siegl reflects interestingly on the internal dynamics of the Eakins household and calls attention to the predominant role that relationships with older men rather than his contemporaries played in Thomas Eakins's life.[35] Siegl cites Eakins's reverence for his masters, especially Gérôme; his close friendship with

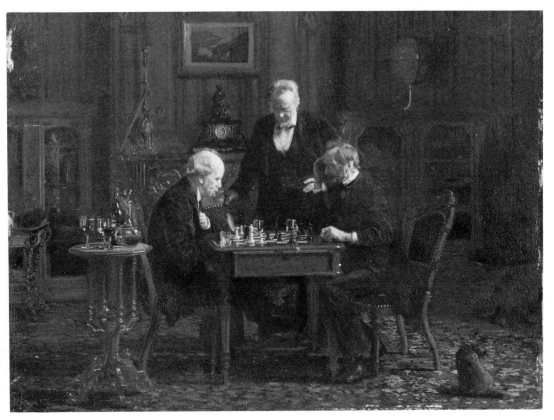

31. THOMAS EAKINS, *The Chess Players*, 1876. The Metropolitan Museum
of Art, New York. Gift of the artist, 1881. (81.14)

his father-in-law, William H. Macdowell, by profession an engraver of
documents, following Eakins's marriage to his student Susan Mac-
dowell in 1884; his relations with Walt Whitman starting around
1887; and his association with the Roman Catholic clergy at the semi-
nary at Overbrook, subjects of a number of impressive portraits from
the early 1900s. More generally, Siegl speculates that a "great respect
for justly deserved authority must account for his looking frequently to
doctors and scientists for friendships and, often, also as subjects for his
pictures."[36] An obvious implication of Siegl's remarks is that the pro-
totype of all these friendships was Eakins's relationship with his father,
and although so unnuanced an insight is bound to have limited
usefulness, there can be little doubt that the conjunction in *The Gross
Clinic* of the theme of writing and the representation of an admired
older man who embodies that theme casts a paternal aura over the
composition as a whole.

This impression gains in force when we consider certain similarities

39

between Eakins's treatment of Gross and his later portrayal of his father in *The Writing Master:* in both cases the dominant physical feature is a domed forehead framed by gray hair and seen under powerful illumination; the document that Benjamin Eakins is engrossing (the pun is unavoidable and might just be significant) lies at roughly the same angle to the picture plane as does the operating table in *The Gross Clinic;* and sharpest focus is reserved for the writer's hands, the right one in particular recalling that of the famous surgeon. In addition there is a bright red accent at one end of the short quill lying on the table to the sitter's left, a characteristic touch that introduces a note of at least potential violence into an otherwise wholly peaceable scene. Something of the same treatment of the head characterizes the image of Eakins's father in *The Chess Players,* and it may not be irrelevant that he is the one standing figure in the picture and that the two seated players are shown concentrating on their game much as the assistants in *The Gross Clinic* are wholly occupied with the patient. There is also a rough but to my mind arresting analogy between the portrayal of father and son in *The Artist and His Father Hunting Reed Birds* and that of Gross and his chief assistant: in both canvases a dominant older male is shown standing composedly while a younger subordinate labors under his aegis, and I am also struck by the extent to which the long pole wielded by Eakins in the hunting picture can be seen as still another version of a pencil or pen (or surgical probe) and Benjamin Eakins's shotgun as anticipating the potentially threatening aspect of Gross's bloody scalpel. It is worth noting too that Benjamin Eakins is said to have posed for the title figure in at least one of the early studies for *William Rush,* [37] a painting I have claimed may be read as interpreting *The Gross Clinic* in crucial respects. All this suggests that part of the drama being played out in *The Gross Clinic* involves what Freud was later to term a "family romance":[38] there seems to be a fairly strong sense in which Gross may be seen as a glorified father figure and Eakins's self-portrayal at the right-hand edge of the painting as at once subordinating his persona to that of the older man and, by virtue of the affinity between their respective actions, as establishing a connection between them as well.

But the family structure of *The Gross Clinic* involves more than just those two figures or for that matter all the figures engaged in writinglike activities. The patient undergoing surgery has always been identified as a young man and the older woman in mourning as a close

relative, almost certainly his mother. (In charity cases a relative was required to be in attendance during an operation. The gold wedding band on the fourth finger of the woman's left hand signifies that she is or was married, which in turn has been taken as further evidence of her relation to the patient.) So we have, fantasmatically, either two more members of the same family or two members of another family, mother and son as opposed to father and son, and bearing a different, or at least manifestly ambivalent, relation to the commanding figure of Gross. (The painting includes still another filial personage, Dr. Samuel W. Gross, son of the great surgeon and his eventual successor; but he seems to me largely to escape the play of forces that eventually we shall have to trace.) Now it is well known that the painter's mother became mentally ill shortly after his return from abroad in 1870, finally dying at home in June 1872 of "exhaustion from mania" after almost two years during which it seems she couldn't be left unattended.[39] No doubt it would be not just crude but misleading to construe the patient's mother as a figure for Caroline Cowperthwait Eakins, and in any case to do so on the basis of the latter's illness and collapse would hardly follow from psychoanalytic considerations. But the actions of the mother have often been felt to be excessive—to introduce a disturbing note of melodrama—at the same time as she has been seen as curiously out of scale, just slightly too small for her location in the amphitheater, and in that sense too as not quite fitting into the painting as a whole. And this raises the possibility that her presence in *The Gross Clinic* may have been at least partly determined by a logic of feeling that had nothing whatever to do with strictly realistic factors. Altogether, then, the juxtaposition in a single, intensely dramatic composition of a dominant, authoritative older man, an intrusive, highly emotional older woman, and no less than two sons—the figures of Eakins and of the patient being operated on (I am eliding the younger Gross)—makes it inevitable that *The Gross Clinic* be construed, sooner or later, in Freudian terms. With Gross's bloody scalpel before our eyes, it should be unnecessary to add that among those terms will be the issue of castration.

IV

So far I have said nothing about the precise articulation of writing and painting in *The Gross Clinic*, but rather than confront that issue directly I want to approach it in stages—to begin with, by considering how Eakins's early masterpiece relates to his previous productions, including works to which it bears no stylistic resemblance.

Very roughly, Eakins's paintings of the first half of the 1870s fall into two groups. The first comprises pictures of interior scenes, mainly involving one or more young women—his sisters Frances and Margaret, his fiancée Kathrin Crowell, his sister-in-law Elizabeth Crowell— engaged in simple actions that assume a dignity by virtue of having been represented as manifestly and intensely *absorptive:* playing or listening to the piano, for example, or (in *Home Scene*) drawing on a slate and watching someone draw, or, in *Elizabeth Crowell with a Dog* (1874; Fig. 32), a picture that remained one of Eakins's favorites, teaching a poodle to sit up. Coloristically, the works in question are dark, with black or dark brown shadows enveloping much of the image, though punctuated by patches of white as well as by areas of bright warm red that are surely meant to mediate between dark and light but often seem almost to leap out of the painting. They are also frankly painterly over much of their surfaces, even if certain passages and details are executed with great precision, and in the largest and most authoritative of these pictures, the splendid *Elizabeth Crowell at the Piano* (1875; Pl. 5), the play of knifework across much of the background, especially toward the upper right, lends a decorative texture to the paint handling itself.

Viewed in the context of previous art, all these paintings belong to an absorptive tradition that goes back at least to Caravaggio and Rembrandt and includes more recent masters like Chardin and Courbet. As these names suggest, the tradition to which I refer is essentially a realist one, and there is every likelihood that the connection between absorption and realism that it evinces is functional rather than merely accidental. Thus for example an absorptive thematics calls for effects of temporal dilation that in turn serve the ends of pictorial realism by encouraging the viewer to explore the represented scene in an unhur-

32. THOMAS EAKINS, *Elizabeth Crowell with a Dog*, 1874.
The San Diego Museum of Art.

ried manner; the same painterly chiaroscuro that lends itself to strong
absorptive effects (e.g., shadowing a given personage's gaze, often in
contrast to bright illumination on the brow) also yields effects of mod-
eling and atmosphere—of the tangibleness but also the continuity of a
perceptual field—that constituted one of the major innovations of sev-
enteenth-century painting; and especially in the work of Vermeer and
Chardin, the seeming obliviousness of one or more figures to every-
thing but the objects of their absorption contributes to an overall im-
pression of self-sufficiency and repleteness that functions as a decisive
hallmark of the "real."[40]

By the 1870s, however, this tradition was all but defunct, at least as
far as advanced painting in Paris was concerned. The last works of
major ambition by a French painter that could be said to belong to it
were Courbet's Realist pictures of the late 1840s and 1850s. The ad-
vent of Manet around 1860 marked the emergence of a radically differ-
ent sort of realism—nonabsorptive, instantaneous, in a certain sense

43

theatrical—that undermined the foundations of the earlier system, and the subsequent development of Impressionism, with its landscape subject matter, brighter palette, and effects of spontaneity, would soon prove even more broadly influential. But none of this appears to have mattered to Eakins, if in fact he was aware of Manet and his successors. Instead he worked out his own version of the absorptive realist mode he found in the art of the old masters he most admired (principally Velázquez, Rembrandt, and Ribera), first and somewhat painstakingly though with growing confidence and undeniable intensity in the pictures of young women in domestic interiors and then, when he was ready, with complete authority and *éclat* in *The Gross Clinic*. Not that the latter is altogether homogeneous with the absorptive works that preceded it. For one thing, the contrast between darks and lights in *The Gross Clinic* is more emphatic than in any of the domestic paintings, which by itself adds an element of high drama, virtually of confrontation, absent from the earlier works. For another, the almost wholly male environment of the operating room would seem to have nothing in common with the distinctly female expressive register of the interior scenes. But the primacy of absorption in *The Gross Clinic* is everywhere manifest—in the portrait of the master surgeon about to speak (his brow is slightly contracted, his eyes narrowed, their whites indiscernible); in the personages of the recording physician and, to the extent that we can make him out, Eakins himself, wholly engaged in their respective acts of writing/drawing; in the attitudes of Gross's audience; and, most perspicuously, in the combined actions of the assisting surgeons around the operating table, a motif comparable in its single-mindedness as well as in aspects of its content to one of the most compelling seventeenth-century images of collective engrossment (this pun too is hard to avoid), the probing of the open wound in Christ's side in Caravaggio's *Doubting Thomas* (ca. 1602–3[?]; Fig. 33). [41] Also reminiscent not just of Caravaggio but of paintings by Courbet such as the *After Dinner at Ornans* (1848–49), the *Stonebreakers* (1849), and the *Wheat Sifters* (1854), though no doubt derived from Velázquez's *Las Hilanderas*, is Eakins's representation of one of the assisting surgeons mostly from the rear, a device that, in the work of all four masters, promotes a heightened sense of the figure's absorption in the situation of which it is a part. (It is impossible to know just how familiar with Courbet's paintings Eakins was in 1875, or for that matter whether or not Caravaggio was of interest to him

44

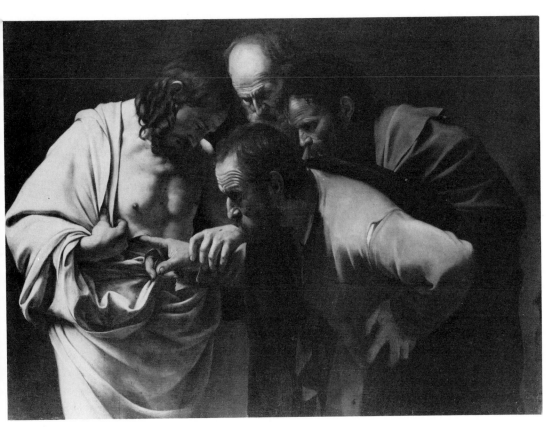

33. CARAVAGGIO, *Doubting Thomas*, ca. 1602–3(?). Staatliche Schlösser und Gärten, Potsdam–Sanssouci.

then or later. My point in any case is not that Eakins was influenced by either of those predecessors but rather that in the art of all three painters, as well as in *Las Hilanderas*, the exploitation of an absorptive thematics as a matrix for a realist mode of representation led to analogous motifs and groupings.)[42]

Another difference between the domestic scenes and *The Gross Clinic* concerns the apparent contrast between the decorousness of the first and the violence of the second. But this contrast loses at least some of its force when we recognize that it overlooks an important common term—Eakins's predilection for the color red. For there is a sense in which the obsessive recurrence of bright red or coral or intense pink accoutrements in the domestic pictures (e.g., the sash around the sitter's waist in *Frances Eakins*, the trim on Margaret's jacket and the color of Caroline's dress in *Home Scene*, Elizabeth Crowell's jacket and the collar of the dog in *Elizabeth Crowell with a Dog*, the electrifying rose in Elizabeth's hair in *Elizabeth Crowell at the Piano*) finds its climax

45

or fulfillment in the open wound and bloody hands in *The Gross Clinic*. But this is to imply that the meaning of those accoutrements was perhaps not entirely benign in the first place—that whatever the factual or formal rationale for Eakins's exploitation of red in the paintings of young women, it may also have served as a vehicle for extremities of feeling that had no real home in his art until they found their place in *The Gross Clinic*. Indeed the basic coloristic structure of that painting—a stark opposition between black and white mediated by flesh tones and punctuated by a shocking, liquid crimson—may be seen in retrospect to have been latent in the domestic pictures all along.[43]

The second group of early works that I want to consider are the scenes of rowing and boating that remain among Eakins's most original and admired productions. On the face of it, there is a world of difference between those scenes and the domestic pictures he made during the same years: for example, the rowing and boating paintings represent men engaged in vigorous activity; they are set outdoors; they are brightly and for the most part evenly illuminated; and characteristically they are executed with scrupulous attention to minute technical detail. They are also, it need hardly be said, intensely realistic, and one of the most arresting facts about Eakins's early career is that he practiced two such ostensibly disparate modes of realism simultaneously and with equal conviction. I have just claimed that *The Gross Clinic* may be seen as a further instance of the absorptive, chiaroscuro mode, which it carries to a new sublime of explicitness and power. Now I want to suggest that it also subsumes, if not the rowing and boating pictures as such, at any rate crucial aspects of their realism, which perhaps goes part of the way toward explaining why that type of picture disappears from Eakins's art after 1874–75.

For our purposes, the most impressive feature of the rowing pictures in particular is the use they make of reflections in water, a class of motif that Eakins considered especially beautiful and was later to lecture on at the Pennsylvania Academy. Thus we find a reflection of both shell and oarsman summarily indicated in probably the earliest of all his images of rowing, the oil sketch for *Max Schmitt in a Single Scull* (ca. 1870–71; Fig. 34), while the finished canvas, a work of amazing maturity for an artist as inexperienced in picture making as Eakins was then, presents a rich array of inverted images reflected from the mostly placid surface of the Schuylkill: images of Schmitt and his scull and oars, of the trees at the lower left, of Eakins rowing in the middle

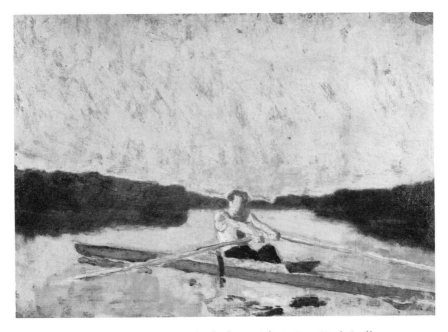

34. THOMAS EAKINS, *Sketch of Max Schmitt in a Single Scull,*
ca. 1870–71. Philadelphia Museum of Art.
Given by Mrs. Thomas Eakins and Miss Mary Adeline Williams.

distance, of the piers of the bridge and, toward the right, of the hill-
side with trees and of other boats in the distance, all seen against the
reflection of the overarching blue sky (though not of the clouds that
seem almost to mirror the attenuated form of Schmitt's boat). In other
works of these years, notably *The Pair-Oared Shell* (1872; Fig. 35), *The
Biglin Brothers Turning the Stake* (1873; Fig. 36), *The Biglin Brothers
Rowing* (1873), and the oil and watercolor versions of *John Biglin in a
Single Scull* (1873–74; Fig. 37), the surface of the river is covered with
countless ripples or wavelets, with the result that the reflections that
appear in it are broken, mingling fragmented images of rowers and
their shells (and, in *The Pair-Oared Shell,* the dark stone pier of a
bridge) with mirrorings of sky and perhaps also with glimpses through
the surface into the water. The phenomenon of broken reflections is
itself treated analytically in Eakins's lecture notes, and in fact two fine
drawings for *The Pair-Oared Shell* survive in which a rigorous perspec-
tive construction has been carried out to determine the precise (i.e.,
minutely approximate) appearance of the reflections that are so impor-

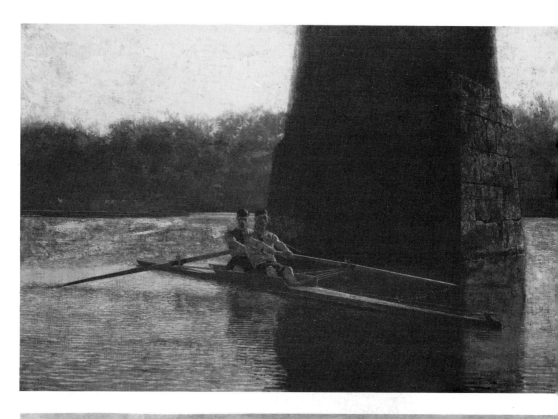

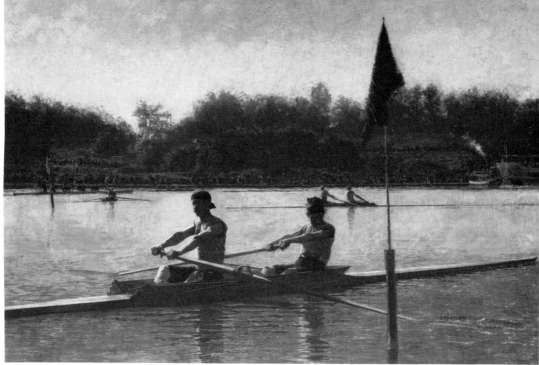

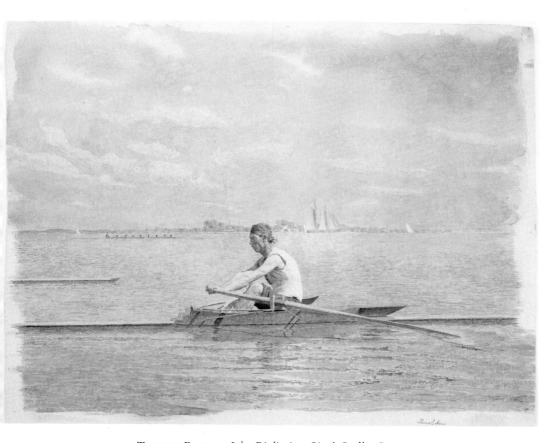

37. THOMAS EAKINS, *John Biglin in a Single Scull,* 1873–74,
watercolor on paper. The Metropolitan Museum of Art, New York.
Fletcher Fund, 1924.

35. (opposite, top) THOMAS EAKINS, *The Pair-Oared Shell,* 1872. Philadelphia
Museum of Art. Given by Mrs. Thomas Eakins and Miss Mary Adeline Williams.

36. (opposite, bottom) THOMAS EAKINS, *The Biglin Brothers Turning the Stake,*
1873. The Cleveland Museum of Art. Hinman B. Hurlbut Collection.

49

tant a feature of the finished painting (Fig. 38).[44] (Similar preparatory drawings survive for *The Biglin Brothers Turning the Stake* and *John Biglin in a Single Scull* [Fig. 39].)

All this leads me to characterize the realist mode of the rowing pictures as essentially *reflective,* by which I mean to allude both to inverted images in water and to an activity of inward representation that traditionally has recognized in the production of such images a natural analog to its own mysterious processes. Reflection in the second of these senses is manifestly an absorptive activity in its own right, from which it follows that the domestic interior scenes and the rowing pictures are at least indirectly linked. The link is confirmed by the depiction of the reflection of Frances Eakins's hands in the polished wood of the piano and perhaps also in the piano keys above which her hands hover in the painting that bears her name (the latter reflection, if such it is, can't be made out in black-and-white reproduction). And if we now consider the figures of oarsmen in all but one of the pictures I have cited, it becomes apparent that their trancelike engagement (made all the more salient by the depiction of self-mirroring pairs of rowers) in the physically demanding but also protracted and rhythmically repetitive activity of rowing provides an actional and psychological matrix not unlike the one I have associated with the depiction of piano playing and related motifs in the domestic interiors. The exception is the first of the rowing pictures, *Max Schmitt in a Single Scull,* in which the title figure trails his oars and, squinting into the light, turns in his seat to confront the painter and/or viewer; yet even there the small but exactly delineated figure of Eakins rowing energetically into the distance presages the works to come.

In other words, the absorptive mode of the domestic pictures and the reflective mode of the rowing pictures are less dissimilar than they appear at first.[45] But there remains a significant difference between the two groups of works that concerns what might be described as the transparency of the second to the perspectival drawing (and by im-

38. (opposite top) THOMAS EAKINS, *Perspective Drawing for "The Pair-Oared Shell,"* 1872. Philadelphia Museum of Art. Purchased, The Harrison Fund.

39. (opposite, bottom) THOMAS EAKINS, *Perspective Drawing for "John Biglin in a Single Scull,"* 1873–74. Gift of Cornelius V. Whitney. Photograph courtesy of Museum of Fine Arts, Boston.

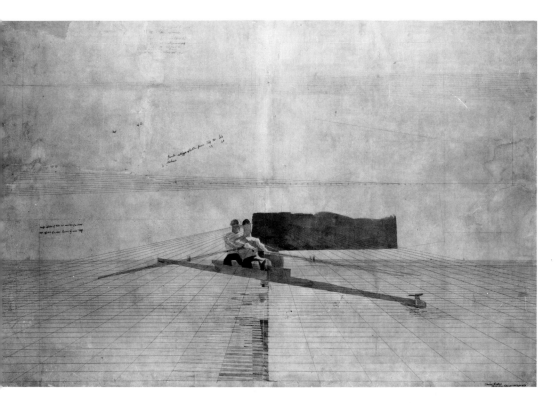

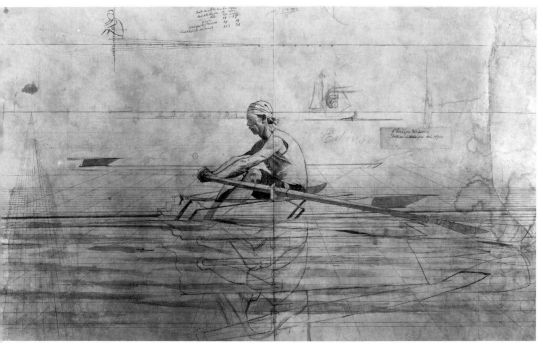

51

plication *writing*) constructions that underlie them as opposed to the obscurity or indeed opacity of the first in that regard. By this I intend something more than a stylistic distinction between the linear character of many of the rowing scenes and the painterly character of the interiors, though such a distinction is by no means beside the point. What I want to emphasize is, first, that Eakins's lifelong interest in perspective, which incidentally sets him apart from French masters like Courbet and Manet (though not of course from his teacher Gérôme), was rooted in the writing/drawing complex that figured greatly in his early training and, as we have seen, found remarkably diverse expression in his art throughout his career; and second, that the basic structures and motifs of the rowing pictures are such as enabled Eakins not only to bring his formidable knowledge of perspective into play but also, more important, to do so perspicuously, in a manner that allowed a certain relation to writing—to writing/drawing—to come to the fore.

I am thinking in particular of the role of the assertively foreshortened ground plane in the rowing pictures and of the implicit analogy between that plane and the horizontal plane of writing/drawing, which in this context must be distinguished fundamentally from the vertical or upright plane of painting. That is, a principal effect of the underlying perspectival structure in these pictures is to make us acutely aware of the surface of the water as an image-bearing horizontal plane; and inasmuch as the underlying structure belongs to a complex of practices that at once posits and articulates such a plane, it is tempting to see in the finished paintings images of that condition of their own production, which is to say of their genesis in writing/drawing. Put slightly differently, the rowing pictures refuse to allow the implied horizontality of the "original" sheet of paper to be wholly superseded and in effect suppressed by the verticality of the stretched canvas.[46] (I shall have a lot more to say about the relationship between horizontality and verticality in Eakins's art before I am through.) The inversion relative to the viewer of motifs of writing in pictures such as *The Writing Master, The Agnew Clinic,* the *Forbes* portrait, and the Brooklyn Museum *William Rush* reinforces this impression, as does—a wholly unexpected detail—the faint but unmistakable reflection of Benjamin Eakins's right hand and cuff from the surface of the document on which he is working in the first of these (Fig. 22). Was Eakins as a child or youth captivated by a similar reflection, perhaps

along with the inversion of his father's writing relative to himself as onlooker, and did he recall both, no doubt unconsciously, in the rowing pictures? (The curiously low, hence childlike, point of view from which Benjamin Eakins has been portrayed contributes to *The Writing Master*'s aura as of a primal scene.) Or is it rather that in this most explicit of all Eakins's representations of the enterprise of writing, also no doubt unconsciously, he reinscribed the reflective surface of the rowing pictures in a context whose association with the writing/drawing complex is beyond question, thereby giving rise, as by *Nachträglichkeit,* to a fantasy of origination—of his art if not of himself—in and by the figure of the father?[47] In any event, the faint gleam of flesh and linen just beneath his father's hand and sleeve must be given its due. Indeed we might go on to connect the flourishes that Benjamin Eakins has drawn toward the top of his page with the curving wakes and darkish whirlpools that have been almost literally incised by Schmitt and Thomas Eakins into the otherwise peaceful surface of the Schuylkill in *Max Schmitt in a Single Scull.* And if we then consider that to the infant Eakins all writing would have been "mere" flourish, the decoratedness and illegibility of the document on which Benjamin Eakins is at work may be taken as further indices of *The Writing Master*'s fantasmatic character; but I don't insist on this.[48]

Even regarding the relation to writing/drawing, however, the difference between the domestic interiors and the rowing and boating pictures is less than absolute. As we have remarked, several of the interiors contain images of writing in the form of musical notation, while *Home Scene* depicts the figure of Caroline Eakins drawing on a slate. The imaging of reflection in *Frances Eakins* is perhaps relevant as well, even if in that early work the principal reflection doesn't involve inversion across a horizontal axis. Nor should we overlook the fact that in several of the domestic scenes, as in many of Eakins's portraits throughout his career, richly patterned Oriental rugs and carpets create an image-bearing ground plane almost comparable in interest to that of the reflective surface of the Schuylkill. (The *Brinton* and *St. John* portraits are cases in point.) In addition, two of the most highly wrought interior scenes, the early *Kathrin* (1872) and the masterly *Elizabeth Crowell at the Piano,* bear at the lower right Eakins's signature in script plus the date, both of which have been depicted—that is, painted—in perspective so as to coincide with the floor plane without quite *belonging* to it (Fig. 40).[49] Thus each of the signatures is conspic-

40. THOMAS EAKINS, *Elizabeth Crowell at the Piano*,
1875, detail of signature and carpet. Addison Gallery of
American Art, Phillips Academy, Andover, Massachusetts.

uously misaligned with the pattern of the carpet on which it appears to
rest, and its inky color seems to belong to another representational
system entirely. The result is a compromise-formation that in effect
suspends the signature and date between the respective "spaces" of
writing/drawing and of painting, thereby calling attention both to the
superimposition and to the mutual incommensurability of those
"spaces." Significantly, this remained one of Eakins's favorite devices
for signing his pictures throughout his career.

The Gross Clinic itself, which I have associated with the domestic
interiors and which obviously resembles them far more than it does the
rowing and boating pictures, nevertheless relates importantly to the
latter in at least six respects.

First, the predominantly male population of the operating room in
The Gross Clinic is in keeping with the masculine world of the rowing
and boating scenes. This isn't crucial to my present argument but is
worth mentioning; one might also mention the primacy of a thematics
of absorption in both.

Second, the action of the chief assisting surgeon's probe as it enters
and partly disappears inside the open wound in the patient's thigh
might be compared with the way in which the oars penetrate and in

effect are lost to view beneath the surface of the water in the rowing pictures.

Third, a closely related point, the thematization of writing and writinglike activities in *The Gross Clinic,* in particular the parallel between the actions of the chief assisting surgeon wielding his bloody probe and the recording physician writing with a red pen or pencil atop a whitish lectern, suggests an analogy between the horizontal plane of writing/drawing that I have claimed is figured perspectivally in the rowing pictures and, in the later work, the patient lying on the operating table, both of which, patient and table, are also depicted in abrupt foreshortening. (A middle term between the rowing pictures and *The Gross Clinic* in this regard is the magisterial watercolor *Whistling for Plover* [ca. 1874; Fig. 41], which portrays a kneeling black man armed with a shotgun and pursing his lips as he whistles, softly it would appear, to attract his prey. All around him there expands a table-flat field rendered in abrupt foreshortening, and in the distance to the left of the hunter a figure of a man—no doubt another hunter—lies on his back with his head toward the viewer and his body at an

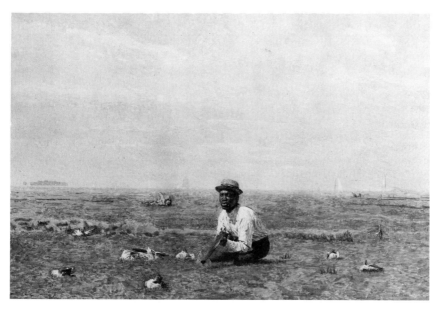

41. THOMAS EAKINS, *Whistling for Plover,* 1874, watercolor.
The Brooklyn Museum. Museum Collection Fund.

angle relative to the picture surface approaching that of the patient in *The Gross Clinic.* A second such figure, all but invisible in the illustration, lies farther away toward the right. Between the personage of the black man cradling his shotgun and that of the distinguished surgeon holding his scalpel there is an underlying affinity of conception that could serve as a small epitome of the obsessional nature of Eakins's concerns.)[50]

Fourth, the tray of medical instruments in the left immediate foreground is naturally aligned to allow the doctors ready access to those instruments. But this means that the tray is inverted relative to the viewer, like reflections in water in the rowing pictures or, again, like the words "UNIVERSITY HOSPITAL" in *The Agnew Clinic,* which in this respect may be seen as spelling out a less emphatic feature of *The Gross Clinic.* Furthermore, the deliberate blurring or imprecision of the representation of the medical instruments, usually taken simply as an index of extreme nearness, recalls the brokenness of the reflections in the later rowing scenes, as do the multiple broken contours of the mostly obscured figure behind Gross, another detail that tends to become lost in reproduction.

Fifth, I see a connection between the almost *trompe-l'oeil* illusionism with which Eakins has depicted the gleaming metal retractors, steel scalpel, and fingers covered with blood (both Gross's fingers and his chief assistant's) in *The Gross Clinic* and the play of light from reflective surfaces and indeed the description of minute engineering details in the rowing pictures as a group. It is as though, at the twin foci of a manifestly absorptive painting whose dramatic chiaroscuro and evocation of an encompassing interior space seem far removed from the bright, outdoor, reflective world of the rowing scenes, we find concentrated the very essence of reflectiveness: shining highlights that confer an extra, in a sense gratuitous, degree of illusion on the representations of blood and steel (and, in contrast, flesh) that simultaneously attract and repel our fascinated gaze. Insofar as reflectiveness in early Eakins has been shown to belong to what I have called the writing/drawing complex, this is tantamount to discovering a further relation to that complex where one might least have expected it.

Finally, among the more than one hundred works by Eakins at the Philadelphia Museum of Art is a small, thickly brushed and knifed oil sketch for *The Gross Clinic* that seems to represent the artist's first idea for his composition and may have been executed *sur le motif* (Fig. 42).

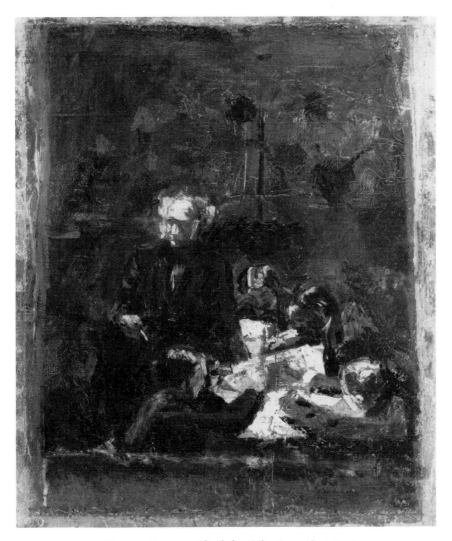

42. THOMAS EAKINS, *Sketch for "The Gross Clinic,"* 1875.
Philadelphia Museum of Art. Given by Mrs. Thomas Eakins
and Miss Mary Adeline Williams.

As Siegl notes in his catalog entry on the oil sketch, it was painted
"right over an old canvas that already had a number of rowing studies
on it," and in an appendix to the catalog he reproduces an inverted X-
ray of the underlying image (Fig. 43)—inverted because Eakins evi-
dently turned the original image upside down before starting to depict

43. Inverted X-ray of THOMAS EAKINS, *Sketch for "The Gross Clinic,"* 1875. Philadelphia Museum of Art. Given by Mrs. Thomas Eakins and Miss Mary Adeline Williams.

the scene in the operating theater.[51] I see a suggestive resemblance between the poses of the two rowers in the X-ray and those of three of the four assisting surgeons in the oil sketch, and find food for thought in the implicit analogy between the inversion of the studies of rowers and the prominence of inverted imagery—reflections in water—in the rowing pictures. That the initial image of rowers is no longer visible on the surface of the oil sketch, or that the sketch in turn has been superseded by the finished painting, doesn't make the relation of *The Gross Clinic* to the initial image any less intriguing.

<p style="text-align:center">V</p>

At this juncture I want to take up several cruxes barely touched on earlier, all of which have to do with the staging in *The Gross Clinic* of what might be called a drama, some would say a melodrama, of visibility. This requires that we suspend discussion of the relation between writing/drawing and painting in Eakins's art, though as will later become clear we shall not be leaving that issue behind even for a moment.

First, there is the matter of the depiction of the patient's body (Fig. 44). As Goodrich has been quoted as observing and as the painting's first reviewer, William Clark, also remarked, the disposition of the body is something of an enigma and requires considerable effort by the viewer to be understood.[52] What should also be said (Clark implies as much) is that the effort of looking and reconstructing that is called for in order to make sense of the patient's body is distinctly unpleasurable: there is a large component of deliberate aggression, even, I suggest, of sadism, both in Eakins's rendering of that body and, ultimately more important, in the attitude toward the viewer that that rendering implies. For not only is the patient represented in drastic foreshortening with most of his body, including the head, lost to view; the portions of the body that can be seen are not readily identifiable, so that our initial and persisting though not quite final impression is of a few scarcely differentiated body parts rather than of a coherent if momentarily indecipherable ensemble. Moreover, there is a quasi-sexual note of violence in the climactic recognition, the end result of the viewer's labors, that those are stockinged feet, a length of naked thigh seen mostly from below, and a bony posterior, the last of which in particular raises

<p style="text-align:center">59</p>

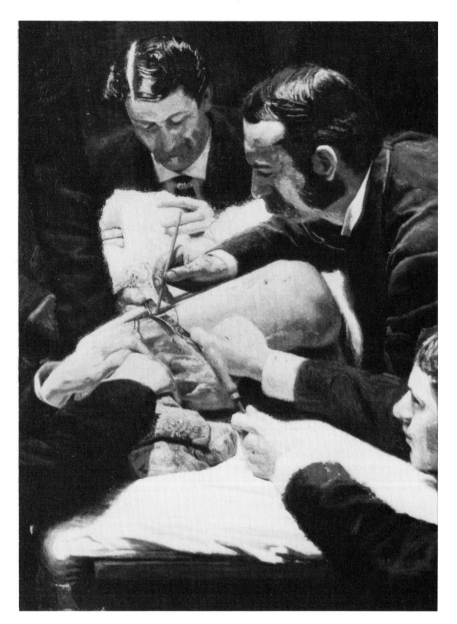

44. THOMAS EAKINS, *The Gross Clinic*, 1875, detail of operating table.
Jefferson Medical College, Thomas Jefferson University.

but conspicuously fails to answer the question of the body's gender. (The traditional assurance, which I don't dispute, that the patient is a young man derives from contemporary accounts of Eakins's intentions, not strictly from a viewing of the painting.) In comparison with all this, the operation itself seems, if not anticlimactic, at any rate a ratification of the violence that the body has already been subjected to by its placement and treatment in the composition.

Then there is the way in which the seated figure earlier designated as the third assistant surgeon—he who holds the farther of the two retractors—is almost wholly eclipsed by the standing figure of Gross. As Goodrich and Johns acknowledge, the obscuring of that figure has strong affinities with the partial elision of the body on the operating table. In fact the realization that there is someone mostly hidden behind Gross, which ordinarily comes about late in the viewing of *The Gross Clinic* if it comes about at all, at once reiterates and deepens the thematics of violence, invisibility, and undifferentiation that I have associated with the figure of the patient. That Eakins may have "exaggerated the knee of the surgeon behind Gross"—John's words quoted earlier—to increase the likelihood that his presence would be noted by the viewer in no way disproves my point. On the contrary, it shows that Eakins wished to force the viewer to confront an arrangement that was bound to appear anomalous, baffling, discomfiting.

The third crux of this sort that I want to examine concerns the competing foci of the operation and of Gross's bloody right hand holding a scalpel. No one who has ever stood before *The Gross Clinic* needs to be reminded just how complex and disturbing are the responses that these inevitably elicit. In the first place, the extreme sharpness of detail and almost *trompe-l'oeil* illusionism with which both the operation and the hand and scalpel have been represented irresistibly attract the viewer's attention. But the operation itself—not just the oozing incision but the pull of the retractors against its sides and the probing of the wound with a long, thin, pencil-like instrument—is acutely unpleasant, indeed painful, to look at, though perhaps a crueler (because more unexpected) violence to our sensibilities is perpetrated by the image of Gross's scalpel-bearing right hand, crimson blood gleaming wetly upon his fingers and upon the point of the scalpel's blade, spotlighted against the background of his dignified black suit and vest (Pl. 8). And yet despite that painfulness and violence we find ourselves unable to tear our eyes away from the scene—rather, we compulsively

shift our gaze from the probing of the wound to Gross's hand and scalpel and back again—until at last it becomes apparent that something in all this must be distinctly pleasurable, which is to say that the act of looking emerges here as a source of mingled pain and pleasure, violence and voluptuousness, repulsion and fascination. That the subject of *The Gross Clinic* is surgery, an art of necessary violence, functions as an implicit moral justification of the experience, as does the recognition that the patient is anesthetized and so can feel nothing himself. (So for that matter does the fact that the operation being performed would have been understood by Gross's professional contemporaries to involve helping nature do its work.)

Finally, the pain of seeing is dramatized by a figure who in the first instance seems both less and more than a surrogate for the viewer—the woman in black who has traditionally been identified as the patient's mother (Fig. 45). Less, in that while her act of throwing her left arm across her eyes so as not to be able to see what is taking place on the operating table has an obvious bearing on the issues we have been tracing, the apparently unequivocal character of that act—a refusal to look—differs sharply from the more complex and ambivalent relationship that obtains between the motifs we have just examined and the audience they posit. (I shall soon claim that her refusal may not be as unequivocal as this implies.) And more, in that the mother also belongs to a network of relationships that cannot be reduced to the single issue of spectatorship, although no account of that network will be adequate that doesn't take questions of spectatorship into account. Just a portion of that larger network is suggested by the analogy between the emphatic *emptiness* of her clawlike left hand, in fact of both her hands, and the *sightlessness* that, alone among the painting's protagonists, she so feelingly embodies. There is even a sense in which the extremity of affect expressed in her left hand's violent contortion is apprehended by the viewer as a threat—at a minimum, an offense—to vision as such, though simultaneously the viewer's attention is drawn, as if against its will, to the thin gold wedding band on the fourth finger of that hand. This is a further instance of the ambivalence or dividedness I have already attributed to the viewer's relation to *The Gross Clinic*. (The offense to vision is compounded by what almost seems a hint of monstrosity in the region of the mother's forehead, where her features are perhaps further obscured by a scarf. I don't mean to suggest that the mother's features are imagined by Eakins as liter-

45. THOMAS EAKINS,
The Gross Clinic, 1875, detail
of cringing woman.
Jefferson Medical College,
Thomas Jefferson University.

ally monstrous, only that it is impossible for the viewer to make sense
of what is depicted of her profile and that this is nearly as disturbing as
the clawlike hand itself.)

I have remarked that the usual explanation of these motifs holds
that because *The Gross Clinic* is a work of undeniable and, it is often
claimed, uncompromising realism, it therefore represents with some-
thing approaching total fidelity the painter's perception of an original,
actual situation, from which the further conclusion is drawn that any
features of the painting that are at all unusual have their rationale in
the specifics of that situation and in the emphases and limitations
inherent in the painter's point of view. And I have said that this expla-
nation is unsatisfactory, first, because it confuses effect with cause—

63

the only evidence we have of that original situation and determining point of view is the painting itself, which therefore can't be taken to establish the priority of either—and second, because by limiting the role of (conscious or unconscious) intention to an initial choice of subject and point of view plus a general will to realism, it implies a prejudicial conception of the realist project as merely photographic, by which I mean that it interprets pictorial realism according to a certain model, itself prejudicial, of photography. To these objections we are now in a position to add that the features of *The Gross Clinic* we have been discussing are all in different ways manifestly so excessive and provocative that the traditional argument from reality seems particularly inappropriate to their case. In fact there could be no more vivid testimony to the blandly normalizing bias of that argument, as well as to the argument's fixated place in art-historical discourse, than the persistence down to the present of the standard realist reading of *The Gross Clinic* in the face of so much that ought to have made such a reading untenable.

Having insisted on this point, which I regard as fundamental, I now want to suggest that some if not all of the features we have just examined may be seen as contributing to *The Gross Clinic*'s nearly overwhelming realism of effect. *Contributing to* that effect, not *explained by* it: that is, just as I have associated *The Gross Clinic* with an absorptive realist tradition dating back at least to the early seventeenth century, so I want to compare Eakins's radical, disfiguring foreshortening of the patient's body and his sharp-focus, deliberately shocking delineation of the operation and of Gross's bloodstained right hand with those moments in the history of that tradition when tactics of shock, violence, perceptual distortion, and physical outrage were mobilized against prevailing conventions of the representation of the human body specifically in order to produce a new and stupefyingly powerful experience of the "real." More than any other earlier master, including even Rembrandt, it is Caravaggio, founder of the tradition and painter of, for example, *Doubting Thomas, Judith and Holofernes* (1598–99), *The Sacrifice of Isaac* (1603), *The Death of the Virgin* (ca. 1605–6), *The Crucifixion of St. Andrew* (1607), *The Beheading of St. John the Baptist* (1608), and *David with the Head of Goliath* (ca. 1609–10), that the calculated aggressions of *The Gross Clinic* call to mind. As often in Caravaggio, there is in those aggressions, as well as in the blackness and opacity of Eakins's chiaroscuro, an implied affront to seeing—a

stunning or, worse, a wounding of seeing—that leads me to imagine that the definitive realist painting would be one that the viewer literally could not bear to look at: as if at its most extreme, or at this extreme, the enterprise of realism required an effacing of seeing in the act of looking (hence the peculiar centrality to the realist canon of Caravaggio's *Medusa* [ca. 1597?]). Or perhaps I should say, recalling our discussion of the motifs in question, that what confronts us as viewers in *The Gross Clinic,* as repeatedly in Caravaggio, is an image at once painful to look at (so piercingly does it threaten our visual defenses) and all but impossible, hence painful, *to look away from* (so keen is our craving for precisely that confirmation of our own bodily reality), and that it is above all the conflictedness of our situation that grips and excruciates and in the end virtually stupefies us before the picture. (The actions of the patient's mother, by which I mean not simply her refusal to expose herself to the operation but also the excessiveness of her gesture, as if covering her eyes required a convulsive effort, may be reinterpreted as a commentary on the painting as a whole understood in these terms.) It is probably significant that the two arch-representatives within the absorptive realist tradition of the esthetic of implied affront to seeing I have just evoked come at the tradition's beginning and end: Eakins's project in *The Gross Clinic* of revivifying an otherwise already defunct system of picture making based in part on an iconoclastic relation to the human body being roughly symmetrical with Caravaggio's momentous project of returning painting to the high ambitiousness of Renaissance art while shattering canons of bodily beauty authorized by that art.[53]

All this may be placed in a different context. Briefly, there is in the dialectic of pain and pleasure I have been tracing more than a hint of an updated version of the esthetics of the Burkean sublime, according to which a scene of menace—typically a natural phenomenon—is capable of yielding delight when viewed from a position that affords safety, though it is also a feature of the paradoxical logic of the sublime that too absolute an assurance of safety threatens to vitiate the experience being courted by these means.[54] What makes this context especially interesting is that it allows us to return to still another topic that was touched on earlier in this essay but had to be deferred—*The Gross Clinic*'s aspect as "family romance" and more broadly the significance of that painting from a psychoanalytic point of view. In a highly influential discussion of the deep structure of the dynamic or negative

sublime, Thomas Weiskel has associated the imagined terror of the first phase of the dynamic sublime with Freud's account of castration anxiety and the culminating experience of delight with the viewer's identification with the "paternal" power that was the immediate or anyway the ostensible cause of the terror. A single long quotation conveys the gist of his argument:

> The power of anything is ultimately "its ability to hurt" [Burke]. The fear of injury points genetically and synecdochically to castration anxiety. We know that the castration fear of the young boy is not realistic; nevertheless it operates subjectively as a real fear. A fantasy of aggression or resistance toward a superior power is played out in the imagination, and the boy sees at once that he would lose. . . . The fantasized character of castration anxiety seems related to the mediated conditionality of the sublime moment: on the one hand, the "ability to hurt" must be objective and obvious; on the other hand, it must not be actually directed against oneself, or the fantasy dissolves into genuine panic and the objective defense of flight. . . . This makes possible a positive resolution of the anxiety in the delight of the third phase, which is psychologically an identification with the superior power. . . . The boy must have introjected or internalized an image of the superior power in order to picture to himself the consequences of aggression, and in the reactive defense this introjected image is reinforced as the affects line up on its side. The identification which thus establishes the superego retains an essential ambiguity. The boy neutralizes the possibility of danger by incorporating or swallowing it: it is now within and can't hurt him from without. But he must also renounce the aggression and turn himself into—be swallowed by—the image, now an ideal, with which he is identifying. . . . The sublime moment recapitulates and thereby reestablishes the oedipus complex, whose positive resolution is the basis of culture itself.[55]

Several observations seem appropriate. First, the ambiguity or ambivalence that is an essential part both of the sublime and of the oedipus complex is expressed in *The Gross Clinic* with superb economy in the manifestly paternal figure of the famous surgeon pausing in his labors, distinguished head aureoled by his white yet vigorous-seeming hair. On the one hand, Gross the master healer is deeply reassuring, an exemplum of perfect calm and mature resource; on the other, his bloody right hand holding the scalpel may be read not only as threatening castration but as having enacted it. (The parallel between that scalpel and Benjamin Eakins's shotgun in *The Artist and His Father*

Hunting Reed Birds and, visually even more arresting, the black hunter's shotgun in *Whistling for Plover*, underscores the surgical instrument's character as a weapon.) Furthermore, by virtue of the analogy noted earlier between Gross's hand and scalpel and the painter's hand holding a brush or palette knife as he worked on *The Gross Clinic*, the precise focus of menace would have been an immediate channel of access for the painter's fantasmatic identification with the threatening paternal power and thus also for his confirmation of the latter's identity as healer, though it is also true that the painting disperses attention from that analogy by multiplying images of figures wielding pencil- or penlike instruments within and across the representational field. (The brighly lit, laconically gruesome depiction of the chief assistant surgeon's probing of the wound plays a crucial role in promoting this dispersal.) But the multiplying of such images is tantamount, as was noted earlier as well, to a thematization of writing that itself is clearly under the sign of the paternal function and in which the figure of Eakins at the right-hand margin of the composition absorbedly takes part. What is more, the red color of the two indubitable writing instruments in the picture, the pencils wielded by the figures of the recording physician and Eakins, has the effect of bringing writing back to the bloody probe and scalpel after all.

Second, the presence in *The Gross Clinic* of figures traditionally identified as a mother and a son—the woman in black and the patient undergoing surgery—may be seen at once as foregrounding a thematics of family relations and as helping to defuse or at least depersonalize that thematics for the painter himself by confining it to the realm of manifest content, of the objectively representable, in short of the "real." Similarly, the representation in the same painting of two distinct sons, the second being the figure who after an interval of many years has been recognized as Eakins, although hinting at an affinity between the one and the other, could have served to reassure the painter that the first of the pair—manifestly the beneficiary, psychoanalytically the victim of paternal authority—was no surrogate of his. We might say that the painter sacrificed the first, anonymous, prostrate son to the father's power not only in an attempt to assume that power but also precisely to establish this point: thus the virtual dismemberment of the patient's body by the agency of foreshortening functions simultaneously as a figure for castration and as a distancing device *par excellence*.

Having said this, however, it must also be acknowledged that there are in *The Gross Clinic* elements of what Freud in the Schreber case history calls a "paranoiac" scenario based on the homosexual wish-fantasy of being sexually possessed by a man.[56] For Schreber himself the object of the wish-fantasy (and therefore of a defensive struggle that took the form of delusions of persecution) was his physician, behind whom Freud detects the figure of Schreber's father; the precise details of Freud's speculations as to the etiology of paranoia need not concern us other than to note that there too the threat of castration is said to play a constitutive role. What I want to stress in connection with *The Gross Clinic* is, first, Schreber's particular fantasy that his body is to be transformed into a female body "with a view to sexual abuse,"[57] which I would relate to the sexual indeterminacy of Eakins's figure of the patient, and second, the implication in Freud that according to Schreber the act of sexual possession is to take place through the anus,[58] the relevance of which to Eakins's painting is at once apparent. It is as though two competing though by no means unrelated structures are at work in *The Gross Clinic,* the one suggestive of the successful resolution of the oedipus complex via the fantasmatic identification of the son with the father, the other of the pathological wish-fantasy of being sexually possessed by the father, a wish-fantasy that at best excludes the mother and at worst makes of her an object of jealous hatred. Indeed the scapegoating of the patient-son in the first structure may be seen as complemented by the scapegoating of the patient's mother in the second, a quasi-maternal, quasi-nurturing function being there assumed by the downward-gazing anesthesiologist. In that *The Gross Clinic* manifestly glorifies Gross as master healer (i.e., presents him in the aspect of the "good" father), the oedipal structure must be considered dominant over the "paranoiac." But the unmistakable copresence of the two structures, as of different resolutions of the same primal trauma, gives the painting as a whole an extraordinarily dense affective resonance.[59]

Looked at anew in this double context, the mother's empty and contorted left hand itself emerges as a figure for castration, or perhaps I should say both for the act of castration (by virtue of its clawlikeness and more broadly its offensiveness to vision) and for castratedness as such (by virtue of its emptiness and more broadly of its function as a marker of femininity). In fact the obvious contrast between the mother's hand and those of the male protagonists, Gross in particular, sug-

gests a further, ideologically charged contrast *between thematizations of castration*—the one chaotic, hysterical, and unassuageable (i.e., "feminine"), and the other regulated, masterly, and in the end healing (i.e., "masculine"). This is virtually to say that the second thematization may be understood in part as a defense against the first, which would mean that the mother rather than the patient-son is the painting's ultimate scapegoat, the personage who more than any other has been sacrificed in the interests of representation. (In a few years the motif of an empty, convulsing hand will recur in Eakins's *Crucifixion*.)[60] Insofar as the mother in the Freudian scenario of paranoia undergoes rejection, this would seem to confirm the "paranoiac" structure of repressed homosexual desire. But insofar as our argument identifies the realm of the masculine with an ideal of regulation and mastery, it also confirms the oedipal structure of fantasmatic identification with paternal power, from which I conclude that the figure of the mother functions psychoanalytically as a pivot around which both structures turn. No wonder her very position in the painting appears problematic.[61]

Finally, an aspect of the sublime that has been given prominence in recent years by Weiskel, Harold Bloom, Bryan Jay Wolf, and others is its relation to issues of artistic belatedness and the struggle for originality. Thus the threatening paternal power has been interpreted as a figure for the overwhelming authority of major predecessors whose achievements an (often young) artist aspires to match and, if possible, surpass, and the sublime "joining" with that power has been understood as a "counteroffensive of identification or mimesis" by which the latecomer makes that authority temporarily his own.[62] At stake in *The Gross Clinic*, I have argued, was Eakins's ability to summon up the resources of an all but extinct absorptive realist tradition that he believed comprised the greatest painters who had ever lived. This in turn suggests that his extreme version of that tradition's periodic tactics of shock and iconoclasm and an oedipal struggle with his major artistic precursors through the medium of a kind of figural sublime would have been mutually reinforcing.

VI

We are at last in a position to start bringing this essay to a close. Again I shall proceed indirectly, this time by giving a brief account of a related drama of visibility played out in several pictures of the 1870s and early 1880s, before moving on to a final discussion of the respective claims of writing/drawing and painting in *The Gross Clinic*.

A small, impressive canvas from the mid-1870s, *Will Schuster and Blackman Going Shooting for Rail* (1876; Pl. 6), depicts the title figure standing in the middle of a shallow boat and taking aim with his shotgun, presumably at one or more birds breaking cover somewhere off to the left, and, toward the stern, a tall black man with bare feet wielding a long pole with which he has been propelling the boat along. The setting is a pond or marsh, with greenish marsh grass everywhere and a few trees on the horizon; the sky is featureless but the rippled surface of the water in the right foreground is alive with broken reflections, and there is a further development of the motif in the curving patterns of light (or caustics) reflected back from the water onto the hull of the boat.

As is true of almost all of the pictures by Eakins we have considered, *Will Schuster* depicts a scene of intense absorption—most obviously Schuster's as he sights down the barrel of his gun apparently with total concentration, but also that of his pusher, who is shown simultaneously looking intently with tilted head in the direction of Schuster's aim and doing all he can to hold the boat steady as the latter prepares to fire. What I want to emphasize, however, is not simply the general thematics of absorption in the picture nor precisely the intensity of the absorptive states it represents but rather the quite extraordinary degree of empathy—of something like willed imaginative projection—that each of the two figures seems to demand of the viewer. Thus for example we miss the force of Eakins's minutely precise and highly finished depiction of Schuster's head and hands if we fail to grasp, and by this I mean something more than simply note, the exclusiveness of the hunter's concentration on his target, the weight but also the balance of the shotgun in his hands, even the pressure of his finger against the resistance of the trigger. Similarly, Eakins's treatment of the pusher

invites us to register as if corporeally the quality of the effort he is making—involving his entire body, from the tensed soles of his bare feet through his lightly bent, flexed knees, through his arms and torso and the long pole itself, culminating in his finely poised head gazing past Schuster—to keep the boat steady in the water as Schuster aims and shoots. Nor can we doubt that the painter intended us to feel these things; in particular the relatively bright accent provided by a sunken post immediately beyond and to the left of the pusher's right knee highlights the tension in that knee and thereby subtly underscores the instability of the situation. And we are further encouraged to project ourselves into the world of the painting by the inclusion, on a diminutive scale, of the heads of a second pair of hunters in the far distance immediately to the right of the pusher, the leap in size from one pair of figures to the other calling for an abrupt shift of imagined focus into the depths of the scene. I don't wish to be understood as saying that Eakins is unique in encouraging his viewers to project themselves into and by so doing to "activate" this and other pictures. It could hardly be denied that all paintings require of the viewer a minimal level of imaginative engagement if they are not to remain inert, or that certain types of pictures, small-scale genre scenes in particular, tend to invite close and sympathetic examination of facial expression and bodily gesture. But *Will Schuster* seems to me unusual both because it brings a special urgency to the demand for "activation" and because that demand is oddly inconsistent with, indeed is contradicted by, other equally important aspects of the picture.

In the first place, we are not shown the bird or birds that Schuster is aiming at and that the pusher is watching attentively, so our impulse to share imaginatively in each figure's actions is compromised, though by the same token underlined, from the start. (Just as in *The Gross Clinic* we feel ourselves excluded from the acts of vision of the chief assisting surgeon and the anesthesiologist, and as in *Between Rounds* we only barely glimpse the watchface being studied by the timekeeper.) Nor *a fortiori* can we hope actually to feel the weight of the shotgun, the resistance of the trigger, the pressure of the black man's pole against the muddy bottom of the pond, or, in an instant to come, the recoil of the weapon against the shooter's shoulder. More important, the broad, painterly manner in which the picture has been rendered over most of its surface would appear to call for a wholly different mode of visualization on the part of the viewer: comparatively dis-

tanced and detached, attuned to the flow of pigment and the play of brushwork, above all concerned with the total effect of the painting not simply as a realistic scene but also as a worked artifact. (That the figures are depicted more or less in profile, silhouetted against the marsh grass beyond them, is also pertinent here.) The result is a tension or competition between two fundamentally different modes of seeing: one that looks to "enter" the representational field and to identify its interests with those of the protagonist, inevitably losing sight of the whole in the process of doing so (in *Will Schuster* such an identification would direct the viewer's attention well beyond the framing edge), and another that remains emphatically outside the representation, viewing the painting with something like disinterest but also with special concern for "formal" values of a certain sort. I think of this second mode as "pictorial" seeing (the term is somewhat loaded, as will become clear) and want to leave unanswered for the moment the question as to what the first, projective or participatory, mode might be called. The distancing called for by "pictorial" seeing is further encouraged by the most remarkable feature of *Will Schuster*, the incandescent red of Schuster's long-sleeved shirt, which by virtue of its coloristic explosiveness repels the viewer from the painting as with the force of a blast. Insofar as it also explodes the unity that "pictorial" seeing characteristically seeks to confirm, it recalls the peculiar, anarchic intensity of the reds not only in *The Gross Clinic* but in the early domestic interior scenes as well.

Other canvases of the 1870s and 1880s evince versions of the same basic tension or conflict. To take another wholly characteristic example, *The Pathetic Song* (1881; Pl. 7) depicts one of Eakins's students, Margaret Harrison, performing a piece of vocal music in domestic surroundings. She is accompanied by a pianist (Susan Macdowell Eakins) and a male cellist, and once again an evocation of the collective absorption of all three personages in a single activity is crucial to the painting's mood. Equally important is a heightened attention to psychological and physical nuance that invites the viewer to interpret the scene in minute detail. Johns, for example, is led to remark that "the pianist turns slightly toward the singer, sensitive to the slightest pause or change of dynamic level that would call for her mirroring it in her accompaniment, and the cellist focuses intently on the score of his obligato . . . , the fingers of his left hand stopping notes high in the register of the strings, the fingers of his right hand holding the bow

with precision."[63] In a similar vein, it has always seemed to me that the singer has been represented holding the final note in her song, and that if only one were sufficiently familiar with the sentimental repertoire of the day, as well as knowledgeable about the movements of the mouth and throat as they form specific notes and sounds, one would be able to determine—in effect to see—the precise tones filling the shadowed room. Obviously this isn't practicable, though it is striking that a decade later, in *The Concert Singer* (Fig. 29), Eakins portrayed Weda Cook singing the opening phrase from an aria by Mendelssohn and, as already mentioned, went on to carve that phrase into the bottom portion of the picture's frame.[64] What I wish to suggest, however, is that the apparent specificity of *The Pathetic Song* in this regard goes far beyond the norm of the realist tradition that Eakins revered and in fact comes close to asking of both the art of painting and its viewers more than either is capable of delivering. (Much the same can be said of *The Concert Singer* and, on slightly different grounds, of *Will Schuster*.)

Furthermore, as is true of *Will Schuster,* the effort to project oneself imaginatively into the represented scene is openly in conflict with the desire, also stimulated by the painting, to keep one's distance and apprehend the painting as an object of "pictorial" seeing. In particular one becomes aware of an almost tangible disjunction between the fragility and inwardness of the drawn-out moment of affecting song and Eakin's scrupulously exact notation of the oblique fall of daylight on Margaret Harrison's flesh and hair and across the innumerable creases and flounces of her satiny lavender-gray gown, by means of which he has at once conjured up the solidity and in a sense the impassiveness of her physical presence and established a play of lights and darks that more obviously aims at unity of effect than anything in *Will Schuster*. I am also struck, and reminded of *The Gross Clinic,* by the way in which the figure of the singer almost entirely eclipses the seated cellist's instrument and music stand as well as by our being shown neither the face of the musical score on the piano nor the pianist's fingers on the keys—further motifs (or antimotifs) of exclusion that point up what might be thought of as the ultimate unresolvability of the representational field even as they isolate and thus make all the more poignant the exquisite delicacy of the musicians' gestures and expressions.

Again, I don't want to be taken as claiming that previous painting lacks all tension between the inner space of the representation and the

surface of the picture considered as a worked artifact; on the contrary, a playing off of one against the other has always been fundamental to the pictorial enterprise and especially to the practice of easel painting, the dominant form of that enterprise in the West since the Renaissance. What sets Eakins apart, I am suggesting, and incidentally throws into relief the integrative tendencies of his major European predecessors, is the acuteness of the tension, amounting often to outright disjunction, between a representational field that has been articulated expressively to the limit of visibility (even, I have suggested, beyond that limit) and a region of the picture, say the picture surface and the foreground taken together, that invites an altogether different mode of seeing by virtue not only of its affirmation of certain "formal" values but also, in a work like *The Pathetic Song,* of its minutely careful and objective-seeming portrayal of the fall of light on and across creased and textured fabric. In fact there is in this tension or disjunction more than a hint of a dividedness of point of view: simultaneously drawn into the representational field and held at a distance from the picture surface (in *Will Schuster* actually repulsed), the viewer ends up suspended between conflicting possibilities of relation to the work—not quite excruciated or stupefied, as before the ravishing atrocities of *The Gross Clinic,* but nevertheless baffled, even frustrated, in that sense brought to a stand. And this too differs fundamentally from the strategies by which European painting characteristically has sought to transfix the beholder before the canvas.

A third, smallish, but intellectually ambitious picture with which we are already familiar, *William Rush Carving His Allegorical Figure of the Schuylkill River* (Pl. 3), interprets the conflict between modes of seeing largely in terms of an opposition between facing and facing away. Thus the naked figure of Rush's model standing on a round wooden block and holding a heavy book on her right shoulder faces mostly into the picture, which means that her nakedness is perceived as fully (i.e., frontally) revealed only to Rush, whom we see toward the left-hand edge of the picture working on the lower portion of his statue in the shadowy depths of his studio. In contrast to the model, the allegorical figure itself is turned toward the viewer, but what faces the viewer far more dramatically (though not quite dead frontally) is the chair piled and draped with the model's discarded clothes in the center foreground, an extraordinary motif that recalls another naked model's discarded costume in Courbet's *Painter's Studio.* Simply put, I

associate what I have tentatively been calling a projective or participatory mode of seeing with the model's bodily orientation, or say with Rush's access to her nakedness as she stands facing him. And I associate what I have characterized as "pictorial" seeing with the chair covered with clothes in the immediate foreground, both because the chair faces the viewer with a vengeance and is located nearer to the picture surface than any other element in the painting, and because the play of direct daylight especially on the white articles of clothing with their multiple creases and folds implies a further assertion of surface values (including an ideal of unity of effect) that anticipates the treatment of the singer's costume in *The Pathetic Song* a few years later.

Moreover, as in *The Pathetic Song* though even more conspicuously, *William Rush* advertises the disjunction between those modes of seeing even as it attempts to bring them together in a single complex *mise-en-scène*. For example, although Rush's frontal view of the model may be seen as reflected, more or less, in the allegorical figure facing the viewer, the congruence in that regard between the figure and the chair piled with clothes in the near foreground takes second place to the latter's disconcerting proximity to the picture surface, which in effect detaches the chair from the rest of the composition, as well as to the sheer attentiveness involved in the meticulous description of the model's linen. (The attentiveness is so palpable it seems subtracted from the rest of the picture.) Even more unsettling, perhaps, is the cutting off of the chair's legs high up by the bottom framing edge, which in conjunction with the other factors I have just mentioned tends to extrude the chair from the world of the representation. (That Eakins's paintings characteristically question the status of their physical limits was suggested earlier by my brief remarks on framing in *The Concert Singer* and *Professor Henry A. Rowland* and is implicit also in my reading of *Will Schuster*.) Conversely, the shadowiness and even more the looseness of execution of the figures of Rush and the statue on which he is working are disconcerting in their own right, especially in contrast with the sculptural solidity of the model and the extreme crispness of definition of the clothes on the chair. One immediate consequence of that shadowiness and looseness is that the viewer is prevented from participating imaginatively in Rush's activity in the manner that I have suggested is encouraged by the highly finished execution of the figures of the hunter and his pusher in *Will Schuster,* but I don't take this to be a fault: *William Rush* is concerned with

articulating competing points of view rather than with evoking indi-
vidual bodily or mental states (though once again each of the three
figures may be characterized as absorbed), and in any case the acute
disparity in handling between foreground and background elements
more than makes up for the fact that we aren't quite drawn into the
representation as in the earlier work or indeed as in *The Pathetic Song*.

Finally, the naked back of Rush's model can itself perhaps be
thought of as facing the viewer, which raises the further possibility
that the model may represent an attempt to bring together in a single
figure—a single object of viewing—the two modes of seeing whose
interaction in this and other works by Eakins I have been tracing. But
the chair heaped with clothes in the near foreground suggests that
something more aggressively surface-oriented was required to express
the second, "pictorial" mode as strongly as turned out to be necessary.
And as though in reaction to *that* the presence to the model's right of
the seated chaperone occupied in her knitting, a figure that provides a
counterweight to the dominating chair while repeating the downward
cast of the model's head as well as aspects of her general orientation,
effects a sort of compromise between points of view that are given
vigorous expression elsewhere in the painting—far too vigorous to be
knitted together in this way, if I am right in taking that to be the
chaperone's formal function.[65]

A consideration of still other paintings by Eakins of the 1870s and
1880s would improve our grasp of these issues, but I hope enough has
been said to allow me to take the next step in my argument. Earlier I
suggested that Eakins's lifelong interest in perspective was rooted in
the writing/drawing complex of his early training, and in my discus-
sion of the rowing pictures of 1871–74 I called attention to what I saw
as an analogy between the strongly receding image-bearing ground
plane that is a conspicuous feature of those pictures and the horizontal
plane of writing/drawing, which I distinguished sharply from the ver-
tical or upright plane of painting. Putting this together with my anal-
ysis of competing modes of seeing leads in turn to the following
propositions: that the vertical or upright plane of painting is, although
not literally the object of "pictorial" seeing, at any rate the determin-
ing form or matrix of that object; that the horizontal, which is to say
perspectival, plane of writing/drawing is the arena of the first, projec-
tive or participatory, mode of seeing; and that the disjunction between
those modes in *Will Schuster, The Pathetic Song,* and *William Rush* is a

particularly clear manifestation of a more general tension or conflict in Eakins's art between the rival claims of painting and of writing/drawing.

At this point careful qualification is necessary. I don't intend by these propositions to equate illusionism as such with the "space" of writing/drawing any more than I wish to identify everything that appears on or near the picture surface or in an upright plane with the "space" of painting. Thus for example Margaret Hamilton's gown in *The Pathetic Song* and the chair heaped with clothing in *William Rush*—paradigmatic objects of "pictorial" seeing—are *tours de force* of illusionism and moreover of meticulous delineation, just as the patterns for ship's scrolls and the handwritten notes on the studio wall in *William Rush*—obvious emblems of writing/drawing—are located in an upright plane, and just as another emblem of writing/drawing, the sheet music that Margaret Hamilton holds tilted slightly downward before her, belongs, as she does, to the painting's foreground. Indeed it may be said of the paintings we have been considering that the "spaces" of writing/drawing and of painting interpenetrate without losing their separate identities, that they *coincide through and through but do not merge*. This last formulation recalls my previous description of Eakins's foreshortened signatures in *Kathrin* and *Elizabeth Crowell at the Piano* as coinciding with but not belonging to their respective ground planes, and in fact those and similarly deployed signatures epitomize the double "spatiality" of Eakins's art.[66] (Other paintings illustrated in this essay that contain such signatures are *Baby at Play, Dr. John H. Brinton, The Pathetic Song, Professor Henry A. Rowland, Professor Leslie W. Miller,* and *Professor William Smith Forbes.*) Another characteristic expression of that double "spatiality" is the tension in *Max Schmitt* between the painting viewed as a whole, by which I mean at a commanding distance from its surface (at which distance a world of detail is indiscernible), and viewed intensively, at close enough range to distinguish the figure of Eakins energetically rowing in the middle distance and indeed to read the name and date on the stern of his scull (at which range the larger composition is lost to view).[67] Here as in *Will Schuster* the "space" of painting is implicitly opposed to another "space" requiring the viewer to "enter" the representation and, once there, to perform feats of reading that are beyond the powers of "pictorial" seeing, including in the present instance an act of reading fairly minute graphic characters. (In *William Rush* too the writing on the

studio wall is legible only close up and to a gaze that ignores the rest of the picture.) This suggests that the projective or participatory mode of seeing might best be called "graphic" in contrast with the epithet "pictorial," a coinage that by itself may seem counterintuitive but that the entire argument I have been pursuing makes inevitable.[68]

The opposition in Eakins's art between the "spaces" of writing/drawing and of painting is the more impressive in that it doesn't seem to have been a function of a socially sanctioned hierarchy; on the contrary, as I have tried to show, Eakins, faithful to his early education, appears to have regarded writing and painting as aspects of a single vocation. It is therefore especially interesting to find in the primary textbook of that training, Peale's *Graphics,* a suggestive analysis of a problematic disjunction between horizontal and vertical planes of representation. Peale's topic is "Drawing from Patterns," as Preparatory to Drawing from Solid Objects," a practice that he strongly recommends but with the following qualifications:

> To derive the greatest benefit from what has been drawn by another as a pattern, it must be placed so as to be seen in the same *direction* as the objects were which it represents. The common practice of laying the drawing or print to be copied FLAT upon the table, is, therefore, disadvantageous to the young student. It is seen in a false angle [i.e., foreshortened] and is liable to frequent change [presumably as the student moves either the pattern or his own drawing or shifts his point of view]. The only position in which it can be correctly viewed is ERECT, exactly in front, and still better, if it be fixed *as high* as the eye; as it then most perfectly occupies the place of the object which it represents, and must, obviously, be imitated, or copied, with the same observances in regard to the direction and character of lines, as if it was a solid object at a distance from the eye.

Peale continues:

> Without touching the pattern, the student may move his pencil in the air *in front of* the drawing or print, exactly as he would do in pointing to, in tracing or imitating the direction of lines or parts, and the contour of curves in the solid or distant object itself; and thus learn how to produce similar movements or marks on his paper. Thus real objects, viewed through a sheet of glass, may be accurately traced on it, and may, of course, be imitated on paper, exactly as they might be marked on the

glass, in the exact direction of every line . . . producing, *necessarily*, the most perfect perspective. When the pupil is sufficiently advanced to draw from solid objects, he will *analyze* them as he would the drawings from them, placed erect before him . . .[69]

In the light of the interpretation of Eakins's art that has so far emerged, this seems to me a remarkable passage on several counts. For one thing, it describes the world of objects—call it reality—as essentially upright, vertical, erect, in contrast with the horizontal "space" of writing/drawing. For another, it considers that this difference in orientation presents serious problems for the student who wishes to copy a drawing as a first step in learning to draw from real objects: for either the student will lay that drawing flat on the table before him (the obvious thing to do, one might think), in which case Peale seems to be saying that it no longer accurately represents the upright objects it ostensibly depicts, or, the course of action Peale urges, the student will place the drawing upright before him, in which case what becomes problematic is how it can be copied faithfully onto a horizontal plane that Peale characterizes as necessarily viewed at a false angle and as particularly subject to changes in point of view. Peale doesn't dwell on this second difficulty, but it is obviously on his mind when he suggests that the student "move his pencil in the air in front of the drawing or print" that has been placed upright before him, as if only by internalizing a particular set of bodily motions and then, machinelike, transposing those motions from one plane to the other could the student hope to achieve his aim. Just how much is at stake becomes clear when Peale immediately goes on to note that "real objects, viewed through a sheet of glass, may be accurately traced on it, and may, of course, be imitated on paper," a process that he claims "*necessarily* [produces] the most perfect perspective." For Peale as for Eakins after him, the most perfect perspective yields the truest representation of reality. But the radical discrepancy between the upright plane of reality, or perhaps we should say of its "primordial" projection on or through a sheet of glass, and the horizontal plane of writing/drawing makes it seem unlikely that perfect perspective understood in these terms can ever be attained.*

*A further source of difficulty is acknowledged elsewhere in Peale's book. "The Drawing or Pattern to be copied should be placed ERECT before the student," Peale writes, "who will thus get the habit of viewing it entire and in detail, in the same

In Eakins's art, as we have seen, the crucial tension or conflict be-
tween planes of representation takes place at a more advanced or any-
way a different stage. But the source of the conflict is, I think, the
same as in the passage from Peale: the mutual identification of writing
and drawing that *Graphics* systematically advocates and that all of
Eakins's early training reinforced. That is, I suggest that it was pri-
marily the strength and explicitness of that identification that defined
the "space" of drawing as essentially horizontal in distinction to the
vertical or upright "space" of reality on the one hand (Peale) and of
painting on the other (Eakins). Not that the "space" of writing is
always and everywhere intrinsically or naturally horizontal; on the con-
trary, there have been cultures and epochs that would have found that
association positively unnatural (modern technological society may be
on the verge of doing so), and in any case the explicitness with which
Peale argues his position represents a specific cultural formation.[70]
Given that formation, however, the emergence of a sense of disjunc-
tion between planes of representation may be imagined to have fol-
lowed naturally enough, though it is only in Eakins, so far as I am
aware, that an attempt to come to grips with that disjunction becomes
the implicit project of a large and significant body of painting. (Let me
affirm once more that I take Eakins to have been unconscious of the
terms of the project as I have described them.)

What this meant in practice was that painting, in obvious respects
the more comprehensive enterprise, had to be made to contain or sub-
sume writing/drawing, which in one sense it couldn't fail to do even

manner that he would the solid object, to ascertain what is perpendicular, horizon-
tal, or oblique, and the direction that any one part stands in relation to any other or
every part of the object, as they might be marked on a plate of glass held between the
object and the eye" (*Graphics,* p. 44, emphasis his). This is immediately followed by
a cautionary footnote: "When a plate of glass, or window pane, is employed as the
medium on which to delineate, with pen and ink, the forms of objects seen beyond
it, it is necessary to shut one eye and (to be most accurate) to look through a small
hole permanently fixed." But this is to say that what I have characterized as reality's
"primordial" projection on or through a pane of glass is a product of elaborate
artifice, which in turn makes Peale's larger project of teaching the student to draw
accurately from nature seem even more forlorn. Most likely only a camera, with its
vertical plane of (automatic) inscription and its one small "eye" permanently fixed,
could satisfy Peale's requirements.

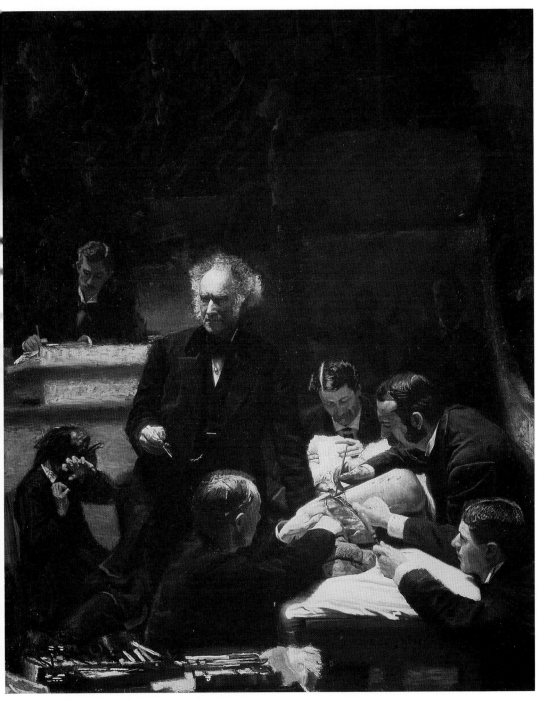

PLATE 1. THOMAS EAKINS, *The Gross Clinic*, 1875. Jefferson Medical College, Thomas Jefferson University, Philadelphia.

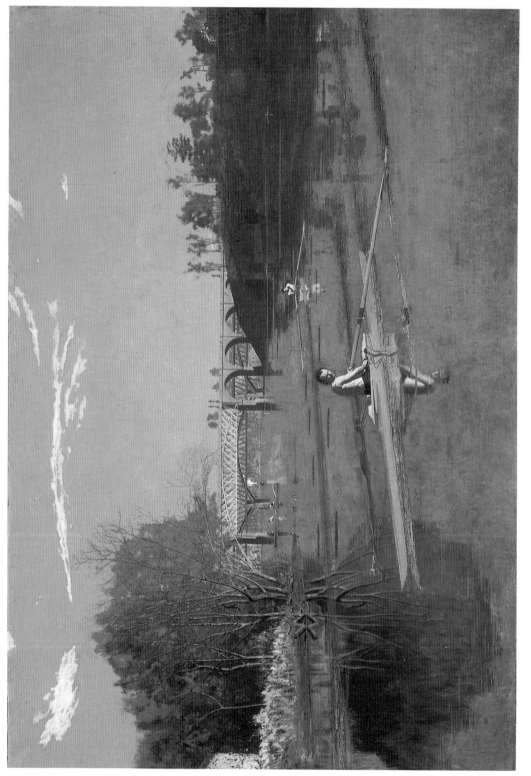

PLATE 2. THOMAS EAKINS, *Max Schmitt in a Single Scull*, 1871, The Metropolitan Museum of Art, New York

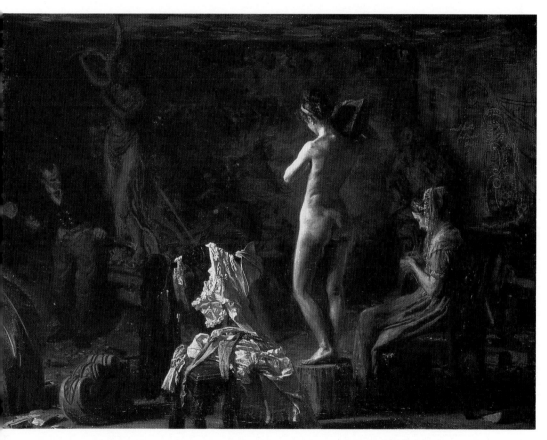

PLATE 3. THOMAS EAKINS, *William Rush Carving His Allegorical Figure of the Schuylkill River*, 1876–77. Philadelphia Museum of Art. Given by Mrs. Thomas Eakins and Miss Mary Adeline Williams.

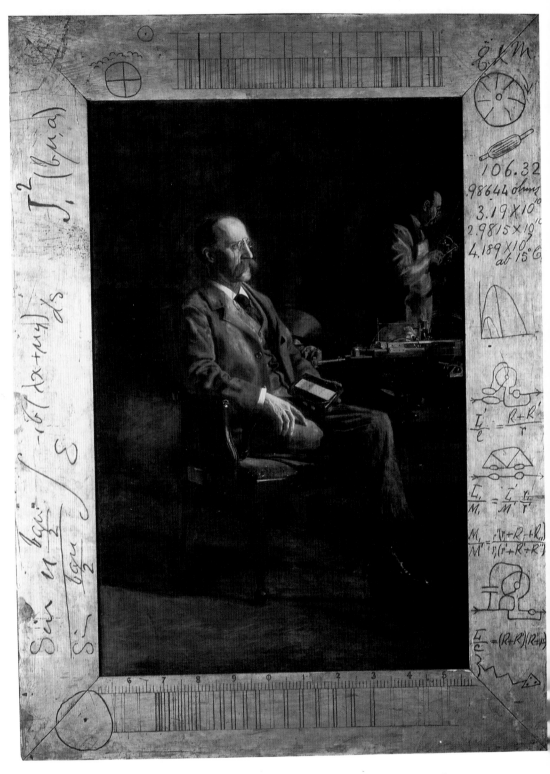

PLATE 4. THOMAS EAKINS, *Professor Henry A. Rowland*, 1897, with frame.
Addison Gallery of American Art, Phillips Academy, Andover, Massachusetts.

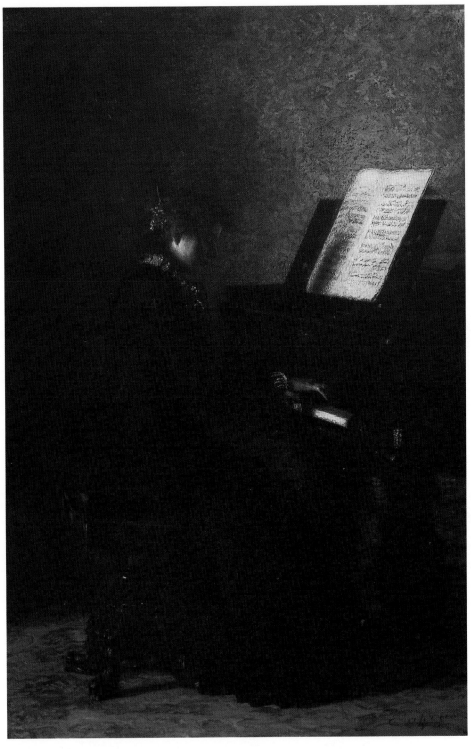

PLATE 5. THOMAS EAKINS, *Elizabeth Crowell at the Piano*, 1875.
Addison Gallery of American Art, Phillips Academy, Andover, Massachusetts.

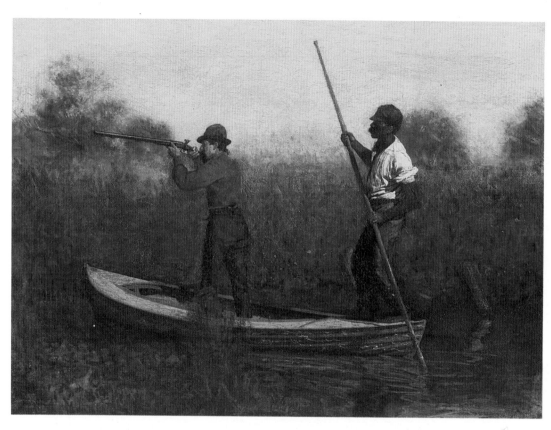

PLATE 6. **Thomas Eakins**, *Will Schuster and Blackman Going
Shooting for Rail*, 1876. Yale University Art Gallery, New Haven.
Bequest of Stephen Carlton Clark, B.A. 1903.

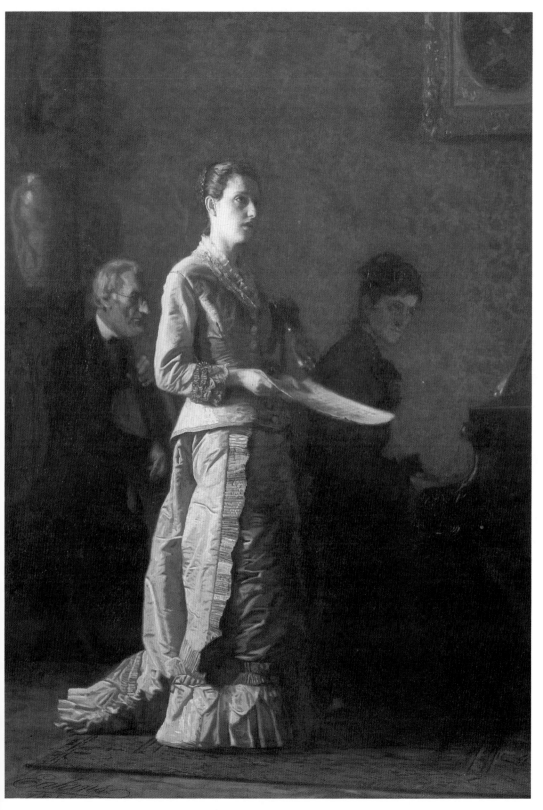

PLATE 7. THOMAS EAKINS, *The Pathetic Song,* 1881. In the collection of
The Corcoran Gallery of Art, Washington, D.C. Museum purchase, 1919.

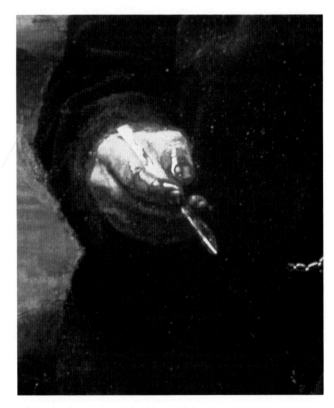

PLATE 8. THOMAS EAKINS, *The Gross Clinic*, 1875,
detail of hand and scalpel. Jefferson Medical College,
Thomas Jefferson University, Philadelphia.

while in another, ultimately more important sense the disparity be-
tween the "spaces" of writing/drawing and of painting was such that
no true containment or subsumption, certainly no perfect dissolving of
the first into the second, could be accomplished. Thus the prolifera-
tion of images of writing in Eakins's pictures may be seen both as
representing an effort at containment—painting depicting writing
and thereby mastering it—and as an index of the less than complete
success of that effort—writing investing painting and thereby escap-
ing its control. How, for example, could one begin to determine
which of these characterizations best applies to the handwriting on the
studio wall in *William Rush?* To the caustics dancing on the side of the
boat in *Will Schuster?* To the parchment covered with Greek and Ro-
man text in *The Crucifixion?* Or even to the inscribed frames that
surround *The Concert Singer* and *Professor Henry A. Rowland?* The second
of those frames in particular may seem to embody the definitive tri-
umph of writing/drawing over attempts to keep it in check, but the
erosion of the physical limits of the painting under the influence of the
writing/drawing complex can be viewed as having set the stage for a
renewed attempt to contain writing/drawing after all. In fact the
Rowland portrait may be seen as emblematizing this double valence in
and through the image of the brightly lit diffraction grating that the
physicist is shown holding in his left hand. A diffraction grating, after
all, is "a series of fine parallel grooves evenly spaced on a flat or curved
surface at a tolerance much less than the wavelength of light,"[71] which
is to say that it is an essentially "graphic" device that nevertheless
yields brilliant "pictorial" effects. In addition, Rowland's gratings
worked by reflection—the grooves were scratched into a mirrored sur-
face—which implies a further relation to the "space" of writ-
ing/drawing as it is thematized in Eakins's art. Eakins's correspon-
dence with Rowland about the painting and frame records his decision
to give added emphasis to the physicist's machine for inscribing dif-
fraction gratings, which emerges virtually as a surrogate for the
artist.[72]

Probably, though, I have drawn too neat a distinction between
Peale and Eakins at the same time that I have aligned them with each
other. For Eakins himself subscribed to a myth of realism that has him
starting out, à la Peale in *Graphics,* from a view of the world as
through a glass pane (a passage in his unpublished lecture notes on

perspective makes this explicit*). It follows that the elaboration of
that view into a finished picture would involve not one but two trans-
formations: from the upright plane of reality to the horizontal one of
writing/drawing and thence to the upright one of painting. Moreover,
the arbitrary, *unmotivated* nature of those transformations—the ab-
sence of any intrinsic connection between one plane and the other—
raises the further possibility that the finished work might bear the
marks of that double discontinuity, or to put this more emphatically,
that its representation of the "real" might be doubly disfigured: as for
example by the inversion and also the brokenness of the reflections in
the rowing pictures, or by the precipitous foreshortening of the pa-
tient's body and the operation cutting into its flesh in *The Gross Clinic*,
or simply by the eliciting of opposed modes of seeing, one excessively
intimate and the other equally excessively detached.

An indication that Eakins may actually have found some such state

*In that passage Eakins cites as the paradigm method for producing a perspec-
tively accurate image of the world the tracing of a view through a window pane with
one eye closed. He observes that the slightest alteration either in the viewer's stance
before the pane or in the position of the pane itself causes all the relations in the
image seen through the pane to change, and goes on to state that "this proves that a
picture can be correctly looked at from one point only and [that] the spectator should
have care to place himself in that point." The affinity between these remarks and
Peale's strictures on the proper use of the view through a pane of glass is evident. But
what I want particularly to emphasize is, first, the difficulty of making good the
notion that Eakins's pictures can be correctly looked at from one point only—prac-
tically speaking, how is the viewer to determine that point?—and second, the extent
to which a perceptual tension if not disjunction is implicit in Eakins's theory and
practice of perspective, which on the one hand would locate the viewer at a fixed
position before the picture's surface and on the other would seem to require that the
viewer perform the minutely attentive feats of seeing and reading in the depths of the
representational field that Eakins's works repeatedly solicit. This suggests that the
conflict I have been analyzing between the respective "spaces" of writing/drawing
and of painting was foreshadowed in the structure of the "space" of writing/drawing
alone, and that the complications introduced by the demands of the "pictorial"
amounted in large measure to a new thematization of a prior—a "primordial"—
tension. And it suggests too that the inordinate subjectivity of response that I have
associated with "graphic" as opposed to "pictorial" seeing in Eakins is largely an
effect of that tension, which in the name of objectivity of vision calls for the view-
er/reader to exceed the evidence directly available to the senses. Perhaps indeed we
should think of "pictorial" seeing as in essence a defense against the contradictions
inherent in "graphic" seeing, or say against its unquenchable drive to see more than
is there to be seen in the "space" of writing/drawing.

of affairs disturbing is his exploitation in the early 1880s of the pho-
tographic image not simply as an aid to the memory or a source of
compositional ideas but as a guide to the treatment of selective focus in
his finished paintings.[73] No doubt Eakins was attracted to pho-
tographs mainly because of their unprecedented realism of effect. But
it may be that another source of their appeal was that they promised a
means of casting reality directly onto the vertical "space" of painting,
or if not directly then with the aid of a middle term, the photographic
plate, that itself was vertical. Interestingly, the pictures that come to
mind in this connection—for example, *Mending the Net* (1881; Fig.
46) and *Shad Fishing at Gloucester on the Delaware River* (1881; Fig.
47)—are oddly remote in feeling—they seem almost to image the
withdrawal of reality from the viewer[74]—which I take as confirming
the assumption at work throughout these pages that the tensions and
discontinuities we have been tracking were fully as productive as they
were problematic. And although consideration of Eakins's later por-
traits lies outside the compass of this study, it can be argued that

46. THOMAS EAKINS, *Mending the Net*, 1881. Philadelphia Museum of Art.
Given by Mrs. Thomas Eakins and Miss Mary Adeline Williams.

47. THOMAS EAKINS, *Shad Fishing at Gloucester on the Delaware River*, 1881. Philadelphia Museum of Art. Given by Mrs. Thomas Eakins and Miss Mary Adeline Williams.

between those tensions and discontinuities and the characteristic features and interests of the genre there obtained a fit that helps account both for the great distinction of many of the portraits and for what has always been felt to be their profoundly idiosyncratic tenor. Thus the nearness and uprightness of the sitters relative to the picture surface may be thought of as consistent with the "space" of painting, as may the portraits' characteristic effects of strong chiaroscuro, effects that especially in some of the portraits of women are dramatically set off by the fall of light across textured or gauzy material. At the same time, when modern viewers praise Eakins's portraits for their masterly rendering of "character," they are discovering in his often ruthless delineations of the human face and bodily carriage infinitely readable (which also means endlessly disputable) texts of spirit and experience, hence a perfect if less than monumentally ambitious fulfillment of the "graphic" component of his enterprise (see for example *Addie* [ca. 1900; Fig. 48] and *Professor Leslie W. Miller* [1901; Fig. 49]).[75]

Finally, though, it is *The Gross Clinic* that remains the most dramatic, various, and memorable expression of the struggle between the

systems of writing/drawing and of painting in all of Eakins's art. For example, the dialectic of fascination and repulsion (and repulsion and fascination), of craving to look but finding it painful to look and yet not being able to look away, that I have associated both with the savage foreshortening of the patient's body and with the dual foci of the operation and Gross's bloody hand and have correlated with the shock tactics of particular moments in the realist tradition can also be understood as an extreme instance—a hypostatization in the realm of feeling—of the conflicted nature of the viewing function posited by the other pictures by Eakins we have considered. In fact I interpret the

48. THOMAS EAKINS, *Addie*, ca. 1900.
Philadelphia Museum of Art. Given by Mrs. Thomas Eakins
and Miss Mary Adeline Williams.

49. THOMAS EAKINS, *Professor Leslie W. Miller*, 1901.
Philadelphia Museum of Art. Given by Martha P. L. Seeler.

prevalence of the color red in Eakins's art, and *a fortiori* the lurid crimson blood in *The Gross Clinic,* as a sign of that conflictedness, as if, by resisting integration into a "pictorial" unity and at the same time tending to expel the viewer from the "space" of writing/drawing, Eakins's reds call attention to a division within the enterprise of painting that cannot finally be healed. The signatures in perspective are an analogous device, grounded in the system of writing/drawing rather than, as are the reds, in that of painting. As for individual figures in *The Gross Clinic,* the eclipsed assistant takes his place in a densely conflictual field keyed to fundamentally different modes of articulating surfaces, most importantly as a token of what earlier in this section I called ultimate unresolvability, which is to say of an ineluctable collison between the demands of the "graphic" (to see more and more) and the claims of the "pictorial" (seeing stops here).* Similarly, the figure of the mother serves as an image of the excruciation between incompatible attitudes towards seeing that I have argued characterizes the viewer's relation to the painting. In addition, by virtue of her pivotal role in the oedipal and "paranoiac" structures discussed earlier, she subserves the rival fantasies of filial identification with the paternal figure of Gross, whose uprightness and Velázquez-like stance may be associated with the "pictorial," and of homosexual penetration by the father of the patient-son, a fantasy that hovers over the description in perspective of the latter's buttocks and thus in at least that respect may be aligned with the "graphic."

Furthermore, *The Gross Clinic*'s hidden connection, by way of its initial oil sketch, to an inverted study of rowers and by extension to the rowing pictures as a group and beyond that to a whole poetics of reflection can be read as at once acknowledging and disavowing a basic involvement with the writing/drawing complex. This might also be said, by analogy with specific aspects of the rowing scenes, of the deliberately out-of-focus treatment of the inverted surgical instruments in the left foreground and of the virtually *trompe-l'oeil* illusionism with which Eakins has depicted the glistening blood and the steel scalpel and retractors. More openly ambivalent, the progressive

* Alternatively, one might think of the eclipsed assistant (along with similar motifs of exclusion in Eakins) as epitomizing a structural impossibility inherent in the "graphic": as if the "primordial" form of what I have been calling unresolvability were precisely the insatiableness of the demand to see more and more that I have associated with the "space" of writing/drawing as opposed to that of painting.

elevation of the amphitheater audience appears to belong to the up-
right "space" of painting at the same time that the downward gazes of
the members of that audience, as well as of the chief assistant surgeon
and the anesthesiologist, bear an obvious relation to the horizontal
"space" of writing/drawing; and of course the patient himself, by vir-
tue both of his orientation and of his status as archexample of the
effects of perspective, amounts almost to a personification of that
"space." Conversely, the multiplication of motifs of writing and wri-
tinglike activity, one of which involves a portrait of Eakins, seems
unequivocal, and yet, as I observed toward the beginning of this essay
(and have just had occasion to confirm), the erect figure of Gross
standing scalpel in hand resembles nothing so much as that of a paint-
er holding a paintbrush and stepping back or turning momentarily
away from a canvas on which he has been working. But as our earlier
analysis of copresent oedipal and "paranoiac" structures in *The Gross
Clinic* may be taken to suggest, for Eakins the realist painter to have
represented himself allegorically through the personage of Gross the
master surgeon was to interpret his own enterprise not only as cooper-
ating with nature and causing necessary pain but also, inescapably, as
divided or excruciated between competing systems of representation.

 This becomes vivid if we consider by far the most condensed and
potent image in *The Gross Clinic* of the conflict between those systems,
the scalpel itself (Pl. 8), which being hard and sharp, an instrument
for cutting, belongs unmistakably to the system of writing/drawing,
but which being poised in Gross's sanguine right hand and bearing on
the tip of its blade a touch of blood—a vital, clinching detail—refers,
by means of an irresistible analogy, to that of painting. In my discus-
sion of the oedipal scenario that partly structures the composition, I
characterized Gross's right hand holding the scalpel both as a precise
focus of menace and, on the strength of a further analogy to Eakins's
right hand wielding a brush or palette knife, as an immediate channel
of access for the artist's impulse to introject and thereby to identify
with the threatening (and healing) paternal power. Entangled in that
scenario, I now suggest, may have been a desire to subsume writ-
ing/drawing under painting not simply as one representational
"space" or system within another but also on a personal, a fantasmatic,
level—a desire, that is, to recast his writing father (Benjamin Eakins)
as a figure for his painting fathers (Caravaggio, Velázquez, Ribera,

Rembrandt, Gérôme) and simultaneously to identify that figure as a version of himself. But even within the oedipal scenario the desire would not have gone unimpeded, and what I have more than once described as a competition for the viewer's attention between Gross's hand and scalpel and the absorbed probing of the wound in the patient-victim's thigh refuses to allow the gleaming, blood-tipped blade to come clear even for an instant from a problematic of inscription.[76]

2

Stephen Crane's Upturned Faces

———————

A little ink more or less!
It surely can't matter?
Even the sky and the opulent sea,
The plains and the hills, aloof,
Hear the uproar of all these books.
But it is only a little ink more or less.

Stephen Crane, from *War Is Kind*

———————

2

Stephen Crane's
Upturned Faces

In a well-known passage early on in *The Red Badge of Courage*, Henry Fleming (whom the narrative mainly refers to as "the youth") encounters the first of several corpses that turn up in the novel:

> Once the line encountered the body of a dead soldier. He lay upon his back staring at the sky. He was dressed in an awkward suit of yellowish brown. The youth could see that the soles of his shoes had been worn to the thinness of writing paper, and from a great rent in one the dead foot projected piteously. And it was as if fate had betrayed the soldier. In death it exposed to his enemies that poverty which in life he had perhaps concealed from his friends.
>
> The ranks opened covertly to avoid the corpse. The invulnerable dead man forced a way for himself. The youth looked keenly at the ashen face. The wind raised the tawny beard. It moved as if a hand were stroking it. He vaguely desired to walk around and around the body and stare; the impulse of the living to try to read in dead eyes the answer to the Question. [1]

All of Stephen Crane's formidable powers of defamiliarization are quietly at work in this passage. The corpse is inert but active, betrayed and poverty-stricken but also invulnerable and forcing, avoided by the ranks of living men, which we imagine parting to give it a certain berth, and yet its tawny beard is manipulated by the wind in a gesture of extraordinary intimacy that more than anything else establishes the dead soldier's uncanniness for us. As for Henry Fleming's relation to the corpse, it is at once apparently straightforward, as when we are told that the youth could see the soles of the dead man's shoes or that

93

he looked keenly at the dead man's face, and conspicuously indeterminate, as when Crane's prose formulates thoughts that could not possibly be those of his protagonist ("And it was as if fate had betrayed the soldier.") but seem nevertheless to follow from the latter's perceptions. Indeed the apparent straightforwardness itself has disconcerting aspects. Thus the succession of grammatically simple sentences in the second paragraph ("The youth looked keenly at the ashen face. The wind raised the tawny beard. It moved as if a hand were stroking it.") seems almost to imply causal relationship, as if the youth were acting on the corpse through the medium of the wind, though characteristically the next sentence (beginning "He vaguely desired to walk around and around the body and stare . . .") comes close to dissolving the distinction between living and dead both by virtue of the ambiguity of the initial pronoun and because staring is precisely the action attributed to the corpse in the second sentence of the first paragraph. It is as though throughout the passage the separateness of the youth both from the corpse and from the narrator is palpably the accomplishment of *absolutely* local effects of writing, which here as elsewhere in *The Red Badge* suggests that we may be in the neighborhood of a "sublime" scenario of fantasized aggression, identification, and differentiation not unlike the one that partly governs the painter's relation to key personages in *The Gross Clinic*.[2]

But my aim in citing this passage is not to insist on that affinity. Instead I want to emphasize, first, the salience in both paragraphs of a particular bodily position, that of the corpse lying flat on its back (this is what allows the wind to get at the beard); second, the characterization of the corpse's upward-staring face as an object of another character's keen attention and the related fact that something, in this case something seemingly gentle, is done to the face or at least to a metonym for it (the tawny beard); and third, the dramatization, through the image of the protruding foot, of an unexpected detail—that the soles of the dead soldier's shoes "had been worn to the thinness of writing paper." I won't try to gloss these matters here but will move directly on to another passage in Crane, this one from his novella *The Monster*.

The passage is taken from an astonishing scene in which the Negro Henry Johnson, who works for the Trescott family as a coachman, goes heroically into a burning house in order to save young Jimmie Trescott

from certain death. Johnson rushes up the stairs and finds Jimmie
having just awakened in his own room, but when he tries to carry the
boy down he discovers that flames and smoke have made the route
impassable. For a moment he despairs, then recalls a private staircase
leading from another bedroom to an apartment that Jimmie's father, a
doctor, had fitted up as a laboratory. But when Johnson finally makes
his way there he discovers not only that that room too is on fire but
that the doctor's chemicals are exploding in fantastic hues and forms
("At the entrance to the laboratory he confronted a strange spectacle.
The room was like a garden in the region where might be burning
flowers. Flames of violet, crimson, green, blue, orange, and purple
were blooming everywhere. There was one blaze that was precisely the
hue of a delicate coral. In another place was a mass that lay merely in
phosphorescent inaction like a pile of emeralds. But all these marvels
were to be seen dimly through clouds of heaving, turning, deadly
smoke" [pp. 405–6].). After pausing on the threshold, Johnson
rushes across the room with the boy still in his arms; just then an
explosion occurs and "a delicate, trembling sapphire shape like a fairy
lady" blocks his path; Johnson tries to duck past her but she is "swifter
than eagles" and her talons are said to catch in him as he does so.
Whereupon, "Johnson lurched forward, twisting this way and that
way. He fell on his back. The still form in the blanket flung from his
arms, rolled to the edge of the floor and beneath the window" (p.
406). (Jimmie will later be saved.) The scene concludes:

Johnson had fallen with his head at the base of an old-fashioned desk.
There was a row of jars upon the top of this desk. For the most part, they
were silent amid this rioting, but there was one which seemed to hold a
scintillant and writhing serpent.

Suddenly the glass splintered, and a ruby-red snakelike thing poured
its thick length out upon the top of the old desk. It coiled and hesitated,
and then began to swim a languorous way down the mahogany slant. At
the angle it waved its sizzling molten head to and fro over the closed eyes
of the man beneath it. Then, in a moment, with mystic impulse, it
moved again, and the red snake flowed directly down into Johnson's up-
turned face.

Afterward the trail of this creature seemed to reek, and amid flames
and low explosions drops like red-hot jewels pattered softly down it at
leisurely intervals. (p. 406)

95

By the end of this passage we again are presented with an unmoving body lying face up on the ground. In this case the body is not that of a corpse and its eyes are closed rather than open;[3] but the extent of the author's, or say the novella's, investment in the body's final position becomes plain when we consider the oddly unpersuasive account of the lurchings and twistings that produce it. Another difference from the description of the corpse in *The Red Badge* is that no second character is represented gazing at Johnson's upturned face. But the passage from *The Monster* narrates the destruction of Johnson's face (we are soon told that "he now had no face. His face had simply been burned away" [p. 411]), and the remainder of the plot will turn on the dreadfulness to sight of the nonface with which he has been left (although never described, it gives rise to horrendous consequences whenever it is glimpsed). Maybe too the sheer gorgeousness of the color imagery of the burning laboratory should be read in part as a displacement of effects of seeing that the logic of the narrative doesn't allow the scene to represent directly (the "sapphire shape like a fairy lady" comes closest to being a possible agent of vision). In any event, something is done to Johnson's face, and this time what is done is far from gentle. Finally, in light of the comparison of the soles of the dead man's shoes to writing paper in the excerpt from *The Red Badge,* I am struck by the fact that Johnson ends up lying "with his head at the base of an old-fashioned desk," a piece of furniture that one inevitably connects with the activity of writing; and just in case this seems to be making too much of an incidental detail, I shall quote again the sentence that immediately precedes the account of Johnson's appalling disfiguration, but with two key verbs italicized: "For the most part, they [the jars on the desk] were silent amid this *rioting,* but there was one which seemed to hold a scintillant and *writhing* serpent." Whether or not we understand the particular jar to contain ink, the verbs in question evoke a third verb, *writing,* that comes close to rhyming, audially and visually, with the other two. (Later in this essay I shall argue that the images of serpents and fire that turn up frequently in Crane's texts belong essentially to a metaphorics of writing.)

The third text by Crane I want to consider is the late short tale "The Upturned Face"; in effect it takes the motifs and preoccupations I have identified in the passages from *The Red Badge* and *The Monster* and constructs around them a brief, two-part narrative of tremendous force and uncertain significance.[4] What ostensibly is narrated is the burial,

under enemy fire, of a dead officer by two fellow officers who had served with him for years. The opening paragraphs read as follows:

> "What will we do now?" said the adjutant, troubled and excited.
> "Bury him," said Timothy Lean.
> The two officers looked down close to their toes where lay the body of their comrade. The face was chalk-blue; gleaming eyes stared at the sky. Over the two upright figures was a windy sound of bullets, and on the top of the hill, Lean's prostrate company of Spitzbergen infantry was firing measured volleys. (p. 1283)

Two men from the company are assigned to dig a grave and Lean and the adjutant proceed to search the corpse's clothes for "things" (as the adjutant puts it). Lean hesitates to touch the first bloodstained button on the dead man's tunic but at last completes the search and rises "with a ghastly face. He had gathered a watch, a whistle, a pipe, a tobacco pouch, a handkerchief, a little case of cards and papers" (pp. 1283–84). Meanwhile the bullets keep spitting overhead and the two lower ranks labor at digging the grave; their completion of the task is announced in the following short paragraph:

> The grave was finished. It was not a masterpiece—poor little shallow thing. Lean and the adjutant again looked at each other in a curious silent communication. (p. 1284)

The two officers proceed to tumble the dead man into the grave, taking care not to feel his body as they do so; after saying a mangled prayer (based, it would seem, on the service for the dead at sea) they are ready to oversee the covering up of his remains. At this point, the first paragraph of the second part of the narrative, the motif of the upturned face returns with new force:

> One of the aggrieved privates came forward with his shovel. He lifted his first shovel load of earth and for a moment of inexplicable hesitation it was held poised above this corpse which from its chalk-blue face looked keenly out from the grave. Then the soldier emptied his shovel on—on the feet.
> Timothy Lean felt as if tons had been swiftly lifted from off his forehead. He had felt that perhaps the private might empty the shovel on—on the face. It had been emptied on the feet. There was a great point

gained there—ha, ha!—the first shovelful had been emptied on the feet. How satisfactory! (pp. 1285–86)

Suddenly the man with the shovel is struck by a bullet in the left arm and Lean seizes the shovel and begins to fill the grave himself; as the dirt lands it makes a sound—"plop." The adjutant suggests that it might have been better not to try to bury the body just at that time, but Lean rudely tells him to shut his mouth and persists at his task. The tale concludes:

> Soon there was nothing to be seen but the chalk-blue face. Lean filled the shovel. . . . "Good God," he cried to the adjutant. "Why didn't you turn him somehow when you put him in? This—" Then Lean began to stutter.
>
> The adjutant understood. He was pale to the lips. "Go on, man," he cried, beseechingly, almost in a shout. . . . Lean swung back the shovel; it went forward in a pendulum curve. When the earth landed it made a sound—plop. (pp. 1286–87; ellipses Crane's)

Much of the cumulative effect of "The Upturned Face" has been lost in my summary, but even so several points are clear. First, once more we find at the center of the scene a dead man lying on his back staring upward; in fact, as I have noted, we are presented with such a figure twice over, at the opening of the tale, where it is described as lying at the feet of Lean and the adjutant, and at the beginning of the second part, as the first shovelful of dirt is held suspended above it. Second, the corpse's chalk-blue upturned face is on both occasions the principal object of Lean's and the adjutant's attention, and once again something uncanny and in a strong sense disfiguring happens to that face— in fact the entire second part of the tale turns on Lean's repugnance at the prospect of having to cover the dead man's face with dirt. (The exact degree of violence this implies seems to fall somewhere between the scenes from *The Red Badge* and *The Monster*.) And third, although a thematics of writing is no more than hinted at by the recurrent epithet "chalk-blue" and perhaps also by the little case of cards and papers that Lean removes from the dead man, the newly excavated and still empty grave is characterized, indeed is half-addressed, as "not a masterpiece—poor little shallow thing," a phrase that, however ironically, deploys a vocabulary of artistic valuation that one can imagine

the author applying (again ironically: Crane seems to have thought especially well of this tale)[5] to "The Upturned Face" itself. I suggest too that the ostensible action of the tale—the digging of a grave, the tumbling of a corpse into its shallow depths, and then the covering of the corpse and specifically its upturned face with shovelfuls of dirt— and the movement of the prose of its telling are meant as nearly as possible to coincide, as if each were ultimately a figure for the other: this is one reason why, for example, the text comes to an end with the quasi-word "plop," which is nothing more nor less than the verbal representation of the sound made when the last shovelful of dirt falls on the grave, or if not the very last at any rate the one that covers the chalk-blue face once and for all. That the protagonist's name, Timothy Lean, invites being read as a barely disguised version of the author's reinforces this suggestion, all the more so in that the adjutant remains nameless and the dead man is referred to only once, by Lean, as "old Bill."[6] All this is to read "The Upturned Face" as representing, and in a sense enacting, the writing of "The Upturned Face," which as a general proposition about a literary work is today pretty much standard fare. What is interesting to consider, however, is why this particular text lends itself so fully to such a reading, or to broaden our discussion to include the passages from *The Red Badge* and *The Monster,* what it means that motifs of an upturned face and the disfiguring of that face are in all three cases conjoined with a thematization or, in "The Upturned Face" itself, a sustained if displaced representation of the act of writing.

Here is a partial answer. Just as in Peale's *Graphics* a primitive ontological difference between the allegedly upright or erect "space" of reality and the horizontal "space" of writing/drawing emerged as problematic for the graphic enterprise, and just as in Eakins's art an analogous difference between the horizontal "space" of writing/ drawing and the vertical or upright "space" of painting turned out to play a crucial role with respect both to choice of subject matter and to all that is traditionally comprised under the notion of style, so in the production of these paradigmatic texts by Crane an implicit contrast between the respective "spaces" of reality and of literary representation—of writing (and in a sense, as we shall see, of writing/drawing) —required that a human character, ordinarily upright and so to speak forward-looking, be rendered horizontal and upward-facing so as to match the horizontality and upward-facingness of the blank page on

which the action of inscription was taking place. Understood in these terms, Crane's upturned faces are at once synecdoches for the bodies of those characters and singularly concentrated metaphors for the sheets of writing paper that the author had before him, as is spelled out, by means of a displacement from one end of the body to the other, by the surprising description of the worn-down soles of the dead soldier's shoes in the passage from *The Red Badge.* (The displacement is retroactively signaled by the allusion to reading in the last sentence of the second paragraph.)

Thus for example the size and proportions of a human face and that of an ordinary piece of writing paper are roughly comparable.[7] An original coloristic disfiguration of all three faces, either by death making one ashen and another chalk-blue or simply by Henry Johnson's blackness, may be taken as evoking the special blankness of the as yet unwritten page. (A preparatory blankness is associated with Johnson's face—actually with his facelessness—in a scene in Reifsnyder's barber shop; the crucial passage reads: "As the barber foamed the lather on the cheeks of the engineer he seemed to be thinking heavily. Then suddenly he burst out. 'How would you like to be with no face?' he cried to the assemblage" [p. 423].)[8] And their further disfiguration, by the wind that is said to have raised the soldier's tawny beard (in this context the verb betrays more aggressive connotations than at first declare themselves),[9] by the ruby-red snakelike thing that flows down into the unconscious Johnson's visage, and by the shovelful of dirt that Lean agonizingly deposits on the last visible portion of his dead comrade, defines the enterprise of writing—of inscribing and thereby in effect covering the blank page with text—as an "unnatural" process that undoes but also complements an equally or already "unnatural" state of affairs. (It goes without saying that the text in question is invariably organized in *lines* of writing, a noun that occurs, both in plural and singular form, with surprising frequency in Crane's prose, as for example in the sentence, "Once the line encountered the body of a dead soldier.")[10] In fact one way of glossing the tumbling of the body into the newly dug grave in "The Upturned Face" is as an acknowledgment that the upward-facingness of the corpse, hence of the page, is not so much a brute given as a kind of artifact—not precisely the result of conscious choice (Lean and the adjutant don't try to arrange the corpse face up) but by the same token not the issue of inhu-

man necessity (before a word has been written on it, the blank page tells a story of agency).

What remains obscure, however, is why in the passages we have examined the act of writing is thematized as *violent* disfigurement and, especially in those from *The Monster* and "The Upturned Face," why it is associated with effects of horror and repugnance—as though writing for Crane, like painting for Eakins, were in essential respects an excruciating enterprise. Nor does anything I have said begin to answer the broader question of what it means that figures of the blank page and of the action or process of writing play an important role in three of Crane's greatest works. In order to confront these questions, I shall consider three additional texts by Crane, each of which also crucially involves the description of an upturned face.

II

The first text is a passage from the most famous of the so-called New York City sketches of 1894, "An Experiment in Misery." Composed in the third person and featuring a persona for the author called simply "the young man" or "the youth," the sketch—written to be published in a newspaper, as in fact it was—recounts a winter night spent dressed in tattered clothes first as a loiterer on the Bowery and then in a flophouse full of unspeakable odors, sudden cries, and men down on their luck sprawled about on slablike cots.[11] The crucial passage occurs roughly halfway through the sketch; the young man having lain down on a cot near a window looks around him, first at a new acquaintance whom he refers to as "the assassin" and then at a figure nearer still:

> Within reach of the youth's hand was one who lay with yellow breast and shoulders bare to the cold drafts. One arm hung over the side of the cot and the fingers lay full length upon the wet cement floor of the room. Beneath the inky brows could be seen the eyes of the man exposed by the partly opened lids. To the youth it seemed that he and this corpse-like being were exchanging a prolonged stare and that the other threatened with his eyes. He drew back, watching his neighbor from the shadows of his blanket edge. The man did not move once through the night, but lay

in this stillness as of death, like a body stretched out, expectant of the surgeon's knife. (pp. 542–43)

As in the quotations from *The Red Badge* and "The Upturned Face," a corpselike being lies staring upward with unseeing eyes, while a comparable discoloration is ascribed to his breast and shoulders (and implicitly to his face). The theme of writing is touched on both directly, by the reference to the sleeping man's inky brows, and indirectly, as when in the first and last sentences of the paragraph he is said to lie within reach of the youth's hand (i.e., at what might be called writing distance from the author-persona) and then is likened to a body waiting for the surgeon's knife—a penlike instrument, as *The Gross Clinic* has taught us to recognize. Another feature in common with the passage from *The Red Badge* is the pointedly ambiguous use of pronouns in the sentence, "To the youth it seemed that he and this corpse-like being were exchanging a prolonged stare and that the other threatened with his eyes." This is always read as meaning that the corpselike being seemed to threaten with *his own* eyes, but of course the sentence can just as well be read as stating that it seemed to the youth that the sleeping man threatened with his, *the youth's,* eyes. I am further encouraged to take the ambiguity seriously by the intimation of a slight but telling disparity of scale in the description of the sleeping man's fingers lying "full length" on the floor of the room: the phrase seems to me to evoke something larger than mere fingers, or if not physically more imposing (the following alternative is the one I favor) then physically more proximate, as if what is being described is the youth's own hand seen from his point of view. In any event, there will be more to say about the deliberate ambiguity involved in the exchange of stares.

Two other paragraphs in "An Experiment in Misery" are worth glancing at here, if only because they begin to show how the metaphorics of writing that I have been tracing in Crane is not confined to passages that depict an upturned face. The first paragraph occurs early in the sketch:

> Through the mists of the cold and storming night, the cable cars went in silent procession, great affairs shining with red and brass, moving with formidable power, calm and irresistible, dangerful and gloomy, breaking silence only by the loud fierce cry of the gong. Two rivers of people swarmed along the side-walks, spattered with black mud, which made

each shoe leave a scar-like impression. Overhead elevated trains with a shrill grinding of the wheels stopped at the station, which upon its leg-like pillars seemed to resemble some monstrous kind of crab squatting over the street. The quick fat puffings of the engines could be heard. Down an alley there were sombre curtains of purple and black, on which street lamps dully glittered like embroidered flowers. (pp. 538–39)

A great deal might usefully be said about this passage (I shall allude to it more than once later on), but for the present I want simply to suggest that at least four of its principal images—the mostly silent procession of cable cars, the scar-like impressions left by the pedestrians' shoes on the muddy sidewalks, the shrilly grinding elevated trains, and the street lamps like embroidered flowers on sombre curtains—can be glossed as figures for writing in one way or another.[12]

The second paragraph I wish to cite comes shortly after the description of the corpselike being with inky brows and partly opened eyes, and concerns another tenant of the flophouse—a man who, assaulted by terrible dreams, "began to utter long wails that went almost like yells from a hound, echoing wailfully and weird through this chill place of tombstones [a figure for tall clothes-lockers], where men lay like the dead" (p. 543). The text continues:

> The sound, in its high piercing beginnings that dwindled to final melancholy moans, expressed a red and grim tragedy of the unfathomable possibilities of the man's dreams. But to the youth these were not merely the shrieks of a vision-pierced man. They were an utterance of the meaning of the room and its occupants. It was to him the protest of the wretch who feels the touch of the imperturbable granite wheels and who then cries with an impersonal eloquence, with a strength not from him, giving voice to the wail of a whole section, a class, a people. This, weaving into the young man's brain and mingling with his views of these vast and somber shadows that like mighty black fingers curled around the naked bodies, made the young man so that he did not sleep, but lay carving biographies for these men from his meager experience. At times the fellow in the corner howled in a writhing agony of his imaginations. (p. 543)

This passage too is full of interest, but I will settle for observing, first, how the reference to shadows curling like mighty black fingers around naked bodies at once confirms the hint of aggrandizement in the previous description of the corpselike man's hand resting on the floor and

lends support to my suggestion that what essentially are being imaged are the *writer's own* fingers, which we are to imagine gripping—that is, curling around—a pen or pencil in the act of producing the very text we read;[13] and second, how in the context of the other passages we have looked at the sequence of gerunds "piercing," "weaving," and "carving" (the last as part of the phrase "carving biographies for these men," presumably on the tombstones/clothes lockers) can be read as adumbrating a metaphorics of the act of writing that the further gerund "writhing" in the final sentence all but makes explicit (cf. *The Monster*'s "scintillant and writhing serpent").[14] Until now, however, the force of that "all but" has been decisive, and before this essay is done we shall have to consider the implications of that fact.

Another of the New York City sketches, the comparatively little known "When Man Falls, a Crowd Gathers," has an even more highly charged bearing on our inquiry.[15] Its basic plot is minimal: a man and a boy, both foreigners, are walking together on a street on the East Side at around six o'clock in the evening when the man falls to the ground in what appears to be an epileptic fit. (Like the other writings we have considered, "When Man Falls" is composed in the past tense but retains the feel of an ongoing chain of events.) A dense crowd quickly gathers, almost crushing the object of its interest in its collective anxiety to see what is going on, and much of the sketch consists in the dramatization of a sort of mass frenzy to view the fallen man face to face. One extended passage describes in successive paragraphs, like filmic "shots," a violent spasm to which the fallen body is subjected, the response of the crowd to that sight, and various features of the immediate surroundings:

> Those that were nearest to the man upon the side-walk at first saw his body go through a singular contortion. It was as if an invisible hand had reached up from the earth and had seized him by the hair. He seemed dragged slowly, relentlessly backward, while his body stiffened convulsively, his hands clenched, and his arms swung rigidly upward. A slight froth was upon his chin. Through his pallid half-closed lids could be seen the steel-colored gleam of his eyes that were turned toward all the bending, swaying faces and in the inanimate thing upon the pave yet burned threateningly, dangerously, shining with a mystic light, as a corpse might glare at those live ones who seemed about to trample it under foot.
>
> As for the men near, they hung back, appearing as if they expected it to

spring erect and clutch at them. Their eyes however were held in a spell of fascination. They seemed scarcely to breathe. They were contemplating a depth into which a human being had sunk and the marvel of this mystery of life or death held them chained. Occasionally from the rear, a man came thrusting his way impetuously, satisfied that there was a horror to be seen and apparently insane to get a view of it. Less curious persons swore at these men when they trod upon their toes.

The loaded street-cars jingled past this scene in endless parade. Occasionally, from where the elevated railroad crossed the street there came a rhythmical roar, suddenly begun and suddenly ended. Over the heads of the crowd hung an immovable canvas sign. "Regular dinner twenty cents." (pp. 601–2)

Soon a tall German appears and orders the crowd to move back; then he and another

knelt by the man in the darkness and loosened his shirt at the throat. Once they struck a match and held it close to the man's face. This livid visage, suddenly appearing under their feet in the light of the match's yellow glare, made the throng shudder. Half articulate exclamations could be heard. There were men who nearly created a battle in the madness of their desire to see the thing. (p. 602)

Presently a policeman arrives, followed by a doctor; the latter examines the fallen man, who begins to breathe heavily, "as if he had just come to the surface from some deep water" (p. 603). Another match is struck and the doctor feels the man's skull to discover whether it was fractured by the fall. The crowd continues to press forward and is resisted by the policeman and scolded by the doctor. Then a black ambulance "with its red light, its galloping horse, its dull gleam of lettering and bright shine of gong clattered into view. A young man, as imperturbable always as if he were going to a picnic, sat thoughtfully upon the rear seat" (p. 603). The body is carried into the ambulance, which then leaves. And although part of the crowd disperses with an air of relief, others continue to stare at the departing ambulance with discontent "at this curtain which had been rung down in the midst of the drama. And this impenetrable fabric suddenly intervening between a suffering creature and their curiosity, seemed to appear to them as an injustice" (p. 604).

It is a remarkable narrative, one whose ostensible occasion, the wit-

nessing of a man in the throes of an epileptic seizure, would seem to fall far short of justifying the intensity of feeling that, both in the action of the sketch and in the urgency of its prose, is everywhere in play. And it is precisely that overdraft of intensity that colors the sketch's relationship to the other, by no means unintense, texts by Crane we have examined. To begin with, "When Man Falls" not only has as its central focus a disfigured upturned face with open, unseeing eyes, it also thematizes that face as an object of an almost insane collective will-to-see as well as of fascination mingled with fear and horror on the part of those near enough to look on it directly. (The full implications of this thematization remain to be drawn out.) The difficulty of seeing, and by implication the desperateness of the will-to-see, is expressed both in terms of the size of the crowd and by a highly subjective imagery of darkness: thus we are told early on that "the shadows caused by [the crowd's] forms . . . barely allowed a particle of light to pass between them" (p. 600), and the later revelation of the fallen man's livid visage is effected by the yellow glare of a match.

A further relation to our previous texts, especially *The Red Badge* and "The Upturned Face," is a recurrent imagery of battle, as in the description of persons nearest the fallen man as "those in the foremost rank" (p. 600) and the statement, "Others behind them crowded savagely for a place like starving men fighting for bread" (p. 600). There is also the remark about the men who nearly created a battle, which I will look at more closely in a moment, and a little later the policeman is said to charge the crowd "as if he were a squadron of Irish lancers" (p. 602). Still later, after calling for an ambulance, the policeman returns to fight with the crowd again (p. 603). The exchange of insults that takes place from time to time (e.g., " 'Say, quit yer shovin', can't yeh? What d' yeh want, anyhow? Quit!' " [p. 601]) also recalls the dialogue in parts of *The Red Badge.* As for the thematization of writing that I have associated with Crane's upturned faces, I find it here in the immovable canvas sign hanging over the heads of the crowd as well as, toward the end of the sketch, in the dull gleam of lettering on the side of the black ambulance.

An aspect of "When Man Falls" that has no equivalent in our previous texts is that precisely owing to its dramatization of the difficulty of seeing, it raises as a question the matter of the point of view, by which I mean in the first instance the implied physical location, of the narrator, the writer. On the one hand, the account of the forming of

the crowd ("Two streams of people coming from different directions met at this point to form a crowd. Others came from across the street" [p. 600].) and the repeated evocations of the crowd's thickness and frenzy suggest an elevated perspective, as if the writer were literally above the battle. On the other, his hallucinatorily vivid description of the fallen man in the grip of a seizure and, still more intimate in its relation to its object, his conjuring up of the man's livid features suddenly appearing in the glare of a match imply that the narrator is at the center of the crowd, in the small contested space surrounding the fallen man and enjoying (if that is the word) a close-up view of what we imagine most of the others in the sketch to be striving vainly to glimpse. My claim isn't quite that there is a contradiction between these points of view: the all but uncontrollable desire of the crowd to look directly down on the fallen man is in effect fulfilled by the narrator's simultaneously fascinated and horrified descriptions of the latter, and in particular by his account of still another virtual exchange of gazes with that threateningly corpselike being (in the sentence beginning, "Through his pallid half-closed lids could be seen the steel-colored gleam of his eyes that were turned toward all the bending, swaying faces . . ."). But to the extent that we are made aware that this is so, we are invited to associate the narrator, or at least the narratorial function, with the madness of the crowd; and if we bear in mind that the author of "When Man Falls" had already written *The Red Badge* (which in fact began to appear in a shortened version as a newspaper serial the day after the publication of "When Man Falls" in the New York *Press*), it is difficult not to attribute altogether extraordinary significance to the sentence that closes the paragraph describing the livid visage in matchlight: "There were men who nearly created a battle in the madness of their desire to see the thing." *Nearly* created a battle? Or indeed—virtually—created one?[16]

Finally, however, there is in "When Man Falls" another, antithetical figure for the writer, who turns up only toward the end of the narrative in close connection with the ambulance, which I have already associated, through the lettering on its side, with the theme of writing: "A young man, as imperturbable always as if he were going to a picnic, sat thoughtfully upon the rear seat." I interpret the young man as the writer's ego ideal, an exemplar of detachment yet not quite of disengagement, or say of the disinterestedness—a deeply problematic concept[17]—that ultimately distinguishes the author of this text from

the maddened crowd that is equally a projection of his desire. And this leads me, reading backward as it were, to find another emblem of disinterestedness in the immovable canvas sign hanging over the heads of the crowd. In sum, the sketch turns out to represent two antithetical points of view after all: the first identified with the crowd and connoting an irrational overinvolvement with seeing, the second identified both with the young man seated at the rear of the ambulance and with the elevated sign (the latter recalling the elevated perspective of portions of the narrative) and connoting a fundamentally different attitude toward the fallen man. The paradox, of course, is that functionally speaking the two attitudes are complementary—more precisely, the second, detached or disinterested or (as I shall say) "esthetic" attitude would seem to be a necessary condition for the effective representation of the first attitude, which in "When Man Falls," as in the other texts we have considered, is maximally dramatized in and through an encounter with a disfigured upturned face.

But even this may be too simple. For if we accept the immovable canvas sign as an emblem of disinterestedness comparable in significance to the imperturbable young man, then the flatly quotidian nature of the legend on that sign ("Regular dinner twenty cents") suggests that the text's ideal of disinterestedness might perhaps be characterized not just as "esthetic" but also, simultaneously, as "journalistic," which is to say that attitudes and practices keyed to the primary fact of publication in newspapers and magazines are perhaps to be understood as given here as exemplary for literary writing as such.[18]

These speculations prepare the ground for an examination of a short story that I shall argue goes further toward explaining the issues we have been trying to understand than any other piece of writing in the Crane corpus—"Death and the Child." The story, impossible to summarize briefly, begins by describing a horde of frightened peasants loaded with bundles and accompanied by a variety of farm animals streaming down a mountain trail in an effort to escape the scene of a battle that we quickly understand is taking place on the other side of the mountain.[19] A single figure, the journalist Peza, climbs against the stream, actually moving toward the fight; soon he notices another man, a lieutenant of infantry, marching the same way, and the two join forces. It at once emerges that Peza is a Greek and that although he had come merely as a reporter for an Italian newspaper, he now

intends to join the fight on the side of his native land. Presently the two men reach the crest of the mountain from which they look down on the scene of conflict:

> Before them was a green plain as level as an inland sea. It swept north-ward, and merged finally into a length of silvery mist. Upon the near part of this plain, and upon two grey treeless mountains at the sides of it, were little black lines from which floated slanting sheets of smoke. It was not a battle to the nerves. One could survey it with equanimity, as if it were a tea-table; but upon Peza's mind it struck a loud clanging blow. It was war. (p. 946)

The two men rush down a primitive track at the foot of which they come to a wide road extending toward the battle. On this road they encounter wounded soldiers moving in the opposite direction, some of whom "were bandaged with the triangular kerchief upon which one could still see through blood-stains the little explanatory pictures il-lustrating the ways to bind various wounds. 'Fig. 1.'—'Fig. 2.'—'Fig. 7.'" (p. 947). After some minor incidents, Peza and the lieuten-ant continue to walk toward the front and soon reach a series of trenches occupied by Greek troops whose calm in the presence of the still somewhat distant fighting impresses Peza deeply.

At this juncture the narrative shifts radically to another point of view. On top of a mountain a small peasant child is amusing himself, having been abandoned by his parents in their rush to escape the im-minent battle. The child is explicitly described as too young to under-stand the meaning of the events taking place on the plain before him. The nature of his play, however, is developed in considerable detail:

> The child ran to and fro, fumbling with sticks and making great machina-tions with pebbles. By a striking exercise of artistic license the sticks were ponies, cows, and dogs, and the pebbles were sheep. He was managing large agricultural and herding affairs. He was too intent on them to pay much heed to the fight four miles away, which at that distance resembled in sound the beating of surf upon rocks. . . .
>
> He was solitary; engrossed in his own pursuits, it was seldom that he lifted his head to inquire of the world why it made so much noise. The stick in his hand was much larger to him than was an army corps of the distance. It was too childish for the mind of the child. He was dealing with sticks.

The battle lines writhed at times in the agony of a sea-creature on the sands. These tentacles flung and waved in a supreme excitement of pain, and the struggles of the great outlined body brought it nearer and nearer to the child. Once he looked at the plain and saw some men running wildly across a field. He had seen people chasing obdurate beasts in such fashion, and it struck him immediately that it was a manly thing which he would incorporate in his game. Consequently he raced furiously at his stone sheep, flourishing a cudgel, crying the shepherd calls. He paused frequently to get a cue of manner from the soldiers fighting on the plain. He reproduced, to a degree, any movements which he accounted rational to his theory of sheep-herding, the business of men, the traditional and exalted living of his father. (pp. 949–51)

The narrative then returns to Peza who is compared with "a corpse walking on the bottom of the sea, and finding there fields of grain, groves, weeds, the faces of men, voices" (p. 951). Struck by the coolness of soldiers leaving the battle, Peza speculates that "[p]erhaps during the fight they had reached the limit of their mental storage, their capacity for excitement, for tragedy, and had then simply come away" (p. 951). He recalls his own visit "to a certain place of pictures . . . [where] he had whirled and whirled amid this universe with cries of woe and joy, sin and beauty, piercing his ears until he had been obliged simply to come away" (p. 951). Although recognizing that the two cases are different, he imagines that, like himself, the "gunless wanderers . . . may have dreamed at lightning speed until the capacity for it was overwhelmed" (p. 952).

The lieutenant soon leaves Peza, who feels himself to be as if "beneath the battle. It was going on above somewhere. Alone, unguided, Peza felt like a man groping in a cellar. . . . The trees hid all movements of troops from him, and he thought he might be walking out to the very spot which chance had provided for the reception of a fool" (pp. 952–53). Shells explode quite close by, until finally Peza climbs a little hill from the top of which "he would be obliged to look this phenomenon"—the battle—"in the face" (p. 954). (What he actually sees when he gets there is a green plain "with three lines of black marked upon it heavily" [p. 955].) On the crest of the hill he approaches a group of artillery officers; in answer to their queries he explains that having come as a correspondent, he now wishes to fight; then, put off by what seems to him their jaded responses to his declara-

tions, he sets off to climb a nearby slope where the Greek infantry is engaged.

As he nears the infantry position he is appalled to meet and exchange gazes with a spectral soldier whose jaw has been half shot away. At the top of the hill he comes upon a battery of mountain guns shelling the streaks of black on the plain, and he becomes aware as well of trenches filled with men all firing away. We are then given an extended view of the battle itself:

> The plain stretched as far as the eye could see, and from where silver mist ended this emerald ocean of grass, a great ridge of snow-topped mountains poised against a fleckless blue sky. Two knolls, green and yellow with grain, sat on the prairie confronting the dark hills of the Greek position. Between them were the lines of the enemy. A row of trees, a village, a stretch of road, showed faintly on this great canvas, this tremendous picture; but men, the Turkish battalions, were emphasized startlingly upon it. The ranks of troops between the knolls and the Greek position were as black as ink. The first line, of course, was muffled in smoke, but at the rear of it battalions crawled up and to and fro plainer than beetles on a plate. Peza had never understood that masses of men were so declarative, so unmistakable, as if nature makes every arrangement to give information of the coming and the presence of destruction, the end, oblivion. The firing was full, complete, a roar of cataracts, and this pealing of connected volleys was adjusted to the grandeur of the far-off range of snowy mountains. Peza, breathless, pale, felt that he had been set upon a pillar and was surveying mankind, the world. In the meantime dust had got in his eye. He took his handkerchief and mechanically administered to it. (pp. 957–58)

A battery of howitzers fires repeatedly on the enemy lines, which after a time begin to go on the attack: "From the black lines had come forth an inky mass, which was shaped much like a human tongue. It advanced slowly, casually, but with an insolent confidence that was like a proclamation of the inevitable" (p. 959). As the defenders excitedly prepare to meet it (again it is described as an "inky mass which was flowing toward the base of the hills, heavily, languorously, as oily and thick as one of the streams that ooze through a swamp"), Peza repeatedly asks a single question: " 'Can they take the position?' " (p. 959). Finally the captain of the battery angrily shouts that they cannot, that

it is impossible, at which point Peza turns to run along the crest of the hill toward the part of the Greek line that seems destined to take the brunt of the Turkish assault.

Here "Death and the Child" reaches the first of its two climaxes. Having arrived among the rifle pits filled with soldiers, he explains to a Greek officer that he wishes to join the fight. The officer then points toward some dead men covered with blankets and tells Peza to take a bandoleer of cartridges from one of them. As Peza moves cautiously toward a body he hears a sound behind him; turning, he finds three soldiers watching him; thereupon the officer comes again and asks him for tobacco; Peza gives the officer his pouch, and as if in compensation the officer directs a soldier to strip the bandoleer from the dead man. "Peza, having crossed the long cartridge-belt on his breast, felt that the dead man had flung his two arms around him" (p. 960). Handed a rifle that had belonged to another dead man, Peza becomes even more uncomfortable: "He heard at his ear something that was in effect like the voices of those two dead men, their low voices speaking to him of bloody death, mutilation. The bandoleer gripped him tighter; he wished to raise his hands to his throat like a man who is choking. The rifle was clammy; upon his palms he felt the movement of the sluggish currents of a serpent's life; it was crawling and frightful" (p. 961). But the worst—one last upturned face—is still to come:

> He looked behind him, and saw that a head by some chance had been uncovered from its blanket. Two liquid-like eyes were staring into his face. The head was turned a little sideways as if to get better opportunity for the scrutiny. Peza could feel himself blanch; he was being drawn and drawn by these dead men slowly, firmly down as to some mystic chamber under the earth where they could walk, dreadful figures, swollen and blood-marked. He was bidden; they had commanded him; he was going, going, going. (p. 961)

Tearing madly at the bandoleer, Peza bolts for the rear.

The story concludes by returning to the child on his mountain. In the late afternoon, the child breaks off his play and gazes in astonishment at the battle now raging almost directly below him:

> Sometimes he could see fantastic smoky shapes which resembled the curious figures in foam which one sees on the slant of a rough sea. The plain,

indeed, was etched in white circles and whirligigs like the slope of a colossal wave. The child took seat on a stone and contemplated the fight. He was beginning to be astonished; he had never before seen cattle herded with such uproar. Lines of flame flashed out here and there. It was mystery. (p. 962)

Hungry and lonely, he begins to weep; he approaches the door of his home and calls softly for his mother; the evening darkens; whereupon he is distracted from his troubles by the sight of a man dragging himself up to the crest of the hill and falling panting onto the ground. Filled with "calm interest," the child approaches the heaving form and asks, "Are you a man?" Peza, disheveled and exhausted, doesn't answer, and the child repeats the question (pp. 962–63). The story's final paragraph reads simply:

Peza gasped in a manner of a fish. Palsied, windless, and abject, he confronted the primitive courage, the sovereign child, the brother of the mountains, the sky and the sea, and he knew that the definition of his misery could be written on a wee grass-blade. (p. 963)

Basically I interpret "Death and the Child" as an implicit commentary on the other writings we have considered, only one of which, "The Upturned Face," dates from a later moment in Crane's career. Several factors are pertinent here. First, there is the maintenance throughout the story of a more than customary sense of distance from its protagonist, Peza, who never is allowed to achieve even fractional coherence as a character and whose continual movement up, down, and around the landscape—climbing, descending, climbing again, ceaselessly shifting from one position to another—at once serves as an emblem of that lack of coherence and prevents the reader from regarding any single perspective that Peza happens to occupy as definitive of his point of view (more on this shortly). Furthermore, Peza's climactic vision of still another upturned face with open unseeing eyes differs sharply from the otherwise similar passages we have discussed in that the description of the face itself seems almost perfunctory. We are thus denied the possibility of identifying with Peza even at that apparently decisive moment in the story, and this in turn helps set the stage for an allegorical reading of his actions and vicissitudes, most importantly of his sudden panic upon donning a dead soldier's bandoleer, being

handed another's rifle, and finally encountering—"by some chance" though not quite by accident—a corpse's uncovered face.

In this connection I am struck by the prevalence of a thematics not simply of writing, as in the repeated allusions to the inky lines of troops on the tablelike plane and the final sentence of the story with its image of writing on a blade of grass, but also of something like pictorial representation, as in the reference to the little numbered illustrations on the bandages of the wounded men, the image of the great outlined body as of an agonized sea-creature that the battle lines describe from the vantage of the child, the account of Peza's visit on a previous occasion to a certain place of pictures, the likening of the enemy advance seen from the Greek battery to an inky mass shaped like a human tongue, the comparison of the battle in the late afternoon near the base of the child's mountain to figures in foam etched on the slope of a colossal wave, and, most impressively, the extended metaphor of the vista of battle as a great canvas or tremendous picture on which the Turkish troops, black as ink, were emphasized startlingly, declaratively, unmistakably. And I am struck as well by the way in which the adverb "declaratively" in particular recalls the pictorial metaphor to its verbal ground, as does even more spectacularly the image of an inky mass in the form of an organ of speech, and as is also suggested by the figure numbers accompanying the little diagrams on the bandages, so like the sort of graphic detail we might expect to find in a painting by Eakins.

All this goes far beyond the thematizations of writing we have hitherto remarked, and suggests that what allegorically is at issue in "Death and the Child" is nothing less than a mode of literary representation that involves a major emphasis on acts of *seeing,* both literal and metaphorical, on the part of author, characters, and reader. Now, from the earliest years of Crane's renown down to the present there has been universal agreement in the critical literature that his highly personal realist or, as is usually said, "impressionist" style rests on such an emphasis. Furthermore, it is altogether standard in that literature to find Joseph Conrad's famous credo from the preface to *The Nigger of the 'Narcissus'* applied to Crane as well: "All art . . . appeals primarily to the senses, and the artistic aim when expressing itself in written words must also make its appeal though the senses, if its high desire is to reach the secret spring of responsive emotions. . . . My task which I am trying to achieve is, by the power of the written word to make

you hear, to make you feel—it is, before all, to make you *see*."[20] I believe that Crane's commentators, early and late, have been right to stress his involvement with seeing, and I too take Conrad's statement of purpose as in crucial respects definitive of Crane's literary practice. The special importance of the allegory implicit in "Death and the Child," however, is that when read in conjunction with the other texts we have examined it reveals what appears to have been for Crane the deeply conflictual nature, and in a sense the ultimate impossibility, of his own extreme version of the "impressionist" enterprise.[21]

The exact meaning of the allegory begins to emerge when we consider the fundamental structural principle of "Death and the Child": the contrast between two radically differentiated points of view, the first associated with the journalist Peza and the second with the peasant child abandoned by his parents on the top of a mountain. (The starkness of that contrast, sometimes criticized as sentimental, is another index of the allegorical.) If we were to put all our trust in the last paragraph of the story, we might conclude that the child is simply one emblem among others of nature's sovereign indifference to human suffering: but even a cursory review of the first account we are given of the child's activities—his use of sticks and pebbles to represent ponies, cows, dogs, and sheep (characterized as a striking exercise in artistic license), and his imitation of the manner and movements of the soldiers fighting on the plain—makes clear that his point of view is better understood as epitomizing a peculiarly mimetic, which is to say "esthetic," stance toward experience, as distinct from Peza's urgent desire to participate actively in the battle. Moreover, if we now think back to the emergence in "When Man Falls" of a contrast between two antithetical points of view, one identified with the crowd and marked by an overinvolvement in seeing, and the other, identified first with the imperturbable young man at the rear of the ambulance and then with the immovable canvas sign above the crowd, termed by me successively "esthetic" and "journalistic" and characterized by a certain manifest "disinterestedness," it begins to appear that "Death and the Child" investigates and in effect invalidates the earlier contrast by exposing the defectiveness of *both* the "esthetic" and the "journalistic" attitudes: specifically, by showing that the apparent detachment of the "esthetic" involves a necessarily narcissistic misreading of the visual data (the child interprets the scene of battle exclusively in terms of his limited prior experience);[22] and, at greater length, by dramatizing the

inherent instability of the "journalistic" attitude and in particular its tendency toward fully as extreme a mode of overinvolvement in seeing as that associated with the behavior of the crowd, and implicitly the writer, in "When Man Falls" (failings that, as presented in "Death and the Child," also have their narcissistic aspects).

Here it might be objected that Peza's ceaseless movement toward and around the battle and his ultimate panic and flight should be understood not as expressing an inherent tendency of the "journalistic" but rather as signs of a merely personal failure to maintain a correct professional distance from his subject. But for one thing Peza is far too unrealized a character to be interpretable in those terms, and for another the sheer multiplicity of perspectives on the battle that the reader is offered makes it seem highly questionable that among that multiplicity there exists a single point of view which, occupied steadfastly, would stabilize Peza's perceptions and thereby forestall his eventual collapse. (One might say, adapting the terms of Peza's anguished question at the moment of the Turkish attack, that there is no position to be held by him in the face of what the battle offers to be seen.) This conclusion appears all the more compelling in that one description of the vista of battle—the long passage quoted above beginning "The plain stretched as far as the eye could see"—presents itself, up to a point, as definitive in its clarity and comprehensiveness. By the end of the passage, however, its exemplary status has been compromised, first, by the image of Peza feeling himself set upon a pillar and surveying mankind, which recalls the narcissistic perspective of the child and in any case would seem to violate the ordinariness implicit in a "journalistic" ideal, and second, by Peza's getting dust in his eye, which at a stroke deflates the pillar image, exposes the fragility of the point of view underwriting the description of the battle, and all but erases the vista itself.[23] Significantly, it is in the next section of the story that Peza undergoes his climactic encounter with bandoleer, rifle, and corpse.

If we now call to mind the array of texts by Crane we have examined in this essay, it becomes apparent, I think, that a comparable overinvolvement in seeing, culminating in effects of horror that by their nature are disruptive of seeing, characterizes all the encounters with upturned faces. (This is least true of the passage from *The Red Badge,* a horrific reaction being reserved for Fleming's encounter with a seated corpse in the "chapel" of high arching boughs toward the end of chap-

ter seven—a scene we shall consider shortly.) Put slightly differently, the descriptions of almost all the upturned faces (in the case of *The Monster,* of the destruction of such a face) are particular triumphs of Crane's "impressionism," and yet the upturned faces themselves are profoundly disturbing to his protagonists, who typically feel themselves personally threatened, above all by the faces' unseeing stares, and who draw back from the encounters when they don't break them off entirely. (Look again, for example, at the actions of the young man in "An Experiment in Misery" or the behavior of the crowd in the long quotation from "When Man Falls.") One way in which that threat is registered by Crane's protagonists is as a loss of all sense of distance and very nearly of distinction between themselves and the corpselike beings that obsess their attention, which I take it is a major source of Peza's horror at feeling the bandoleer grip him from behind as if it were the dead man's arms, as well as of his extreme reaction to the dead man's liquid gaze: "Peza could feel himself blanch; he was being drawn and drawn by these dead men slowly, firmly down as to some mystic chamber under the earth where they could walk, dreadful figures, swollen and blood-marked. He was bidden; they had commanded him; he was going, going, going." (Cf. the description in "When Man Falls" of the stricken man appearing as if seized by the hair and dragged slowly, relentlessly backward.) And if we now appeal to our earlier finding that the upturned faces may be understood as figures for the sheet of paper on which the work of literary writing is taking place, it follows that the image of a chamber under the earth to which Peza despite his intense repugnance feels himself powerfully drawn invites being read as a figure for the "space" of literary representation, here imagined, plausibly but terrifyingly, as looming *below* the surface of the sheet. This suggests in turn that Peza's headlong flight from the partly uncovered corpse expresses a refusal to enter that "space," a refusal I interpret, if not quite as a rejection of representation, at any rate as a collapse or suspension of the "impressionist" project precisely at its characteristic zenith of vividness.[24]

But still more is at stake in the emphasis on Peza's intense discomfort at feeling himself clasped from behind by a dead man's bandoleer and at feeling another dead man's rifle in his hands. For there is a clear sense in which these aspects of Peza's situation emblematize two cardinal features of the actual production of writing: that the writer is not simply a hovering visual apparatus and an executive hand but a sighted

corporeal being whose relation to the horizontal page before him is fairly complex; and that the act of writing involves wielding a sticklike instrument (and here it is pertinent not only that Crane often implicitly analogizes the writer's pen to a knife or razor, both "aggressive" instruments, but also that the rifle in Peza's hands is twice compared to a snake or serpent, a creature that, in *The Monster* and elsewhere, plays a crucial role in Crane's metaphorics of inscription [more on snakes later on]). In sum, there is no escaping the conclusion that what is allegorized by Peza's distress throughout the climactic episode is above all a *fear of writing,* by which I mean a fear of being forced to acknowledge both the reality of the text as writing (a phrase that remains to be unpacked) and Peza's own figurality as a surrogate for the writer. Nothing indeed could be more characteristic of the operations of this particular text than that a lurid double figurality emerges at the instant of extreme crisis: exchanging stares with the dead soldier, Peza feels himself *blanch,* which is to say approach the color of a sheet of paper; and he is then described as being *drawn and drawn* by the dead men, which in view of the story's imagery of representation can be glossed as implying that they are not just luring him to an underworld but delineating him as well, which is to say exposing him as nothing more than an effect of certain practices of literary writing. Is this perhaps the definition of his misery that the last sentence of the story tells us Peza knew could be written on a wee grass blade? And is the reader's ultimate relation to Crane's upturned faces, not only in "Death and the Child" but in each of the cases we have considered, perhaps figured here as well?

What makes these questions and speculations all the more intriguing is that from its opening description of the peasants fleeing from the battle to its unlikely finale on the mountaintop—I take this to be clear from the excerpts I have cited—"Death and the Child" *obsessively and multifariously thematizes writing.** And this leads me to the further

*The opening paragraph of "Death and the Child" reads in its entirety:

The peasants who were streaming down the mountain trail had in their sharp terror evidently lost their ability to count. The cattle and huge round bundles seemed to suffice to the minds of the crowd if there were now two in each case where there had been three. This brown stream poured on with a constant wastage of goods and beasts. A goat fell behind to scout the dried grass, and its owner, howling, flogging his donkeys, passed far ahead. A colt, suddenly frightened, made a stumbling charge up the hill-side. The expenditure was always profligate and always unnamed, unnoted. It was as if fear was a river, and this horde had simply been caught in the torrent, man tumbling over beast, beast over

conclusion that the fear of writing that irrupts as Peza takes up arms and that within a page or two will bring the narrative to a close is essentially a response to something that has been going on all along but that, in the episode in question, threatens finally to engulf the writer-surrogate as no previous episode quite does. Put succinctly, in "Death and the Child" *a thematics of writing is from the outset given manifold expression and then at a critical juncture is personified as terminally dreadful in its effects*. What are we to make of this apparent reversal? And if I am right in claiming that "Death and the Child" provides a general commentary on Crane's "impressionist" enterprise, how is that commentary to be understood?

III

"My task which I am trying to achieve," Crane's new friend Joseph Conrad wrote in 1897, "is, by the power of the written word to make you hear, to make you feel—it is, before all, to make you *see*." I have already quoted this master-credo of literary "impressionism" and have said that I believe Crane's commentators have been right to find in it a statement of purpose to which Crane himself would have subscribed. By "mak[ing] you see" Conrad of course had in mind making the reader visualize with special acuteness scenes and events which are not literally there on the page but which the letters, words, sentences, and paragraphs that *are* on the page somehow contrive to evoke. But what if, for reasons that are not entirely clear, Crane's very commitment to a version of the "impressionist" project—his attempt, before all, to make the reader *see*—at least intermittently led Crane himself to see, by which I mean fix his attention upon, and to wish to make the reader see, by which I mean visualize in his imagination, those things that, *before all,* actually lay before Crane's eyes: the written words themselves, the white, lined sheet of paper on which they were inscribed, the marks made by his pen on the surface of the sheet, even perhaps

man, as helpless in it as the logs that fall and shoulder grindingly through the gorges of a lumber country. It was a freshet that might sear the face of the tall quiet mountain; it might draw a livid line across the land, this downpour of fear with a thousand homes adrift in the current—men, women, babes, animals. From it there arose a constant babble of tongues, shrill, broken, and sometimes choking as from men drowning. Many made gestures, painting their agonies on the air with fingers that twirled swiftly. (p. 943)

the movements of his hand wielding the pen in the act of inscription? Wouldn't such a development threaten to abort the realization of the "impressionist" project as classically conceived? In fact would it not call into question the very basis of writing as communication—the tendency of the written word at least partly to "efface" itself in favor of its meaning in the acts of writing and reading? But now imagine that instead of recognizing the objects of his attention for what they were—instead of understanding himself to be seeing and representing writing and the production of writing—*Crane unwittingly, obsessionally, and to all intents and purposes automatically metaphorized writing and the production of writing (and the viewing of these) in images, passages, and, in rare instances, entire narratives that hitherto have wholly escaped being read in those terms.* Imagine this—all of this—and we have, I suggest, a plausible if improbable scenario for the genesis of the multiple, repetitive, yet also varied thematizations and allegorizations of writing we have been analyzing in this essay.

Indeed we may go further and suppose that a principal function of Crane's relentlessly metaphorical style was to represent, as if under compulsion, the multifarious aspects of what I earlier called the scene of writing, but to do so in a manner that positively obscured the meaning of those representations from both writer and reader, or to put this slightly differently, that displaced those particular meanings by other meanings identified more or less closely with the ostensible or (in the Freudian sense of the word) "manifest" subjects of the narratives.[25] The aim of such a mechanism of displacement would have been to allow the narratives to continue on their paths—that is, to enable the writer to continue pursuing the work of narration without interruption—much as according to Freud the function of dreams is to serve as "guardians of sleep" by giving indirect expression to certain internal mental stimuli—forbidden wishes—that would otherwise cause the sleeper to waken.[26] And just as in the case of dreams the distorting mechanisms of secondary revision can be taxed beyond their ability to cope with the subversive force of those wishes,[27] so in Crane's sketches, stories, and novels the signs of conflict, of the irruption or near-irruption of a repressed and unacknowledged content, can readily be discerned, most dramatically though by no means exclusively in the recurrent descriptions of disfigured upturned faces with open unseeing eyes, or perhaps I should say in the mood of intense ambivalence—of fixated attention but also of repulsion and even

fear—with which one or more personages (in "When Man Falls" an entire crowd) are typically represented gazing at such a face.

In "Death and the Child," as we have seen, Peza's exchange of stares with an unexpectedly uncovered corpse, in conjunction with his being armed with a bandoleer and a rifle taken from other corpses, causes him to flee; and this in turn, although not breaking off the narrative then and there, precipitates an ending within a very few pages, an ending, moreover, in which the motif of writing is brought into microscopically acute focus (". . . and he knew that the definition of his misery could be written on a wee grass-blade."). Most of the time, however, Crane's doubly disfigured upturned faces have less catastrophic immediate effects both on the protagonists of his narratives and on the latter's overall trajectories. And this suggests that the passages that describe the faces and recount responses to them are where Crane's unconscious fixation on the scene of writing not only comes closest to *surfacing* in a sustained and deliberate manner but also, precisely owing to the "manifestly" dreadful nature of the faces and of the vicissitudes that befall them, is most emphatically *repressed*. In other words, the thematization of writing as violent disfigurement and its association with effects of horror and repugnance but also of intense fascination allowed the writer, and *a fortiori* the reader, to remain unconscious of the very possibility of such a thematization in the face of what, from the perspective of this essay, appear almost to be provocations to construe the passages in question in that light: the dead soldier's sole "worn to the thinness of writing paper" in the quotation from *The Red Badge,* for example, or the close conjunction of the verbs "writhing" and "rioting" in the scene from *The Monster,* or the reference to "men who nearly created a battle in the madness of their desire to see the thing" in "When Man Falls." (The developments within and around literary studies that have made this shift of perspective possible are too well known to require more than brief acknowledgment.)[28]

Or consider the following passage, also from *The Red Badge,* in which Fleming, wandering in a thick woods after having run from combat, happens upon an enclosed spot that he proceeds to enter:

> At length he reached a place where the high, arching boughs made a chapel. He softly pushed the green doors aside and entered. Pine needles were a gentle brown carpet. There was a religious half light.

Near the threshold he stopped, horror-stricken at the sight of a thing.

He was being looked at by a dead man who was seated with his back against a columnlike tree. The corpse was dressed in a uniform that once had been blue, but was now faded to a melancholy shade of green. The eyes, staring at the youth, had changed to the dull hue to be seen on the side of a dead fish. The mouth was open. Its red had changed to an appalling yellow. Over the gray skin of the face ran little ants. One was trundling some sort of bundle along the upper lip.

The youth gave a shriek as he confronted the thing. He was for moments turned to stone before it. He remained staring into the liquid-looking eyes. The dead man and the living man exchanged a long look. Then the youth cautiously put one hand behind him and brought it against a tree. Leaning upon this he retreated, step by step, with his face still toward the thing. He feared that if he turned his back the body might spring up and stealthily pursue him.

The branches, pushing against him, threatened to throw him over upon it. His unguided feet, too, caught aggravatingly in brambles; and with it all he received a subtle suggestion to touch the corpse. As he thought of his hand upon it he shuddered profoundly.

At last he burst the bonds which had fastened him to the spot and fled, unheeding the underbrush. He was pursued by a sight of the black ants swarming greedily upon the gray face and venturing horribly near to the eyes. (pp. 126–27)

The resemblance of this passage to Peza's confrontation with the corpse on the hillside is at once evident, though in the present instance the description of the "chapel" as a roomlike space with doors, a carpet, and "religious" lighting brings the scene even nearer to one of writing (and reading). In addition, the seated corpse has something of the character of an open book or notebook (bound in blue cloth faded to green), while the phrase "columnlike tree" suggests columns of print, and the doubly disfiguring image of ants swarming upon the dead man's discolored face and specifically menacing the eyes all but demands to be read—again, from the perspective of this essay—as representing a writing that bears an excruciatingly ambivalent relation to vision. (The hyperesthetic sharpness of focus, as of something seen at much closer range than the narrative context would appear to allow, of the image of the ant trundling its bundle across the corpse's upper lip also recalls the writing on a wee blade of grass at the end of "Death and the Child." In that story too we are told that viewed from the top

of a hill the Turkish battalions "crawled up and to and fro plainer than beetles on a plate.") Similarly, although Fleming unlike Peza is not depicted as grasping a sticklike object, he shudders at the thought (or "subtle suggestion": emanating from where?) of actually touching the corpse with his hand—a reaction that expresses by rejecting (hence disowning) the movement of Crane's own hand across the surface of the page. Another feature of the "chapel" scene that relates to other texts we have looked at is the thrice-repeated allusion to the corpse as a "thing."[29] Considered in isolation, this merely confirms the truism that corpses are inanimate. But read in the context of the passage as a whole, in which what is evoked is the quasi-animateness of the dead man (with whom characteristically the living man is said to "[exchange] a long look"), the word "thing" itself is felt to hover uncannily between inanimateness and animateness: as if the notorious animism of Crane's style—"like nothing else in civilized literature," according to Berryman[30]—were already fully in play in this seemingly rather slight but in fact extremely potent indeterminacy. By now it should be clear that a hovering between inanimateness and animateness captures perfectly the ontological status of writing for the writer (and, on somewhat different grounds, the reader). And this in turn helps explain not just Crane's predilection for corpselike beings but his animism generally.[31]

The chapter immediately following the "chapel" scene begins with two short paragraphs:

> The trees began softly to sing a hymn of twilight. The sun sank until slanted bronze rays struck the forest. There was a lull in the noises of insects as if they had bowed their beaks and were making a devotional pause. There was silence save for the chanted chorus of the trees.
> Then, upon this stillness, there suddenly broke a tremendous clangor of sounds. A crimson roar came from the distance. (p. 128)

(Note, by the way, the strong alliteration—much of it involving the letters "s" and "c"—which of course is another often remarked feature of Crane's style; I shall have more to say about this presently.) Having fled from the "chapel," Fleming is characterized as "transfixed by this terrific medley of all noises" and then is said "to run in the direction of the battle," the din from which makes him doubt "if he had seen real battle scenes" (p. 128). The chapter continues:

Reflecting, he saw a sort of humor in the point of view of himself and his fellows during the late encounter. They had taken themselves and the enemy very seriously and had imagined that they were deciding the war. Individuals must have supposed that they were cutting the letters of their names deep into everlasting tablets of brass, or enshrining their reputations forever in the hearts of their countrymen, while, as to fact, the affair would appear in printed reports under a meek and immaterial title. But he saw that it was good, else, he said, in battle every one would surely run save forlorn hopes and their ilk.

He went rapidly on. He wished to come to the edge of the forest that he might peer out.

As he hastened, there passed through his mind pictures of stupendous conflicts. His accumulated thought upon such subjects was used to form scenes. The noise was as the voice of an eloquent being, describing.

Sometimes the brambles formed chains and tried to hold him back. Trees, confronting him, stretched out their arms and forbade him to pass. After its previous hostility this new resistance of the forest filled him with a fine bitterness. It seemed that Nature could not be quite ready to kill him.

But he obstinately took roundabout ways, and presently he was where he could see long gray walls of vapor where lay battle lines. The voices of cannon shook him. The musketry sounded in long irregular surges that played havoc with his ears. He stood regardant for a moment. His eyes had an awestruck expression. He gawked in the direction of the fight.

Presently he proceeded again on his forward way. The battle was like the grinding of an immense and terrible machine to him. Its complexities and powers, its grim processes, fascinated him. He must go close and see it produce corpses.

He came to a fence and clambered over it. On the far side, the ground was littered with clothes and guns. A newspaper, folded up, lay in the dirt. A dead soldier was stretched with his face hidden in his arm. Farther off there was a group of four or five corpses keeping mournful company. A hot sun had blazed upon the spot. (pp. 128–29)

Although less spectacular than the "chapel" scene, the passage as a whole is charged with import for our argument. Early on, for example, writing is explicitly thematized twice, in the allusions to cutting the letters of one's name (and the letters of Crane's name conspicuously include "s" and "c") into tablets of brass, and to printed reports of the battle in which the encounter from which Fleming had run "would appear . . . under a meek and immaterial title," a curious phrasing

that can be read as intimating that the encounter itself had been an immaterial—a purely intellectual—affair. (Not, however, that the act of writing *is* intellectual as opposed to material: one might take the two allusions between them as embracing extremes present in every instance of writing.) In this connection too it is striking that we are told of Fleming that "there passed through his mind pictures of stupendous conflicts" ("s" and "c" once more), and, in another typically precise and unusual construction implicitly aligning him with the author of *The Red Badge,* that "[h]is accumulated thought upon such subjects was used to form scenes." (Fleming's mind is continually forming scenes and pictures.)[32] Immediately after this, however, there occur in rapid sequence several quasi-personifications—the likening of the noise of the battle to "the voice of an eloquent being, describing," the description of trees and brambles as actively confronting Fleming and resisting his progress, and the imaging of the battle as "an immense and terrible machine"—that have the double effect of directing attention away from Fleming (thereby countering any impulse there might have been to see in him a figure for the writer) and of signaling the irruption in the text of an alien—more accurately, an unacknowledgable—agency, which I take to be that of writing as such. I am further encouraged to make this connection by the sentence, "He must go close and see it produce corpses," not only because we have ample warrant for construing the production (i.e., representation) of corpses by Crane himself in these terms, but also because Fleming's compulsion to go close and watch the machine at work—he would inevitably have seen quite a few men killed by this time—is otherwise inexplicable.[33] And I find confirmation of my surmise in the close conjunction on the far side of the fence of a "dead soldier with his face hidden in his arm" and still another explicit thematization of writing, the folded-up newspaper lying in the dust. Finally, there are the "long gray walls of vapor where lay battle lines" that Fleming sees as he comes clear of the trees and brambles, an image whose spatial ambiguity might lead one to imagine that the lines are inscribed *on* the walls, which can hardly be the case.

Shortly after the passage we have just looked at, Fleming encounters what the narrative calls "the *s*teady *c*urrent of the maimed" (p. 130; from here on I shall put the first letters of "s"-followed-by-"c" phrases in italics)—a procession, which he joins, of wounded and dying men, among whom is a "spectral soldier" he soon recognizes as an admired

friend from his own regiment, Jim Conklin. The chapter-long account of Conklin's ghastly stalking march toward a place to die and then of his protracted death throes, climaxing in the sentence, "The red sun was pasted in the sky like a wafer (p. 137)," is justly famous; and although it would be forcing matters to read that account as an extended figure for writing or the production of writing, more than a few moments in it can be seen to bear on the concerns of this essay. Thus at the outset the spectral soldier is said to have "the gray seal of death already upon his face," and his lips are described as "curled in hard lines" (p. 130); Fleming in this company comes to feel that "his shame could be viewed," and so casts sidelong glances "to see if the men were contemplating the letters of guilt he felt burned into his brow" (p. 133); shortly afterwards Conklin repels the attentions of the other men in the procession, "*signing* to them to go on and leave him alone" (p. 133, italics mine); his features are described as "waxlike," a writing-related epithet that looks forward to the climactic figure of the wafer (p. 133); on his gory hand there is "a curious red and black combination of new blood and old blood (p. 133)," which inevitably suggests a mixture of blood and ink;[34] his terror-stricken face is then described as "turned to a semblance of gray paste" (p. 134), another writing-related image that also anticipates the wafer; Fleming at one point pleads with him "with all the words he could find (p. 135)," a formulation that seems to grant the words an independent material existence; as Conklin lurches toward his final resting place, Fleming and a companion, the tattered soldier, "have thoughts of a *solemn* ceremony," apparently because "[t]here was something *rite-like* in these movements of the doomed soldier" (p. 136; italics mine); watching his slow and painful strangulation makes Fleming "writhe" (p. 136; cf. the passage from *The Monster*), though a moment later he and the tattered soldier are impressed by "a curious and profound dignity in the firm lines of [Conklin's] awful face" (p. 137); immediately after the latter's death, Fleming gazes down "upon the pastelike face" (p. 137); and the final sentence's red wafer pasted in the sky has most plausibly been interpreted as a common item of stationery in Crane's time, "a small, round, orange-red, stickable sealing wafer used for sealing envelopes and affixing legal documents."[35] In the context of the argument I have been advancing, the wafer image would seem definitively if retroactively to place Conklin's agony and death and

upturned face, along with Fleming's responses to these, under the sign of a thematics of writing that the actual prose of their telling might equally plausibly be characterized as struggling to express and to ward off. (Another motif that belongs with those we have just considered is Conklin's terror of falling in the road and being run over by artillery wagons [pp. 134–35]. In light of the images of streetcars and elevated trains in "An Experiment in Misery" and "When Man Falls," as well as of the references to "the wretch who feels the touch of the imperturbable granite wheels" in the former and to the black ambulance "with its red light, its galloping horse, its dull gleam of lettering and bright shine of gong" in the latter, it seems logical to read Conklin's terror as figuring a fear of writing, and in that sense as prefiguring Peza's panic and flight toward the end of "Death and the Child.")

My aim in looking closely, though by no means exhaustively, at a largish portion of *The Red Badge* (roughly, chapters seven through nine) has been to suggest the fundamental, but also fundamentally irruptive and disunifying, nature of the preoccupation with writing that I have been expounding. Unlike "Death and the Child," which in other respects it resembles, *The Red Badge* as a whole cannot be understood as an allegory of Crane's enterprise; it makes no sense to try to discern in Fleming's experiences in his first battle an overarching figure for a literary practice or indeed for a conflict of practices. And this is if anything even more obviously true of much smaller units of the novel, such as the passage beginning, "Reflecting, he saw a sort of humor in the point of view of himself and his fellows during the late encounter," and ending, "A hot sun had blazed upon the spot," or the narrative of Conklin's march to his death, in both of which diverse partial thematizations of the scene of writing succeed one another rapidly, bewilderingly, in any case unsystematically. And because this is so, because there is in *The Red Badge* no comprehensive or even sustained local matching of "manifest" and "latent" contents, critical awareness of the sorts of figurations and foregroundings of writing that I have been tracing is inevitably at odds with traditional attempts to arrive at a more or less totalizing (and invariably psychological and moralistic) interpretation of Fleming's story. In fact the more attuned one becomes to those figurations and foregroundings, the more difficult it becomes to reconcile a desire to read *The Red Badge* for the story (or the moral) with one's interest in the text as the site, almost the

theater, of an incessant becoming-visible and disappearing both of aspects of the scene of writing and of what I earlier characterized as the text's reality as writing (a term that still remains to be unpacked).[36]

Nor does it mitigate the conflict to recognize that there are places in the novel where that becoming-visible and disappearing are themselves thematized, as for example in the superbly nuanced passage that just precedes the description of the corpse staring at the sky with which this essay began:

> The regiment slid down a bank and wallowed across a little stream. The mournful current moved slowly on, and from the water, shaded black, some white bubble eyes looked at the men.
>
> As they climbed the hill on the farther side artillery began to boom. Here the youth forgot many things as he felt a sudden impulse of curiosity. He scrambled up the bank with a speed that could not be exceeded by a bloodthirsty man.
>
> He expected a battle scene.
>
> There were some little fields girted and squeezed by a forest. Spread over the grass and in among the tree trunks, he could see knots and waving lines of skirmishers who were running hither and thither and firing at the landscape. A dark battle line lay upon a sunstruck clearing that gleamed orange color. A flag fluttered.
>
> Other regiments floundered up the bank. The brigade was formed in line of battle, and after a pause started slowly through the woods in the rear of the receding skirmishers, who were continually melting into the scene to appear again farther on. They were always busy as bees, deeply absorbed in their little combats.
>
> The youth tried to observe everything. He did not use care to avoid trees and branches, and his forgotten feet were constantly knocking against stones or getting entangled in briers. He was aware that these battalions with their commotions were woven red and startling into the gentle fabric of softened greens and browns. It looked to be a wrong place for a battle field.
>
> The skirmishers in advance fascinated him. Their shots into thickets and at distant and prominent trees spoke to him of tragedies—hidden, mysterious, solemn. (p. 101)

The youth's impulse of curiosity, his desire to look directly on the battle, anticipates his postflight compulsion to go close to the battle machine and see it produce corpses (and incidentally brings out the primordial character of that compulsion throughout *The Red Badge,*

which is to say its resistance to being accounted for in terms of Fleming's alleged reactions to the events of the narrative).[37] And perhaps the slight sense of anticlimax that accompanies the sentence, "He expected a battle scene," is not unrelated to the absence of corpses from the scene that here meets his eye, an absence partly compensated for when the line of men of which he is a part encounters the body of a dead soldier.[38] But the absence of corpses is by no means synonymous with a lack of figures of writing; on the contrary, the passage is remarkable for the richness and subtlety of its metaphorizations not just of aspects of the scene of writing (I assume that by now these don't require detailed commentary) but also of the intermittence, the becoming-visible and disappearing, of certain characteristic writing-effects. I refer in particular to the image of "knots and wavy lines of skirmishers, who were continually melting into the scene to appear again further on," and to the way in which that image is exemplified (at least up to a point) by the sentence, "They were always busy as bees, deeply absorbed in their little combats." By this I mean that the first part of the sentence with its (no doubt inadvertent) pun on "bees" and "b's" comes close to being about its own alliterative character and in that respect its own writtenness; and that the second part of the sentence, whose topic is absorption, in fact largely undoes that initial double foregrounding by absorbing the crucial signifiers—the b's in "absorbed" and "combat"—back into the play of literary representation.

In another sense of course this combination of foregrounding and absorption marks Crane's treatment of alliteration generally, by means of which an ostensible emphasis on the "mere" repetition of signifiers characteristically becomes the vehicle for a wide range of representational, atmospheric, or indeterminately "poetic" effects. The sentence, "A flag fluttered," from the passage just cited is a paradigmatically succinct case in point: the alliteration, verging on onomatopoeia (another characteristic resource of Crane's prose), is registered as miming both motion and sound and thus as contributing to the sensory vividness of the description of the scene. A seemingly unrelated but in fact functionally nearly identical device that plays a significant role in *The Red Badge* is the conspicuous use of speech in dialect, as when for example the tattered soldier remarks quietly to Fleming, "Ye 'd better take 'im [Conklin] outa th' road, pardner. There 's a battery comin' helitywhoop down th' road an' he 'll git

runned over. He 's a goner anyhow in about five minutes—yeh kin see that. Ye 'd better take 'im outa th' road. Where th' blazes does he git his stren'th from?" (p. 135). (The dialect is even more strongly marked in the manuscript version of 1893–94, though Crane's most extreme exploitation of the device occurs in the prodigious *Maggie,* published pseudonymously early in 1893.)[39] In the notation of dialect too an initial foregrounding of the signifier is more or less instantaneously subsumed, above all by the syntax of the passage as a whole, in a powerful representational effect, the evocation of an idiosyncratic manner of speaking (i.e., of an individual or typical "voice"). Still another device that works along these lines is dialogue in which one or more characters are represented stammering or otherwise mechanically repeating themselves (a frequent occurrence in Crane), which is to say speaking in a way that almost but not quite suspends considerations of sense in favor of the "mere" reiteration of a few isolated words ("Oh, Jim—oh, Jim—oh, Jim," is all Fleming says when he first recognizes the spectral soldier as Jim Conklin [p. 133]).[40] None of these devices—alliteration, onomatopoeia, the use of dialect, and the notation of stammering or repetition—is confined to *The Red Badge* (the most telling instance of onomatopoeia in all of Crane is the word "plop" at the end of "The Upturned Face," the most common one the streetcars' "gong" in "An Experiment in Misery," "When Man Falls," and elsewhere), but each of them is prominent in its pages. My claim is that motivating that prominence is their common faculty of allowing both the foregrounding and the absorption, the appearance and the disappearance, of a crucial feature of the text's reality as writing: that is consists of individual letters grouped in sequences that form words.

It is in these terms also that I understand Crane's frequent recourse to ambiguous pronouns, as in the opening quotation from *The Red Badge* or, to take another familiar example, as in the striking sentence from "An Experiment in Misery": "To the youth it seemed that he and this corpse-like being were exchanging a prolonged stare and that the other threatened with his eyes." We might say of the latter especially that its referential ambiguity enacts the perceptual merging or identification of the protagonist with the object of his perception, and thus epitomizes at the microlevel of syntax Crane's singularly intense version of literary "impressionism." But as soon as we become aware of that ambiguity, we experience it as disruptive of representation (we are

unsure *whose* eyes are doing the threatening), which in turn has the effect of at least momentarily isolating on the page—of foregrounding in its materiality—the word "his" or indeed the entire clause in which it is embedded. William James's account in *The Principles of Psychology* of a parallel phenomenon, the way in which "if we look at an isolated printed word and repeat it long enough, it ends by assuming an entirely unnatural aspect,"[41] is relevant to the entire class of devices I have been considering. James writes:

> Let the reader try this with any word on this page. He will soon begin to wonder if it can be the word he has been using all his life with that meaning. It stares at him from the paper like a glass eye, with no speculation in it. Its body is indeed there, but its soul is fled. It is reduced, by this new way of attending to it, to its sensational nudity. We never before attended to it in this way, but habitually got it clad with its meaning the moment we caught sight of it, and rapidly passed from it to the other words of the phrase. We apprehended it, in short, with a cloud of associates, and thus perceiving it, we felt it quite otherwise than as we feel it now divested and alone.[42]

James's metaphors for the denaturalized or say "materialized" word (a glass eye, a corpselike body) inevitably recall Crane's figures for the written page, just as James's explanation of why in ordinary circumstances this denaturalization or "materialization" does not take place helps explain why Crane's readers, rapidly passing from the ambiguous word or phrase to the words and sentences that follow it, seem not to have registered the disruption of representation that I invoke above. Indeed the import of pronominal ambiguity (as of the other devices) in Crane would seem to lie as much in its propensity to disappear back into the overall "manifest" patterns of meaning of his prose as in its tendency momentarily to attract our attention.[43]*

*In one dramatic instance of "materialization" a disruption of representation would seem at first to be ineluctable. Toward the end of chapter twenty-three of *The Red Badge*, Fleming visualizes his own lifeless body in the following terms: "It was clear to him that his final and absolute revenge was to be achieved by his dead body lying, torn and gluttering, upon the field" (p.202). Because the epithet "gluttering" can't be found in dictionaries, Crane's editors have viewed it simply as a mistake for "glittering" or "guttering"—this despite the fact that "gluttering" appears not only in the Appleton edition but also in the final manuscript. From the perspec-

A great deal more could be said about figurations of writing in *The Red Badge* (the scene in chapter one between Fleming and his mother is replete with these, as are the ferociously imagined battle narratives in the later chapters),[44] but my aims in this essay preclude intensive commentary on the novel as a whole, and in any case it will be useful at this point to turn briefly to one of the masterpieces of Crane's later phase, the novella *The Monster*. Earlier I argued that Johnson's deface-ment in the burning laboratory may be read as imaging the very act of inscription. Now I want to suggest that a metaphorics of inscription is in play in *The Monster* from first to last, and that its relation to the overall structure of that work differs palpably from the analogous rela-tion in *The Red Badge*. Here is *The Monster*'s opening paragraph:

> Little Jim was, for the time, engine Number 36, and he was making the run between Syracuse and Rochester. He was fourteen minutes behind time, and the throttle was wide open. In consequence, when he swung around the curve at the flower-bed, a wheel of his cart destroyed a peony. Number 36 slowed down at once and looked guiltily at his father, who was mowing the lawn. The doctor had his back to this accident, and he continued to pace slowly to and fro, pushing the mower. (p. 391)

This seems innocuous enough, but armed with foreknowledge of what is to come in *The Monster* itself, as well as with an awareness of how extensively in Crane writing is figured via images of streetcars, elevated railways, ambulances, and the like, it is tempting to see in Jimmie Trescott's railroad game still another instance of such a figure and in his accidental destruction of the peony an anticipation of the later destruction of Johnson's upturned face. The temptation gains in force when a few lines further on the doctor (Jimmie's father) is de-scribed as "shaving this lawn as if it were a priest's chin" (p. 391), an image that will later be activated by the scene in Reifsnyder's barber

tive of this essay, however, it seems wonderfully apposite that Fleming's imagination of himself as a corpse, hence metaphorically as a page, should itself be disfigured—desemanticized—in this particular way. At the same time, in that Crane's epithet could hardly be closer to the adjectives with which his editors would replace it, he might almost be taken as sanctioning their project of resemanticization, which is to say that, even here, something like a double process of the surfacing and repression of the materiality of writing turns out to be in play.

shop, and becomes virtually irresistible when, following the doctor's verdict that Jimmie "had better not play train any more to-day," the last paragraph of the first section of the novella states: "During the delivery of the judgment the child had not faced his father, and afterward he went away, with his head lowered, shuffling his feet" (p. 392). (Actually, the immediate effects of the destruction of the peony don't stop there. The second section begins: "It was apparent from Jimmie's manner that he felt some kind of desire to efface himself. He went down to the stable. Henry Johnson, the negro who cared for the doctor's horses, was sponging the buggy. He grinned fraternally when he saw Jimmie coming. These two were pals" [p. 392]).[45]

Without comparing in detail the opening of *The Monster* with that of *The Red Badge,* the first of these seems (again, from the perspective of this essay) single-minded, even perhaps heavy-handed, in its deployment of a constellation of images that will presently be brought to a focus in the literal effacement of Johnson's features. And the question this raises for our inquiry is what to make of that apparent single-mindedness, if in fact I am right in insisting that Crane throughout his career remained wholly oblivious to the possibility that his writing might be read in the terms that I have been expounding here.

The same question is raised even more disturbingly by the long, finely detailed paragraph that describes the evening street life of the town of Whilomville through which Johnson, later the same day and resplendent in his best finery, is taking a stroll:

The shimmering blue of the electric arc-lamps was strong in the main street of the town. At numerous points it was conquered by the orange glare of the outnumbering gas-lights in the windows of shops. Through this radiant lane moved a crowd, which culminated in a throng before the post-office, awaiting the distribution of the evening mails. Occasionally there came into it a shrill electric street-car, the motor singing like a cageful of grasshoppers, and possessing a great gong that clanged forth both warnings and simple noise. At the little theatre, which was a varnish and red-plush miniature of one of the famous New York theatres, a company of strollers was to play *East Lynne.* The young men of the town were mainly gathered at the corners, in distinctive groups, which expressed various shades and lines of chumship, and had little to do with any social gradations. There they discussed everything with critical insight, passing the whole town in review as it swarmed in the street. When the gongs of the electric cars ceased for a moment to harry the ears, there could be

heard the sound of the feet of the leisurely crowd on the blue-stone pave-
ment, and it was like the peaceful evening lashing at the shore of a lake.
At the foot of the hill, where two lines of maples sentinelled the way, an
electric lamp glowed high among the embowering branches, and made
most wonderful shadow-etchings on the road below it. (pp. 395–96)

(As if in response to a feeling that something is lacking from this
scene, Crane a few pages later goes on to say: "After the mails from
New York and Rochester had been finally distributed, the crowd from
the post-office added to the mass already in the park [where a band
concert was taking place]. The wind waved the leaves of the maples,
and, high in the air, the blue-burning globes of the arc lamps caused
the wonderful traceries of leaf shadows on the ground. When the light
fell upon the upturned face of a girl, it caused it to glow with a
wonderful pallor" [p. 399]. The repetition of the bland adjective
"wonderful"—three times in the two quotations, twice in the last two
sentences—and for that matter of the bare verb "caused"—also twice
in the last two sentences—is a sign both of the compulsion Crane
seems to have been under and of the obliviousness with which it was
attended.)*

*It should be noted that Crane rarely describes the upturned face of a girl or
woman (as opposed, say, to his contemporary Harold Frederic's use of the motif in
The Damnation of Theron Ware [1896]). The major instance of this in Crane's work
occurs in chapter seventeen of *Maggie,* the last three paragraphs of which read:

> She went into the blackness of the final block. The shutters of the tall buildings were
> closed like grim lips. The structures seemed to have eyes that looked over her, beyond her,
> at other things. Afar off the lights of the avenues glittered as if from an impossible dis-
> tance. Street car bells jingled with a sound of merriment.
> When almost to the river the girl saw a great figure. On going forward she perceived it
> to be a huge fat man in torn and greasy garments. His grey hair straggled down over his
> forehead. His small, bleared eyes, sparkling from amidst great rolls of red fat, swept
> eagerly over the girl's upturned face. He laughed, his brown, disordered teeth gleaming
> under a grey, grizzled moustache from which beer-drops dripped. His whole body gently
> quivered and shook like that of a dead jelly fish. Chuckling and leering, he followed the
> girl of the crimson legions.
> At their feet the river appeared a deathly black hue. Some hidden factory sent up a
> yellow glare, that lit for a moment the waters lapping oilily against timbers. The varied
> sounds of life, made joyous by distance and seeming unapproachableness, came faintly and
> died away to a silence. (p. 72)

In this famous passage the unseeingness that typically stamps Crane's upturned faces
is attributed to the tall buildings that seem to look over and beyond the girl; the
disfiguration that such faces typically suffer in his fictions is displaced onto the

Once again it seems unnecessary to comment on each of the images in these passages that invites being read as a figure for one or another aspect of the scene of writing, but three points in particular deserve special notice. First, the statement that the young men of the town

repulsive person of the huge fat man who in effect becomes Maggie's fate; and the discoloration that typically precedes the final disfiguration is suggested by the deathly black hue of the oily river followed by the momentary yellow glare from the hidden factory. (Earlier in that chapter the girl herself was characterized as "of the painted cohorts of the city" [p. 70], and of course she is also said to belong to the "crimson legions.")

A further index of the obsessional impulse of Crane's prose is the recurrence of the figure of a fat man in subsequent writings. In chapter twelve of *The Red Badge,* for example, the man with the cheery voice (whose face Fleming never sees) describes the death of Jack, a soldier in his company, partly as follows:

> "Yeh know there was a boy killed in my comp'ny t'-day that I thought th' world an' all of. Jack was a nice feller. By ginger, it hurt like thunder t' see ol' Jack jest git knocked flat. We was a-standin' purty peaceable fer a spell, 'though there was men runnin' ev'ry way all 'round us, an' while we was a-standin' like that, 'long comes a big fat feller. He began t' peck at Jack's elbow, an' he ses: 'Say, where's th' road t' th' river?' An' Jack, he never paid no attention, an' th' feller kept on a-peckin' at his elbow an' sayin': 'Say, where's th' road t' th' river?' Jack was a-lookin' ahead all th' time tryin' t' see th' Johnnies comin' through th' woods, an' he never paid no attention t' this big fat feller fer a long time, but at last he turned 'round an' he ses: 'Ah, go t' hell an' find th' road t' th' river!' An' jest then a shot slapped him bang on th' side th' head." (pp. 152–53)

And in "Death and the Child," Peza, already sickened at having armed himself with bandoleer and rifle taken from dead men, suddenly notices a nearby soldier:

> One bearded man sat munching a great bit of hard bread. Fat, greasy, squat, he was like an idol made of tallow. Peza felt dimly that there was a distinction between this man and a young student who could write sonnets and play the piano quite well. This old blockhead was coolly gnawing at the bread, while he, Peza, was being throttled by a dead man's arms. (p. 961)

After Peza bolts for the rear, the Greek forces prepare to fire again at the enemy. The section ends with the sentence: "The soldier with the bread placed it carefully on a bit of paper beside him as he turned to kneel in the trench" (p. 962). The passage from *The Red Badge* not only dramatizes obsessiveness as such but also rehearses *Maggie*'s connection of fat man and river, while the quotations from "Death and the Child" associate the fat man munching his bit of bread and then placing it on a bit of paper with Peza himself, or at any rate expressly call into question the distinction between the two. (The "great figure" of the fat man in chapter seventeen of *Maggie* is related to other personages in the novel by Hershel Parker and Brian Higgins, "Maggie's 'Last Night': Authorial Design and Editorial Patching," *Studies in the Novel* 10 [Spring 1978]: 74–75, n. 9.)

were gathered in groups "which expressed various shades and lines of chumship, and had little to do with any social gradations" can be read simultaneously as a thematization of literary writing (or say of writing/drawing) *and* as an implicit caution against interpreting *The Monster* primarily in terms of its "manifestly" social subject, Dr. Trescott's attempt to continue to care for the ruined Johnson despite the growing disapproval of his community.[46] In the latter connection it is positively uncanny that the young men are said in the next sentence to have "discussed everything with critical insight," just as in the former it may be relevant that the odd word "chumship" conspicuously involves the letters "s" and "c." (So for that matter does the phrase "critical insight"; an explicit discussion of the status and function of Crane's initials in this and other texts is on its way.)

Second, the sentence "At *numerous* points [the blue of the arc-lamps] was conquered by the orange glare of the *outnumbering* gas-lights in the windows of shops" (italics mine) may be taken to alert us to the surprisingly large role played in *The Monster* by numbers of one sort or another. The novella begins, as we have seen, with Jimmie playing at being "engine Number 36" and at running "fourteen minutes behind time" (this second item is a little strange, when one pauses to consider); it ends with Trescott trying to comfort his wife (we shall look at this scene shortly) and mechanically counting the cups that she had prepared for friends who had stayed away ("There were fifteen of them" is the final sentence); and in between we encounter what seems a more or less endless and random sequence of numbers associated with fire districts, fire companies, distances, quantities (e.g., "three cots, borne by twelve of the firemen" [p. 410]; "six of the ten doctors in Whilomville" [p. 411]; "So the nine little girls and the ten little boys sat quite primly in the dining-room" [p. 427]), hours of the clock (including the information that Bainbridge, the railway engineer whose face is being lathered when Reifsnyder reflects on what it would be like to be without a face, is "[going] out at 7:31" [p. 423]), money, figures of speech ("If [Jimmie and the large boy] had been decorated for courage on twelve battle-fields, they could not have made the other boys more ashamed of the situation" [p. 437]), and in one case even a *name* (that of "John Twelve, the wholesale grocer, who was worth $400,000, and reported to be worth over a million" [p. 445]). Other texts by Crane evince a similar though more spasmodic preoc-

cupation with numbers and counting, as for example (and this is mere-
ly one of many possible examples) in a trio of passages that succeed one
another within little more than a page in *The Red Badge*. Early on it is
said that Fleming in the darkness of his tent "saw visions of a thou-
sand-tongued fear that would babble at his back and cause him to flee,
while others were going coolly about their country's business" (p. 98);
in the next paragraph he hears "low, serene sentences. 'I'll bid five.'
'Make it six.' 'Seven.' 'Seven goes' " (p. 98); and several paragraphs
later—the regiment is now on the march—we read that "[t]he men
had begun to count the miles upon their fingers, and they grew tired"
(p. 99). And if we now juxtapose to all of the above the opening
sentence of a story that has emerged as allegorizing Crane's literary
practice, "Death and the Child"—"The peasants who were streaming
down the mountain trail had in their sharp terror evidently lost their
ability to count" (p. 943; hence the abandonment of the child on the
mountaintop above the battle)—we can scarcely avoid the inference
that motifs of numbers and counting indirectly express the importance
for Crane *of counting words*, both as a journalist and foreign correspon-
dent and as an author of fictions who was paid according to the length,
in words, of his productions. There is copious testimony in Crane's
correspondence and inventories of his work to his concern with word
counts and fees, but what I find still more intriguing because of their
relation to the scene of writing are the pages in his manuscripts on
which he added up the number of words that he had written to that
point (Figs. 50, 51).[47]

The third item in the long description of Whilomville I want to
emphasize is the observation that the little theatre "was a varnish and
red-plush *miniature* of one of the famous New York theatres" (italics
mine). We have met figures of miniaturization before, most notably
the images of the little numbered diagrams on the bandages in "Death
and the Child" and of writing on a *wee* blade of grass at the close of that
story (and perhaps also the little case of cards and papers in "The
Upturned Face" and the ants moving across the dead man's face in the
"chapel" scene in *The Red Badge*), but two further instances from texts
that have not yet come within our purview are particularly telling.
The first text is an article, "In the Depths of a Coal Mine," published
along with illustrations by Crane's friend Corwin K. Linson in *Mc-
Clure's Magazine* in August 1894; toward the end Crane and Linson,

Presently he seemed invaded by a creeping ague that gradually enveloped him. For a moment, the chills of his legs made him dance a sort of a hideous horn-pipe. His arms beat wildly about his head. His tall figure grew suddenly to unnatural proportions then it began to sway slowly forward like a falling tree. At last a final contortion caused the left shoulder to first strike the ground. The body seemed to bounce a little way from the earth. "Gawd," said the tattered soldier.

Fleming had watched, spell-bound, these rites of a departing life this dance of death. His face had been twisted into every form of agony that he had imagined for his friend.

He now sprang to his feet and gazed at the paste-like face. The mouth was open and the teeth showed in a laugh.

As the flap of the jacket fell away from the body, he could see that the side looked as if it had been chewed by wolves.

Fleming turned toward the battle ground. His hands were clenched. And a rage was upon his face. He seemed about to deliver a phillipic.

"Hell."

The red sun was pasted in the sky like a fierce wafer.

$$
\begin{array}{r}
18940 \\
1670 \\
\hline
20610
\end{array}
$$

$$
\begin{array}{r}
1374 \\
246 \\
\hline
1620 \\
52 \\
\hline
1670
\end{array}
$$

$$
\begin{array}{r}
267 \\
282 \\
288 \\
274 \\
\hline
1111 \\
263 \\
\hline
1374
\end{array}
$$

2

$$
\begin{array}{r}
17 \\
32 \\
\hline
49 \\
62 \\
\hline
111
\end{array}
$$

38
24
62

50. STEPHEN CRANE, page from original manuscript of *The Red Badge of Courage* with word count. Stephen Crane Collection (acc. no. 5505), Barrett Library, Manuscripts Department, University of Virginia Library.

some great scheme of life. They were under the
impression that they were fighting for principles and
honor and homes and various things.

Well, to be sure; they were.

Nature was miraculously skilful in exporting
excuses, he thought, with a heavy, theatrical contempt.
~~It could trick a ~~ when he saw how she ~~had~~
~~had~~, as a woman beckons, had cozened
him out of his home and hoodwinked him into
wielding a rifle, he went into a rage.

He turned in ~~superny~~ fury upon the
high, tranquil sky. He would have liked to
have splashed it with a derisive paint.

And he was bitter that among all men,
he should be the only one sufficiently wise to
understand these things.

17747
22410

51. STEPHEN CRANE, page from original manuscript of *The Red Badge of Courage*
with word count. Stephen Crane Collection (acc. no. 5505), Barrett Library,
Manuscripts Department, University of Virginia Library.

having spent considerable time below ground, approach an open elevator to return to the surface:

> In the chamber at the foot of the shaft, as we were departing, a group of the men were resting. They lay about in careless poses. When we climbed aboard the elevator, we had a moment in which to turn and regard them. Then suddenly the study in black faces and crimson and orange lights vanished. We were on our swift way to the surface. Far above us in the engine-room, the engineer sat with his hand on a lever and his eye on the little model of the shaft wherein a miniature elevator was making the ascent even as our elevator was making it. In fact, the same mighty engines give power to both, and their positions are relatively the same always. I had forgotten about the new world that I was to behold in a moment. My mind was occupied with a mental picture of this faraway engineer, who sat in his high chair by his levers, a statue of responsibility and fidelity, cool-brained, clear-eyed, steady of hand. His arms guided the flight of this platform in its mad and unseen ascent. It was always out of his sight, and yet the huge thing obeyed him as a horse its master. When one gets upon the elevator down one of those tremendous holes, one thinks naturally of the engineer. (p. 614)

The second text is one of Crane's early newspaper reports from Asbury Park, "The Joys of Seaside Life":

> The camera obscura is in Ocean Grove. It really has some value as a scientific curiosity. People enter a small wooden building and stand in a darkened room, gazing at the surface of a small round table, on which appear reflections made through a lens in the top of the tower of all that is happening in the vicinity at the time. One gets a miniature of everything that occurs in the streets, on the boardwalk or on the hotel-porches. One can watch the bathers gambolling in the surf or peer at the deck of a passing ship. A man stands with his hand on a lever and changes the scene at will.[48]

Both the engineer and the operator of the camera obscura are instantly recognizable as surrogates for the writer, but in all the passages under consideration, including ones that lack such a surrogate (e.g., the paragraph from *The Monster*), a scale shift complementary to the aggrandizement in "An Experiment in Misery" of the sleeper's fingers, and by implication of the writer's hand, marks images of miniaturiza-

tion as emblems of representation. In fact I would go further and claim that two opposing tendencies, one toward miniaturization and the other toward a certain monstrosity, coinhabit Crane's prose (examples of the latter include the crablike elevated train station and mighty, fingerlike shadows in "An Experiment in Misery," the "huge fat man" and related figures in *Maggie,* and the "fat, greasy, squat" soldier munching a large piece of bread at the first climax of "Death and the Child"). I think of the second tendency as expressing (and repressing) a subliminal awareness of the nearness of the writer's hand, and more broadly of the role of that hand—of the writer as corporeal being—in the production of writing, though alternatively it could be argued that the opposition between miniaturization and monstrosity lines up with the contrast between the relatively minute scale of writing and the unlimited magnitude of writing's representational effects. Perhaps it would be best to say simply that the opposition at once expresses and disguises an unelidable disjunction between the scene of writing and the "space" of representation.[49]

The last passage from *The Monster* I want to examine is the concluding section (pp. 447–48). As already mentioned, the plot of the novella turns on Trescott's determination personally to look after the facially disfigured and no longer mentally competent Johnson despite the mounting disapproval of his fellow townsmen. The section opens with the doctor returning to his home at the end of a winter day; in the sitting room Jimmie sits "reading painfully in a large book"; in the drawing room "bathed in the half-light that came from the four dull panes of mica in the front of the great stove," Trescott finds his wife crying and sits down close to her; presently he casts his eye "over the zone of light shed by the dull red panes [and sees] that a low table had been drawn close to the stove, and that it was burdened with many small cups and plates of uncut tea-cake"; and he realizes that, because of his continued refusal to send Johnson away, his wife has been ostracized by her friends. The last paragraphs read:

> "Who was here to-day, Gracie?" he asked.
> From his shoulder there came a mumble, "Mrs. Twelve."
> "Was she—um," he said. "Why—didn't Anna Hagenthorpe come over?"
> The mumble from his shoulder continued, "She wasn't well enough."

Glancing down at the cups, Trescott mechanically counted them. There were fifteen of them. "There, there," he said. "Don't cry, Grace. Don't cry."

The wind was whining around the house and the snow beat aslant upon the windows. Sometimes the coal in the stove settled with a crumbling sound and the four panes of mica flushed a sudden new crimson. As he sat holding her head on his shoulder, Trescott found himself occasionally trying to count the cups. There were fifteen of them.

I understand this scene as one of reading painfully what has already been written, with the stove representing a domesticated (in effect miniaturized) version of the catastrophic fire and the drawing room's low table burdened with cups and plates figuring a sheet of writing paper bearing a text that Trescott finds all too legible (cf. the image of the plain of battle as a tea table in the first of the quotations from "Death and the Child").[50] Trescott thus emerges as a surrogate for the reader as well as for the writer (it was in his laboratory, at the foot of his desk, that Johnson's face was devastated), and indeed there is an analogy between his inability to do more than "mechanically" count the cups and what I have suggested is the impossibility of extracting from *The Monster* a coherent totalizing interpretation of its "manifest" narrative. At the same time, the intimation—it seems more than just a bare possibility—that Johnson will now have to be abandoned can be taken as a figure for the writer/reader's long-delayed removal from a representational "space" one hallmark of which all along has been its inimicalness to vision.

I referred a while ago to the apparent single-mindedness with which the opening section of *The Monster* deploys images of decapitation, shaving, and effacement that are later recalled and outdone by the scene in the burning laboratory. Something of the same quality, say of an almost mechanically repetitive thematizing of writing, as opposed to an agitated irrupting and disappearing of motifs and effects as in *The Red Badge*, marks the other passages from *The Monster* we have examined, and of course the sheer density of allusions to numbers throughout the novella is in keeping with this as well. The fire itself, for all its infernal imagery of burning flowers, can be seen as the expression of a common property of writing paper—its flammability.*

*Flammability is actually cited as one of the properties of writing paper in a masterly passage in William James's *Principles:*

And yet it isn't the case, at least to my mind it isn't, that *The Monster* is accessible to being construed rigorously as an allegory of Crane's enterprise in the manner of "Death and the Child": between the "manifest" narrative and what I have tried to show are certain "latent" preoccupations there holds a kind of extended truce that confers an almost equal salience on both and at the same time preserves the integrity or at least the mutual noncommunication of the one and the other (approaching *The Monster* in terms of a thematics of writing precisely

All ways of conceiving a concrete fact, if they are true ways at all, are equally true ways. *There is no property* ABSOLUTELY *essential to any one thing.* The same property which figures as the essence of a thing on one occasion becomes a very inessential feature upon another. Now that I am writing, it is essential that I conceive my paper as a surface for inscription. If I failed to do that, I should have to stop my work. But if I wished to light a fire, and no other materials were by, the essential way of conceiving the paper would be as combustible material; and I need then have no thought of any of its other destinations. It is really *all* that it is: a combustible, a writing surface, a thin thing, a hydrocarbonaceous thing, a thing eight inches one way and ten another, a thing just one furlong east of a certain stone in my neighbor's field, an American thing, etc., etc., *ad infinitum.* Whichever one of these aspects of its being I temporarily class it under, makes me unjust to the other aspects. But as I always am classing it under one aspect or another, I am always unjust, always partial, always exclusive. My excuse is necessity—the necessity which my finite and practical nature lays upon me. My thinking is first and last and always for the sake of my doing, and I can only do one thing at a time. (pp. 959–60; italics and emphases James's)

It's impressive, I think, how many of the possible attributes of James's piece of paper figure prominently in Crane's metaphorics of writing (I would argue they all do), though once again it should be emphasized that Crane himself can only have been oblivious to this potential for meaning in his work. Even the geographical attribute seems pertinent to "The Open Boat," a story (based on Crane's actual experience) of the aftermath of a shipwreck, in the course of which four men in a lifeboat repeatedly speculate about where they are (e.g., " 'We must be about opposite New Smyrna,' said the cook, who had coasted this shore often in schooners." [p. 891]). In that story too a distant stretch of land is described as "thinner than paper" (p. 891); a fictive personage in a poem from the protagonist's childhood is said to have then been "less to him than the breaking of a pencil's point" (p. 903); and the knifing of a shark's fin alongside and around the lifeboat through much of a long night is narrated in terms that lead me to see in it still another highly cathected version of a scene of writing ("There was a long, loud swishing astern of the boat, and a gleaming trail of phosphorescence, like blue flame, was furrowed on the black waters. It might have been made by a monstrous knife. . . . [T]he thing did not then leave the vicinity of the boat. Ahead or astern, on one side or the other, at intervals long or short, fled the long sparkling streak, and there was to be heard the whiroo of the dark fin. The speed and power of the thing was greatly to be admired. It cut the water like a gigantic and keen projectile." [pp. 900–901]).

doesn't yield an understanding of the novella as a whole). To sum this up in a single example, from the perspective of the "manifest" narrative there could be no more utter contrast than that between the upturned face of the girl in the park glowing in the light from the blue arc lamps and Johnson's upturned face being devoured by burning chemicals a short while later. But from the perspective of a thematics of writing, the two are interchangeable.

The situation has altered in the latest in time of the works we have discussed and very nearly the last tale Crane ever wrote, "The Upturned Face." On the one hand, there is the absence from that tale of the sort of explicit or semi-explicit allusions to the scene of writing that can be found in most or all of the other works we have considered. (We were able to interpret "The Upturned Face" as representing its composition only by placing it in the context of passages from *The Red Badge* and *The Monster*.) On the other hand, and it is this that I want to stress, the events of the tale provide an almost point-by-point gloss on what I have been arguing was the excruciated character of Crane's "impressionism"—as if at this extreme moment in his life and art the marriage of "manifest" and "latent" contents becomes not only nearly complete but virtually seamless. Thus the opening sentences (" 'What will we do now?' said the adjutant, troubled and excited. 'Bury him,' said Timothy Lean. The two officers looked down close to their toes where lay the body of their comrade. The face was chalk-blue; gleaming eyes stared at the sky."), while preternaturally vivid, not only narrow the zone of visualization to an area the size and character of a sheet of writing paper but also define that area as requiring to be covered over—obscured from view—before the promise implicit in those sentences can be made good. Indeed it is particularly fitting that the work of writing is here thematized as a labor of burial, the excavating and then the filling up of a grave, actions I read, first, as a forcible *re*opening of the "space" of representation that the dead man's face may be taken as canceling at the outset of the tale, and second, as an assertion of control over both the writer's and the reader's inevitable expulsion from that "space" (cf. the last scene of *The Monster*), an expulsion that by a superlative feat of narrative pacing is made to coincide with the tale's ending. (The graphic form of the climactic word "plop"—that it begins and ends with the same letter—encapsulates the structure of the tale as a whole.) From start to finish the steady fire of the enemy sharpshooters emphasizes the point that the

writer's and/or reader's position relative to the horizontal page is anything but comfortable. Similarly, that the mangled ritual Lean and the adjutant improvise over the body of their fallen comrade is taken from the service for the dead at sea and contains references to "deep waters" and "superb heights" (p. 1285) suggests that a problematic of depth and elevation is powerfully if largely implicitly in play throughout the tale. Finally, Lean's anguished reluctance to deposit the last shovelful of dirt on the chalk-blue visage of the corpse captures perfectly the necessary ambivalence of a task of writing the successful accomplishment of which is all but indistinguishable from an acknowledgment of defeat.[51]

IV

In view of the emphasis I have placed on what I have been calling the scene of writing in Crane's prose, it seems altogether appropriate that the "exquisite legibility" of his handwriting was often remarked by his contemporaries,[52] and that eyewitnesses were also greatly struck by the manner in which Crane actually produced his texts. Conrad for example later recalled how at Brede Place, after two hours of steady work, "[Crane] would have covered three of his large sheets with his regular, legible, perfectly controlled, handwriting, with no more than half a dozen erasures—mostly single words—in the whole lot. It seemed to me always a perfect miracle in the way of mastery over material and expression."[53] A few years earlier in New York, Hamlin Garland had been astonished to see Crane "drawing off" his poems "without blot or erasure. Every letter stood out like the writing on a bank bill. . . . He wrote steadily in beautifully clear script with perfect alignment and spacing, precisely as if he were copying something already written and before his eyes."[54] A still more compelling account of Crane at work is by David Ericson, an artist friend of 1893–94:

> I can remember so well how when he came down from the country he would come in and put his little hand bag down in the middle of the Studio floor, sit down on a little sketching stool, pull out his pad, pen, and a bottle of ink, and begin to write with only a few words of greetings. I do not remember that he ever erased or changed anything. His writing

was clean and round with a ring around his periods. He wrote slowly. It amazed me how he could keep the story in mind while he was slowly forming the letters. This I thought the most extra-ordinary thing I had ever seen. . . . I felt an awe for him when I saw how naturally his imagination worked through his hand as though he really lived in another world.[55]

All three accounts imply more than simple depth of concentration. Conrad speaks of a miraculous mastery over material and expression, perhaps a more interesting pairing than Conrad knew; Garland of his impression that Crane was copying something before his eyes, as—in a sense—according to my notions he would have been; and Ericson makes explicit an aspect of Crane's activity as a writer that remains implicit in Conrad and Garland, namely the extraordinary slowness with which he formed his letters, and calls attention to what he, Ericson, takes to be a kind of incommensurability or contradiction between that slowness and the "story." A fourth eyewitness, Ford Madox Ford, who like Conrad knew Crane in England, refers to "his pen that moved so slowly in microscopic black trails over the immense sheets of paper that he affected,"[56] an almost Crane-like image that corroborates Ericson and shows that the writer's habits had not been modified by his success.

I don't claim that there is an obvious or unambiguous significance to the slowness with which Crane formed his letters (the phrasing here is important; to speak of him merely as writing slowly doesn't convey the same idea of slowed physical movement). But as James emphasizes more than once in the *Principles* (a work that first appeared in 1890), ordinary reading in a language in which we are at home takes place at a speed that could not be achieved "if [the reader] had to see accurately every single letter of every word in order to perceive the words."[57] James's point is that individual words are grasped dynamically as meaningful wholes on the basis of a fleeting glance, and moreover that our understanding and indeed preunderstanding of their meaning is largely a function of our sense of the characteristic structures and cadences of English (or American) sentences.[58] If we now imagine applying these considerations to the act of writing, it seems reasonable to suppose that a manner of writing that shaped individual letters with extreme slowness would maximize the likelihood of diverting the writer's attention away from the larger flow of meaning in his prose to the

letters themselves, or say to the letters as variously configured, conspicuously legible (almost an oxymoron), and undeniably material marks on a sheet of paper, inscribed there by the metal point of a pen dipped repeatedly—every several words—in a container of ink.[59] At any rate, the fascination of Ericson's little account lies precisely in its intuition of some such tendency and of the potential conflict this implied for Crane's activity as a maker of fictions. It is as though Ericson realized that below a certain speed of inscription the enterprise in question would threaten to become *merely* the making of marks, which of course would mean that it ceased to be the enterprise of writing. Presumably Crane worked just too quickly for that to happen. I suggest, however, that the deliberateness with which Ericson tells us Crane actually wrote was functionally related to what I earlier characterized as Crane's fixation on the scene of writing, though once again I would stress that he can only have been oblivious to that fixation as well as to his compulsive thematizing and foregrounding of writing by means of the various figures and devices we have examined.

It is above all in this context—of imagining Crane's unconscious responsiveness to the production and physiognomy of his own handwriting—that I want to situate a phenomenon I have been flagging in one way or another throughout much of this essay: his predilection for pairs of words beginning with the letters "s" and "c," either in that order or the reverse. (There are other, unflagged, often quite spectacular instances of this in some of the passages quoted early on from "The Upturned Face," "An Experiment in Misery," "When Man Falls," and "Death and the Child.") The letters themselves are of course Crane's initials—he often signed his correspondence "S.C."—which suggests that there are narcissistic reasons for their foregrounding in his prose,* though perhaps the narcissism itself partly reflects

*According to R. G. Vosburgh, who along with Ericson and Frederic Gordon shared a New York studio with Crane, "[Crane] often declared he would be famous, and sometimes in the intervals when he was not working he would sit writing his name—Stephen Crane—Stephen Crane—Stephen Crane—on the books, magazines, and loose sheets of paper about the studio" (quoted by Berryman, *Stephen Crane*, p. 73; Berryman adds in a note: "So, no doubt, almost every artist."). More intriguing is the fact that Crane's Revolutionary War-era ancestor, also named Stephen Crane, was a member of the Continental Congress until shortly before the Declaration of Independence was signed—indeed Crane's father, though not Crane himself, believed that the earlier Stephen Crane had been one of the signers (Stall-

the perception that a sheet covered with his handwriting is in a sense *all him.* (In other senses, however, it is not all him at all: as a material entity it confronts him as something alien to himself, as a cultural artifact it expresses a commonality of which he is a part but that he doesn't subsume or possess. And these senses too are repeatedly thematized in his prose.) In any event, we might also reasonably expect that specific defenses would have been required to enable Crane not to recognize the frequency with which his initials recur as a quasiunit in his writings—with which he inscribed them on the page—and this is exactly what we find to be the case.

Basically, the defenses take three forms. First, there is the device of reabsorbing those letters, after they have been allowed to surface as the first letters of individual words or pairs of words, back into the *interior* of one or more words, often with the "c" made sibilant instead of hard, as for example in the concluding sentence of "When Man Falls": "And this impenetrable fabric suddenly intervening between a suffering creature and their curiosity, seemed to appear to them as an injustice" (now that the topic is fully exposed we can forgo italics). Or at greater length, as in two representative paragraphs from chapter three of *The Red Badge:*

> The skirmish fire increased to a long clattering sound. With it was mingled far-away cheering. A battery spoke.
>
> Directly the youth could see the skirmishers running. They were pursued by the sound of musketry fire. After a time the hot, dangerous flashes of the rifles were visible. Smoke clouds went slowly and insolently

man, *Stephen Crane,* p. 1; see also Crane's letter to John Northern Hilliard [*Letters,* p. 94]). This suggests that between the most famous signature effect in American history and an altogether different class of such effects—hitherto invisible—in the later Stephen Crane's novels, stories, tales, and sketches a significant if fantasmatic relation may obtain. No doubt the suggestion appears merely fanciful; but consider the following from *The Monster:*

> As Henry reached the front door, Hannigan [the man who first saw that the Trescott house was on fire] had just broken the lock with a kick. A thick cloud of smoke poured over them, and Henry, ducking his head, rushed into it. From Hanningan's clamor he knew only one thing, but it turned him blue with horror. In the hall a lick of flame had found the cord that supported "Signing the Declaration." The engraving slumped suddenly down at one end, and then dropped to the floor, where it burst with the sound of a bomb. The fire was already roaring like a winter wind among the pines. (p. 403)

across the fields like observant phantoms. The din became crescendo, like the roar of an oncoming train. (p. 106)

The latter passage raises the further possibility that in certain cases the letter "k" functions as a surrogate (hard) "c" on aural grounds, which would partly account for Crane's strongly marked use of the words "skirmishers" and, especially, "smoke" throughout *The Red Badge*.[60] (I need hardly add that the animistic smoke clouds can be read as still another figure for the writer, nor that we have learned to see in vehicles that run on tracks or leave traces behind—the oncoming train—one of Crane's obsessional images of writing.)

A second device, closely related to the first, is simply the incorporation of the letters "s" and "c" in single words, a number of which—corpse (naturally), curses, crimson, stick, scorn, crash, shock, scene, colors, processes, silence, chorus, and curiosity, to cite a baker's dozen from *The Red Badge*—are instantly recognizable as among the staples of Crane's idiosyncratic verbal armory. And there may be something of the same import to the names of various personages in his fiction, such as the Trescott family in *The Monster* and the *Whilomville Tales;* the innkeeper Scully in "The Blue Hotel" (whose dead daughter was named Carrie); Scratchy Wilson in "The Bride Comes to Yellow Sky"; the 'Frisco Kid in "The Five White Mice"; Fred Collins in "A Mystery of Heroism"; Corinson (adapted from Corwin Linson) in "Stories Told by an Artist"; Shackles (from Acton Davies) in "God Rest Ye, Merry Gentlemen"; Caspar Cadogan in "The Second Generation" (son of Senator Cadogan, the Skowmulligan war-horse); Rufus Coleman in *Active Service* (the newspaper he works for is the *Eclipse* and its editor is named Sturgeon); and the butcher Stickney in "His New Mittens."[61]

The third form of defense, to my mind the most interesting of all, involves the use of snake imagery as a figure not only for the capital letters "S" and "C," but also for Crane's handwriting generally, by which I chiefly mean the actual forming of the letters (those letters and others) on the lined sheets of paper that he employed for his drafts. Thus to return to the conflagration in Trescott's laboratory, it will be recalled that although most of the jars on top of the desk "were silent amid this rioting, . . . there was one which seemed to hold a scintillant and writhing serpent," and of course it was that "ruby-red snakelike thing" that swam languorously down the mahogany slant of the desk, waved its head to and fro over its unconscious prey, and at

last "flowed directly down into Johnson's upturned face." (The evocation of slowness in this process seems suddenly to the point.) Similarly, in the arming scene in "Death and the Child" it is first said that Peza felt, "besides the clutch of a corpse about his neck [an allusion to the dead man's bandoleer], that the rifle was as unhumanly horrible as a snake that lives in a tomb"; and a few sentences later we read: "The rifle was clammy; upon his palms he felt the movement of the sluggish currents of a serpent's life; it was crawling and frightful." I take it to be more than coincidental that the latter quotation foregrounds the letters "s" and "c," but what is equally important is that images of a snake and a serpent are introduced just as Peza is about to encounter the face of a corpse, and that they are specifically associated with the rifle, a sticklike instrument that I have already proposed may be read as a figure for the writer's pen or pencil. The same association occurs in a brilliant short passage from chapter seventeen of *The Red Badge*:

> When, in a dream [the scene is one of actual combat], it occurred to the youth that his rifle was an impotent stick, he lost sense of everything but his hate, his desire to smash into pulp the glittering smile of victory which he could feel upon the faces of his enemies.
>
> The blue smoke-swallowed line curled and writhed like a snake stepped upon. It swung its ends to and fro in an agony of fear and rage. (p. 173)

Here the rifle is actually characterized as a stick (we shall pick up "impotent" in a moment), and is further associated with "pulp" (no doubt Crane wasn't *thinking* of making paper), with yet one more "line," with a pair of highly suggestive verbs, and finally with the image of a snake in agony that by the end of the second paragraph becomes detached from the reality it is meant to evoke (we can't possibly imagine an actual line of fighting men "[swinging] its ends to and fro in an agony of fear and rage").[62]

Another keenly invested passage occurs in one of Crane's so-called potboilers, the novel *Active Service*. An American journalist, Rufus Coleman, accompanied by a dragoman and two porters, is traveling through the Greek countryside on his way to a war. Coleman and his party soon find themselves among a crowd of Greek soldiers "who were idly watching some hospital people bury a dead Turk." The passage continues:

The dragoman at once dashed forward to peer through the throng and see the face of the corpse. Then he came and supplicated Coleman as if he were hawking him to look at a relic and Coleman, moved by a strong mysterious impulse, went forward to look at the poor little clay-colored body. At that moment a snake ran out from a tuft of grass at his feet and wriggled wildly over the sod. The dragoman shrieked, of course, but one of the soldiers put his heel upon the the head of the reptile and it flung itself into the agonized knot of death. Then the whole crowd pow-wowed, turning from the dead man to the dead snake. Coleman signalled his contingent and proceeded along the road.[63]

There is no rifle or stick in sight (though in the previous paragraph the straight white road was said to pierce the open country "like a lance shaft"),[64] and the passage as a whole falls short by far of the vibrancy of Crane's best writing (the paragraphs just quoted from *The Red Badge* put it in the shade), but from the perspective of a thematics of writing both the irruption of the snake in the vicinity of the corpse and then the killing of the snake could hardly be more significant. (Fascinatingly, the next paragraph begins: "This incident, *this paragraph,* had seemed a strange introduction to war. The snake, the dead man, *the entire sketch,* made him shudder of itself but, more than anything he felt an uncanny symbolism" [italics mine].[65] It is as though the peculiar flatness of Crane's prose in *Active Service* is correlated with a new kind of explicitness in the thematization of writing, or say with a relaxation of the defenses that, in Crane's more characteristic texts, hold such thematizations at a metaphorical remove. And yet I am certain that this relaxation did not involve some new access of authorial awareness. In the passage we have just looked at, the phrases "this paragraph" and "the entire sketch" seem to have been for him merely ways of designating the "manifest" incident in question.)[66]

But by far the most extensive and elaborate treatment of the figure of a snake in all of Crane is the sketch entitled—no surprises here— "The Snake."[67] "Where the path wended across the ridge," it begins, "the bushes of huckleberry and sweet fern swarmed at it in two curling waves until it was a mere winding line traced through the tangle." It goes on to recount how a man and a dog, out for a walk, are abruptly horrified by the sound of a rattlesnake. The man grips a large stick and moves forward carefully, holding the weapon before him. "But when the man came upon the snake," the sketch continues, "his body un-

derwent a shock as from a revelation, as if after all he had been am-
bushed. With a blanched face, he sprang backward and his breath
came in strained gasps, his chest heaving as if he were in the perfor-
mance of an extraordinary muscular trial. His arm with the stick made
a spasmodic defensive gesture." After a brief, astonishingly sym-
pathetic evocation of the snake's point of view, the confrontation
(though not yet the struggle) between the man and the snake is de-
scribed as follows:

> The man and the snake confronted each other. In the man's eyes was
> hatred and fear. In the snake's eyes was hatred and fear. These enemies
> maneuvered, each preparing to kill. It was to be battle without mercy.
> Neither knew of mercy for such a situation. In the man was all the wild
> strength of the terror of his ancestors, of his race, of his kind. A deadly
> repulsion had been handed from man to man through long dim centuries.
> This was another detail of a war that had begun evidently when first there
> were men and snakes. Individuals who do not participate in this strife
> incur the investigations of scientists. Once there was a man and a snake
> who were friends, and at the end, the man lay dead with the marks of the
> snake's caress just over his East Indian heart. In the formation of devices
> hideous and horrible, nature reached her supreme point in the making of
> the snake, so that priests who really paint hell well, fill it with snakes
> instead of fire. These curving forms, these scintillant colorings create at
> once, upon sight, more relentless animosities than do shake barbaric
> tribes. To be born a snake is to be thrust into a place a-swarm with
> formidable foes. To gain an appreciation of it, view hell as pictured by
> priests who are really skilful.
> As for this snake in the pathway, there was a double curve some inches
> back of its head which merely by the potency of its lines made the man
> feel with tenfold eloquence the touch of the death-fingers at the nape of
> his neck. The reptile's head was waving slowly from side to side and its
> hot eyes flashed like little murder-lights. Always in the air was the dry
> shrill whistling of the rattles.
> "Beware!" "Beware!" "Beware!"

The battle that follows is fierce but unequal; the man, gripping his
weapon with two hands and wielding it like a flail, beats the snake to
death, and afterwards hoists it upon the end of the stick and carries it
away.[68]

That the stick may be read as a writing implement is by now ob-
vious. Equally obvious is the play of "s" and "c," both in striking

phrases such as "snake's caress" and "scintillant colorings," and in individual words such as "shock," "muscular," "spasmodic," "scientist," and the like. I might add that the phrase "scintillant colorings" anticipates *The Monster*'s "scintillant and writhing serpent," just as the hell imagery in the first of the paragraphs quoted above adumbrates a connection between snakes and fire that will be exploited with shattering force in the scene in the burning laboratory. (The traditional conception of hell as an underworld also resonates with the "mystic chamber under the earth" to which Peza feels himself "drawn and drawn" at the moment of extreme crisis in "Death and the Child.") Less obvious though no less important is the analogy between the blanching of the man's face (cf. Peza being stared at by the corpse and feeling himself blanch) and the whiteness of a sheet of writing paper, an analogy the sketch goes on to reinforce when, in its account of the actual battle between man and snake, the snake's desperate effort to get at its tormentor is likened to "the charge of the lone chief when the walls of white faces close upon him in the mountains." In this connection too it is relevant that the generic snake is described as "nature's supreme point . . . in the formation of devices hideous and horrible," as if the extreme revulsion that the man in the sketch feels toward the snake in his path has more to do with its meaning as representation than with the objective danger it embodies. Finally, I am struck by the sketch's insistence on the reciprocity of what would seem utterly disparate points of view, which is to say by the description of the presence in the eyes of both man and snake of the same emotions, hatred and fear, as well as by the repeated emphasis on the mutualness of their animosity, culminating in the twin allusions to priestly pictures of hell as a means of evoking, first, the awfulness of snakes to man, and second (an amazing touch), the ubiquitousness of human foes to snakes. The idea of reciprocity is given a somewhat different twist in the second paragraph, where the double curve of the snake is said "merely by the potency of its lines" to make the man feel "the touch of the death-fingers at the nape of his neck," which again draws our attention to the snake's representational (specifically its graphic) character and which also comes close to portraying the man as a pen being gripped by the death-fingers and inscribing the potent double curve on the pathway before him. By way of collateral for these remarks, I give as an example the first page of the handwritten manuscript of "The Snake" (Fig. 52): both the title and the typical

Hold for orders *Please get into type at once*

The Snake.
Stephen Crane.

a s.

1,142.

[Copyright, 1894, by Bacheller, Johnson and Bacheller.]

Where the path wended across the ridge, the bushes of
huckleberry and sweet fern swarmed at it in two curling
waves until it was a mere winding line traced through
the tangle. There was no interference by clouds and
as the rays of the sun fell full upon the ridge
they called into voice innumerable insects which
chanted the heat of the summer day in steady
throbbing unending chorus.

 A man and a dog came from the laurel thickets
of the valley where the white brook brawled with
the rocks. They followed the deep line of the path
across the ridge. The dog — a large lemon
and white setter — walked ~~slowly~~ tranquilly
meditative, at his master's heels.

 Suddenly from some unknown and yet near
place in advance there came a dry shrill
whistling rattle that smote motion instantly
from the limbs of the man and the dog. Like
the fingers of a sudden death, this sound seemed
to touch the man at the nape of the neck, at
the top of the spine, and ~~smite them~~ change him,
as swift as thought, to a statue of listening horror,
surprise, rage. The dog, too — the same icy hand
was laid upon him and he stood crouched and
quivering, his jaw drooping, the froth of terror
upon his lips, the light of hatred in his eyes.

 Slowly the man moved his hands toward

specimen of Crane's signature at the top of the sheet deploy a doubly-curved, backward-leaning, unmistakably snakelike capital "S," a letter that is then repeated at the beginning of the third and fourth paragraphs.

Altogether, then, I see the snake in this sketch—I see Crane's snake and serpent imagery generally—in a double light: as a figure for the writer's initials and more broadly for his handwriting, meaning by that both the script that Crane's contemporaries found remarkable for its beauty and clarity and the act of inscription itself; and as a means of disacknowledging all awareness of and responsibility for these things—of denying the objects of his fixated attention—by virtue of the powerfully aversive emotions traditionally felt toward snakes and serpents, emotions that stem in part from our sense of their utter differentness from us (cf. the phrase "unhumanly horrible as a snake that lives in a tomb" in "Death and the Child"). Snakes in Crane's prose thus complement his corpselike beings with upturned faces not only in their special relation to the scene of writing but also in their repression of that relation in and through a "natural" thematics of horror and revulsion. The battle between man and snake in "The Snake" takes this even further. Whereas the man is represented as flailing his stick in an almost insane effort to obliterate the snake, the disturbingly vivid sentences that recount those events are the product of an act of writing in which the "original" of the stick—the writer's pen—plays a generative, not a destructive, role.

"An artist, I think, is nothing but a powerful memory that can move itself at will through certain experiences sideways and every artist must be in some things powerless as a dead snake," Crane remarked late in his career.[69] The word "sideways," so unexpected on the face of it, suggests the lateral movement of a writing hand, even as the analogy between the limitedness of the artist's powers (i.e., his impotence in certain regards) and the powerlessness of a dead snake obscures a very different, and I believe primary, relationship between this particular artist and the figure of a *live* snake. It is as though the crucial limitation on this artist's powers is emblematized by the fact that he can openly acknowledge an affinity with such a creature only when the snake is represented as dead; alive it threatens him too acutely with the recognition—the fantasy—that it is indeed all him.[70]

V

Although there are major texts that haven't been mentioned in this essay (or if mentioned have barely been examined), I have tried to consider a sufficient range of examples to justify the claims I have been making about the internal dynamic of Crane's prose. There remains one story, however, that I want to call up here, in the first place because it relates intimately to both *The Red Badge* and *The Monster,* and in the second because it mobilizes in a few pages nearly the entire range of thematizations and foregroundings of writing that have been brought to light—I mean "The Veteran."[71] (Actually it lacks both an upturned face and a snake, but just because it does it underscores the point that Crane's unconscious preoccupation with the scene of writing need not issue in any single image or figure.) The protagonist of "The Veteran" is Henry Fleming in old age; the story begins with a view out of a window in a grocery where he is answering questions about his experiences in the Civil War; but rather than proceed by a mixture of summary, quotation, and analysis as I have done until now, I want to give the story whole and then add a brief, closing commentary. If this essay has accomplished its purpose, nothing more should be required.

The Veteran

Out of the low window could be seen three hickory trees placed irregularly in a meadow that was resplendent in spring-time green. Further away, the old dismal belfry of the village church loomed over the pines. A horse meditating in the shade of one of the hickories lazily swished his tail. The warm sunshine made an oblong of vivid yellow on the floor of the grocery.

"Could you see the whites of their eyes?" said the man who was seated on a soap-box.

"Nothing of the kind," replied old Henry warmly. "Just a lot of flitting figures, and I let go at where they 'peared to be the thickest. Bang!"

"Mr. Fleming," said the grocer. His deferential voice expressed somehow the old man's exact social weight. "Mr. Fleming, you never was frightened much in them battles, was you?"

The veteran looked down and grinned. Observing his manner the en-

tire group tittered. "Well, I guess I was," he answered finally. "Pretty well scared, sometimes. Why, in my first battle I thought the sky was falling down. I thought the world was coming to an end. You bet I was scared."

Every one laughed. Perhaps it seemed strange and rather wonderful to them that a man should admit the thing, and in the tone of their laughter there was probably more admiration than if old Fleming had declared that he had always been a lion. Moreover, they knew that he had ranked as an orderly sergeant, and so their opinion of his heroism was fixed. None, to be sure, knew how an orderly sergeant ranked, but then it was understood to be somewhere just shy of a major-general's stars. So when old Henry admitted that he had been frightened there was a laugh.

"The trouble was," said the old man, "I thought they were all shooting at me. Yes, sir. I thought every man in the other army was aiming at me in particular and only me. And it seemed so darned unreasonable, you know. I wanted to explain to 'em what an almighty good fellow I was, because I thought then they might quit all trying to hit me. But I couldn't explain, and they kept on being unreasonable—blim!—blam!—bang! So I run!"

Two little triangles of wrinkles appeared at the corners of his eyes. Evidently he appreciated some comedy in this recital. Down near his feet, however, little Jim, his grandson, was visibly horror-stricken. His hands were clasped nervously, and his eyes were wide with astonishment at this terrible scandal, his most magnificent grandfather telling such a thing.

"That was at Chancellorsville. Of course, afterward I got kind of used to it. A man does. Lots of men, though, seem to feel all right from the start. I did, as soon as I 'got on to it,' as they say now, but at first I was pretty flustered. Now, there was young Jim Conklin, old Si Conklin's son—that used to keep the tannery—you none of you recollect him—well, he went into it from the start just as if he was born to it. But with me it was different. I had to get used to it."

When little Jim walked with his grandfather he was in the habit of skipping along on the stone pavement in front of the three stores and the hotel of the town and betting that he could avoid the cracks. But upon this day he walked soberly, with his hand gripping two of his grandfather's fingers. Sometimes he kicked abstractedly at dandelions that curved over the walk. Anyone could see that he was much troubled.

"There's Sickles's colt over in the medder, Jimmie," said the old man. "Don't you wish you owned one like him?"

"Um," said the boy, with a strange lack of interest. He continued his reflections. Then finally he ventured: "Grandpa—now—was that true what you was telling those men?"

"What?" asked the grandfather. "What was I telling them?"

"Oh, about your running."

"Why, yes, that was true enough, Jimmie. It was my first fight, and there was an awful lot of noise, you know."

Jimmie seemed dazed that this idol, of its own will, should so totter. His stout boyish idealism was injured.

Presently the grandfather said: "Sickles's colt is going for a drink. Don't you wish you owned Sickles's colt, Jimmie?"

The boy merely answered: "He ain't as nice as our'n." He lapsed then to another moody silence.

One of the hired men, a Swede, desired to drive to the county seat for purposes of his own. The old man loaned a horse and an unwashed buggy. It appeared later that one of the purposes of the Swede was to get drunk.

After quelling some boisterous frolic of the farm-hands and boys in the garret, the old man had that night gone peacefully to sleep when he was aroused by clamoring at the kitchen door. He grabbed his trousers, and they waved out behind as he dashed forward. He could hear the voice of the Swede, screaming and blubbering. He pushed the wooden button, and, as the door flew open, the Swede, a maniac, stumbled inward, chattering, weeping, still screaming. "De barn fire! Fire! Fire! De barn fire! Fire! Fire! Fire!"

There was a swift and indescribable change in the old man. His face ceased instantly to be a face; it became a mask, a grey thing, with horror written about the mouth and eyes. He hoarsely shouted at the foot of the little rickety stairs, and immediately, it seemed, there came down an avalanche of men. No one knew that during this time the old lady had been standing in her night-clothes at the bed room door yelling: "What's th' matter? What's th' matter? What's th' matter?"

When they dashed toward the barn it presented to their eyes its usual appearance, solemn, rather mystic in the black night. The Swede's lantern was overturned at a point some yards in front of the barn doors. It contained a wild little conflagration of its own, and even in their excitement some of those who ran felt a gentle secondary vibration of the thrifty part of their minds at sight of this overturned lantern. Under ordinary circumstances it would have been a calamity.

But the cattle in the barn were trampling, trampling, trampling, and above this noise could be heard a humming like the song of innumerable bees. The old man hurled aside the great doors, and a yellow flame leaped out at one corner and sped and wavered frantically up the old grey wall. It was glad, terrible, this single flame, like the wild banner of deadly and triumphant foes.

The motley crowd from the garret had come with all the pails of the farm. They flung themselves upon the well. It was a leisurely old machine, long dwelling in indolence. It was in the habit of giving out water with a sort of reluctance. The men stormed at it, cursed it, but it continued to allow the buckets to be filled only after the wheezy windlass had howled many protests at the mad-handed men.

With his opened knife in his hand old Fleming himself had gone headlong into the barn, where the stifling smoke swirled with the air-currents, and where could be heard in its fulness the terrible chorus of the flames, laden with tones of hate and death, a hymn of wonderful ferocity.

He flung a blanket over an old mare's head, cut the halter close to the manger, led the mare to the door, and fairly kicked her out to safety. He returned with the same blanket and rescued one of the work-horses. He took five horses out, and then came out himself with his clothes bravely on fire. He had no whiskers, and very little hair on his head. They soused five pailfuls of water on him. His eldest son made a clean miss with the sixth pailful because the old man had turned and was running down the decline and around to the basement of the barn where were the stanchions of the cows. Some one noticed at the time that he ran very lamely, as if one of the frenzied horses had smashed his hip.

The cows, with their heads in the heavy stanchions, had thrown themselves, strangled themselves, tangled themselves; done everything which the ingenuity of their exuberance and fear could suggest to them.

Here as at the well the same thing happened to every man save one. Their hands went mad. They became incapable of everything save the power to rush into dangerous situations.

The old man released the cow nearest the door, and she, blind drunk with terror, crashed into the Swede. The Swede had been running to and fro babbling. He carried an empty milk-pail, to which he clung with an unconscious fierce enthusiasm. He shrieked like one lost as he went under the cow's hoofs, and the milk-pail, rolling across the floor, made a flash of silver in the gloom.

Old Fleming took a fork, beat off the cow, and dragged the paralyzed Swede to the open air. When they had rescued all the cows save one, which had so fastened herself that she could not be moved an inch, they returned to the front of the barn and stood sadly, breathing like men who had reached the final point of human effort.

Many people had come running. Someone had even gone to the church, and now, from the distance, rang the tocsin note of the old bell. There was a long flare of crimson on the sky which made remote people speculate as to the whereabouts of the fire.

The long flames sang their drumming chorus in voices of the heaviest

bass. The wind whirled clouds of smoke and cinders into the faces of the spectators. The form of the old barn was outlined in black amid these masses of orange-hued flames.

And then came this Swede again, crying as one who is the weapon of the sinister fates. "De colts! De colts! You have forgot de colts!"

Old Fleming staggered. It was true; they had forgotten the two colts in the box-stalls at the back of the barn. "Boys," he said, "I must try to get 'em out." They clamored about him then, afraid for him, afraid of what they should see. Then they talked wildly each to each. "Why, it's sure death!" "He would never get out!" "Why, it's suicide for a man to go in there!" Old Fleming stared absent-mindedly at the open doors. "The poor little things," he said. He rushed into the barn.

When the roof fell in, a great funnel of smoke swarmed toward the sky, as if the old man's mighty spirit, released from its body—a little bottle— had swelled like the genie of fable. The smoke was tinted rose-hue from the flames, and perhaps the unutterable midnights of the universe will have no power to daunt the color of this soul.

The sheer density of occurrence in "The Veteran" of images, devices, and effects of the sort I have been tracing in this essay is remarkable. But what I want particularly to underscore is the embedding of these within a "manifest" narrative the function of which is unequivocally to answer a pair of questions left undecided by the conflicted textual field of *The Red Badge:* What if anything did Henry Fleming learn from his experience in battle? More broadly, what kind of man did he become? The story's answers, it seems clear, are that Fleming gained an ironic self-knowledge that far surpasses his most enlightened moments in the novel, and that by the end of his life he became, beyond all doubt, a hero, unhesitatingly sacrificing himself in a fore-doomed attempt to rescue two colts ("poor little things") from a burning barn. My point isn't merely that these answers can't unproblematically be read back into *The Red Badge;* it is also that in "The Veteran" Crane emerges as the first (or among the first) of his totalizing readers, who traditionally have felt compelled to subsume under a univocal moral and/or psychological interpretation not only as many of the events of a given narrative as could be made to fit but also the overall shape of that narrative considered as a simultaneous unity. Indeed it is hardly coincidental that totalization in "The Veteran" turns out to involve the heroizing of its protagonist: the story's two-part account of old Fleming's modesty in recalling his battle experiences

and then of his resourcefulness and selflessness in an actual crisis achieves unbroken continuity of focus, just as the apotheosizing imagery and grandly pathetic rhetoric of its stupendous last paragraph has the effect of summing up the entire narrative in a single, expansive, incontrovertible meaning. Yet from the perspective of this essay, Fleming with his competent hands and opened knife, not to mention his references to "Si Conklin" and—three times—to "Sickles's colt," is at least intermittently recognizable as a figure for the writer.[72] And the climactic paragraph itself, with its description of an upward-swarming but downward-pointing funnel of tinted smoke, its image of the old man's body as a little bottle (containing "only a little ink more or less"?), and its concluding play of authorial initials ("the color of this soul"), bears witness to the productivity of the essentially dispersive reading of Crane's prose that I have been expounding. This is gratifying, of course, but it is also just the slightest bit chilling. Perhaps my final point is simply to acknowledge the costs as well as the exhilarations of resisting Crane at his most nearly overwhelming.

Notes

PREFACE

1. This topic is doubly familiar to Americanists because of its salience as a theoretical preoccupation since Derrida and because figures of writing have been held to play a determining role in a number of classic works of American literature—the *Narrative of Arthur Gordon Pym, Moby-Dick,* and *Walden,* to name just three. On *Pym* and *Moby-Dick* see, for example, John T. Irwin, *American Hieroglyphics: The Symbol of the Egyptian Hieroglyphics in the American Renaissance* (New Haven and London: Yale University Press, 1980); and on *Walden* see Stanley Cavell, *The Senses of 'Walden'* (New York: The Viking Press, 1972).

2. In this connection see Walter Benn Michaels, *The Gold Standard and the Logic of Naturalism: Essays on American Literature* (Berkeley: University of California Press, 1987), in particular the introduction, "The Writer's Mark." Briefly, Michaels there suggests, both in elaboration of his argument in the last few essays in his book and with reference to my readings of Eakins and Crane, that in various American texts of the late nineteenth and early twentieth centuries writing as such becomes an epitome of a notion of identity as difference from itself (in that writing *to be* writing must in some sense be different from the mark that simply materially it is); and that this is important above all because, in those texts and others, the possibility of difference from itself emerges as crucial to a concept of personhood that would distinguish persons both from pure spirit (e.g., Josiah Royce's corporation) and from pure matter (e.g., Frank Norris's brute or machine). Another name for difference from itself, of course, might be *différance.*

CHAPTER ONE

1. Recent books, articles, and catalogs that discuss *The Gross Clinic* and the circumstances of its making and exhibition include Ellwood C. Parry III, "Thomas Eakins and the *Gross Clinic,*" *Jefferson Medical College Alumni Bulletin* 16 (June 1967): 2–12; idem, "*The Gross Clinic* as Anatomy Lesson and

Memorial Portrait," *Art Quarterly* 32 (Winter 1969): 373–91; Gordon Hendricks, "Thomas Eakins' *Gross Clinic*," *Art Bulletin* 51 (March 1969): 57–64; idem, *The Life and Work of Thomas Eakins* (New York: Grossman Publishers, 1974), pp. 87–100; Neil Hyman, "Eakins' *Gross Clinic* Again," *Art Quarterly* 35 (Summer 1972): 158–64; Lloyd Goodrich, *Thomas Eakins*, 2 vols. (Cambridge, Mass., and London: Harvard University Press, 1982), 1:123–38; Darrel Sewell, *Thomas Eakins: Artist of Philadelphia* (exhib. cat., Philadelphia Museum of Art, 29 May – 1 Aug. 1982, and Museum of Fine Arts, Boston, 22 Sept. – 28 Nov. 1982), cat. nos. 33–39, pp. 36–44; and Elizabeth Johns, *Thomas Eakins: The Heroism of Modern Life* (Princeton: Princeton University Press, 1983), pp. 46–81. On the various titles Eakins gave the painting during his lifetime see Goodrich, *Thomas Eakins*, 1:323.

2. David Sellin, "1876: Turning Point in American Art," in *The First Pose* (New York: W. W. Norton & Co., 1976), p. 14. See also John Wilmerding, *American Art*, The Pelican History of Art (Harmondsworth, England: Penguin Books, 1976), p. 138.

3. See Johns, *Thomas Eakins*, pp. 65–70. "Not a particular operation, but a philosophical approach to surgery, 'conservative' surgery derived from the conviction that to amputate, so long as there was any other option, was to admit failure as a surgeon. The practice of conservative surgery applied primarily to diseases in the limbs; it often involved a long period of waiting for nature to take a positive course before the surgeon took drastic action" (p. 68). See also Johns's account of the successful conclusion of a necrosis of the humerus of a young patient Gross had been treating for a year and a half, the climactic operation being similar to that depicted in *The Gross Clinic* (p. 70). Johns also identifies many of the personages in the picture.

4. The figure in question was first identified as Eakins in his obituary in the Philadelphia *Inquirer* (2 July 1916). Thereafter the point appears to have gone unnoticed until reintroduced by Hendricks, "Thomas Eakins' *Gross Clinic*," p. 60. Goodrich, dean of Eakins scholars, remains dubious (*Thomas Eakins*, 1:323), but otherwise there is general agreement that the figure at the right depicts the painter.

5. Johns, *Thomas Eakins*, p. 55.

6. The Eakins-Rembrandt connection is one of the staples of the critical literature on *The Gross Clinic*. Feyen-Perrin's picture was first proposed as a source for *The Gross Clinic* by Parry, "*The Gross Clinic* as Anatomy Lesson and Memorial Portrait," 376–80; see also Johns, *Thomas Eakins*, pp. 72–73.

7. Johns, *Thomas Eakins*, p. 75, n. 59.

8. Parry, "*The Gross Clinic* as Anatomy Lesson and Memorial Portrait," 376. In addition Hyman suggests that "the principal pictorial source for the *Gross Clinic* was the famous woodcut on the title page of Andreas Vesalius' *De Humani Corporis*" ("Eakins' *Gross Clinic* Again," 159), which I consider un-

likely, and Wilmerding cites Washington Allston's *Dead Man Revived by Touching the Bones of the Prophet Elisha* in the Pennsylvania Academy as a possible precedent close at hand (*American Art*, p. 138).

9. Goodrich, *Thomas Eakins*, 1:124.

10. Johns, *Thomas Eakins*, pp. 51–52.

11. See for example Goodrich, *Thomas Eakins*, 1:126.

12. This is the view held by Johns in her recent book; see especially chap. 1, "Eakins, Modern Life, and the Portrait," *Thomas Eakins*, pp. 3–18.

13. See for example *Absorption and Theatricality: Painting and Beholder in the Age of Diderot* (Berkeley and Los Angeles: University of California Press, 1980); "The Beholder in Courbet: His Early Self-Portraits and Their Place in His Art," *Glyph*, no. 4 (1978): 85–129; "Representing Representation: On the Central Group in Courbet's *Studio*," in *Allegory and Representation*, ed. Stephen J. Greenblatt (Baltimore and London: The Johns Hopkins University Press, 1981), pp. 94–127; "Painter into Painting: On Courbet's *After Dinner at Ornans* and *Stonebreakers*," *Critical Inquiry* 8 (Summer 1982): 619–49; "The Structure of Beholding in Courbet's *Burial at Ornans*," *Critical Inquiry* 9 (June 1983): 635–83; and "Courbet's Metaphysics: A Reading of *The Quarry*," *Modern Language Notes* 99 (September 1984): 787–815.

14. For illustrations of works by Eakins cited but not reproduced in this essay see the books by Goodrich, Hendricks, and Johns cited in n. 1 above.

15. A similar though much less dramatic equation of blood and paint may be found in Courbet's *Wounded Man* (begun ca. 1844, finished ca. 1854); see Fried, "Representing Representation," p. 123, n. 8.

16. See Goodrich, *Thomas Eakins*, 1:61.

17. The phrase "real allegory" is taken from the full title in French of Courbet's *Painter's Studio: L'Atelier du peintre, allégorie réelle déterminant une phase de sept années de ma vie artistique.*

18. On Rush see the exhibition catalog, *William Rush, American Sculptor* (Pennsylvania Academy of the Fine Arts, 20 June – 21 Nov. 1982). Rush's career is discussed in connection with Eakins's painting by Johns, *Thomas Eakins*, pp. 82–114.

19. Sellin, *The First Pose*, pp. 53–59. Goodrich remarks that "as a matter of historical fact, no evidence has been found that Louisa Van Uxem [Rush's model] posed nude" (*Thomas Eakins*, 1:147).

20. Johns, *Thomas Eakins*, p. 100.

21. The notes read: "formal Scrolls / for S. Girard / Aug. 13 [rest of date illegible]." Girard was a leading Philadelphia merchant who by the early nineteenth century owned a large fleet of ships; over a period of almost forty years Rush carved at least twelve figureheads for his vessels (Linda Bantel, "William Rush, Esq.," in *William Rush, American Sculptor*, p. 10). According to Eakins, "the scrolls and the drawings on the wall [and presumably the

notes as well] are from sketches in an original sketch book of William Rush preserved by an apprentice and left to another ship carver" (quoted by Johns, *Thomas Eakins,* p. 105).

22. Johns, *Thomas Eakins,* pp. 100–101.

23. Quoted by Goodrich, *Thomas Eakins,* 1:325. I don't wish to be understood as claiming that no distinction ought in fact to be made between Rush's figureheads and scrolls on the one hand and his busts and sculptures on the other; indeed William H. Gerdts has argued on historical grounds that Rush's work remained that of an artisan rather than a sculptor ("William Rush: Sculptural Genius or Inspired Artisan?" in *William Rush, American Sculptor,* pp. 57–75). My point is that Eakins evidently wanted not only to memorialize Rush's achievement as an artist but also to emphasize the unity of his endeavor. See in this connection the haunting later painting, *William Rush and His Model* (ca. 1908; Fig. 53), which depicts the sculptor (who appears physically to resemble the aged Eakins) helping a naked model step down from a round wooden block on which she has been posing. The lower portion of the sculptor's body is obscured from view by a large scroll that rises from the bottom of the picture, almost as if scroll and sculptor together formed a single compound figure.

24. Eakins's training at Central High School in writing, drawing, and related skills is examined in detail by Johns in "Drawing Instruction at Central High School and Its Impact on Thomas Eakins," *Winterthur Portfolio* 15 (Summer 1980): 139–49. For general background see Peter C. Marzio, *The Art Crusade: An Analysis of American Drawing Manuals, 1820–1860* (Washington, D.C.: Smithsonian Institution Press, 1976), cited by Johns, "Drawing Instruction," p. 140, n. 2.

25. The edition I consulted was Rembrandt Peale, *Graphics, The Art of Accurate Delineation, A System of School Exercise, for the Education of the Eye and the Training of the Hand, as Auxiliary to Writing, Geography, and Drawing* (Philadelphia: E. C. & J. Biddle, 1850). The remark that "writing is little else than drawing the forms of letters; drawing is little more than writing the forms of objects" occurs first on p. 43. My thanks to Paul Staiti for a helpful discussion of *Graphics* in the context of Peale's other writings.

26. Johns notes that in 1863 and 1864 the Philadelphia City Directory gives Eakins's profession as "teacher" and in 1866 as a "writing teacher" (*Thomas Eakins,* p. 11, n. 10). For a discussion of the competition for the professorship of writing and drawing see Johns, "Drawing Instruction," pp. 144–46.

27. Jules Prown connects *Baby at Play* with *The Gross Clinic* in "Thomas Eakins' *Baby at Play,*" *Studies in the History of Art* 18 (1985): 121–27.

28. A source for this may have been Velázquez's *Crucifixion* (1630) in the

53. Thomas Eakins, *William Rush and His Model,* ca. 1908. Honolulu Academy of Arts. Gift of Friends of the Academy, 1947. (548.1)

Prado, which includes a triple version of that text in Hebrew, Greek, and Latin.

29. According to Goodrich, Forbes, professor of anatomy and clinical surgery at Jefferson Medical College, "drew up the Anatomical Act of Pennsylvania, passed in 1867, one of the best in the country, and the model for many similar acts. . . . Inscribed on the side of the amphitheatre, right center: 'GVLIELMVS S. FORBES, M.D., QVI LEGEM NOVAM DE RE ANATOMICA GVBERNIO STATVS PENNSYLVANIAE PROPOSVIT COMMENDAVIT DEFENSIONE STVDIOSA EX SENATVS CONSVLTV FERENDEM CVRAVIT'" (*Thomas Eakins: His Life and Work* [New York: Whitney Museum of American Art, 1933], p. 201). Note too that several members of Forbes's audience are shown writing.

30. For a list of those paintings see Goodrich, *Thomas Eakins,* 1:320.

31. In a recent article, A. D. Moore remarks that Eakins decorated the frame of the physicist's portrait with "symbols of Rowland's work, photographed, drawn or written by Rowland himself' and goes on to identify each of the symbols in turn ("Henry A. Rowland," *Scientific American* 246

[February 1982]: 150). Other paintings by Eakins with inscribed or decorated frames are *The Agnew Clinic, Frank Hamilton Cushing* (1894 or 1895), and *Salutat* (1898).

32. According to Goodrich, "the hand of the conductor in the foreground was posed for first by someone who held the baton as if it was a brush (it is like this in the preliminary sketch [in the Philadelphia Museum of Art]). Eakins got Charles M. Schmitz, conductor of the Germania Orchestra and one of Philadelphia's leading musicians, to pose for this hand, holding the baton correctly" (*Thomas Eakins,* 1:84). Even so, the conductor's hand suggests that of the painter at work on the painting, which in turn may be taken as evincing a further uncertainty about the status of the painting as an artifact with clear and distinct limits. A similar uncertainty pervades Courbet's oeuvre, though for fundamentally different reasons.

The currency of motifs of writing in Eakins's art bears a striking resemblance to an aspect of seventeenth-century Dutch painting and drawing discussed by Svetlana Alpers in *The Art of Describing: Dutch Art in the Seventeenth Century* (Chicago: The University of Chicago Press, 1983), pp. 169–220. But the nonconflicting, "separate but equal" status of texts and images in the work of Dutch artists (p. 187) differs fundamentally from the relationship between writing and painting that I shall try to show is operative throughout Eakins's oeuvre. (Ironically, the great exception to the Dutch involvement with images of writing is Rembrandt, whom Eakins especially admired.)

Elsewhere in her book Alpers remarks that "Dutch art, like maps, was comfortable with its links to printing and to writing. Not only were Dutch artists often printmakers accustomed to placing images on the surface of a printed page (often of a book), but they also felt at home with inscriptions, with labels, and even with calligraphy. Artists and geographers were related not only generally through their interest in describing the world but specifically through their interest in script" (ibid., pp. 136–37). Writing and drawing are explicitly connected in the most important Dutch art-pedagogical text of the period, Karel Van Mander's *Schilderboek,* to which my attention was drawn by Walter Melion.

33. Originally in Margaret McHenry, *Thomas Eakins, Who Painted* (Oreland, Pa., privately printed, 1946), p. 9; cited by Theodor Siegl, "Introduction," *The Thomas Eakins Collection* (Philadelphia Museum of Art, Handbooks in American Art, No. 1, 1978), p. 21.

34. Siegl, "Introduction," p. 27.

35. Ibid., pp. 21–28, especially p. 24.

36. Ibid., p. 24.

37. Siegl, *The Thomas Eakins Collection,* p. 102.

38. In "Family Romances," *The Standard Edition of the Complete Psychological Works of Sigmund Freud,* 24 vols., trans. James Strachey (London: Hogarth

Press, 1953-74), 9:235-41. Hereafter cited as *Standard Edition*. See also J. Laplanche and J.-B. Pontalis, *The Language of Psycho-Analysis*, trans. Donald Nicholson-Smith (New York: W. W. Norton & Co., 1973), pp. 160-61.

39. Goodrich, *Thomas Eakins*, 1:76-79.

40. See Fried, *Absorption and Theatricality*, p. 43 and *passim*, as well as the essays on Courbet cited in n. 13 above. To speak of an absorptive tradition of painting in the seventeenth and eighteenth centuries is not to imply an opposition with theatricality during that period. On the contrary, my claim is that absorption and theatricality emerge as antithetical—as expressing two radically opposed stances toward the beholder—only around 1750 and then only in France; elsewhere and before that date (as for example in Vermeer) the very notion of theatricality may seem beside the point, or alternatively (as for example in Caravaggio) absorption may appear to serve as a vehicle of theatricality and vice versa (no doubt there are other possibilities as well). The second of these alternatives might be thought to apply to *The Gross Clinic*, though it remains an open question just what force the concept of theatricality would have in such a characterization.

41. On the *Doubting Thomas* see, for example, Howard Hibbard, *Caravaggio* (New York: Harper & Row, 1983), pp. 167-68.

42. A common view holds that among his French contemporaries Eakins only esteemed academic painters such as his masters Gérôme and Bonnat, but the resemblance of his work to theirs has been exaggerated by scholars who have taken his (doubtless sincere) professions of admiration for their art at face value. According to Eakins's former student, Thomas Eagan, Eakins later praised Courbet (Siegl, "Introduction," p. 17, citing McHenry); although his letters from Paris never mention Courbet, it is inconceivable that he was not aware of the latter's work by the time he returned to Philadelphia in 1870. According to Goodrich, Eakins eventually came to esteem Corot, Millet, Barye, Courbet, Manet, Degas, and Forain (*Thomas Eakins*, 2:14-15). It should also be noted that Thomas Couture is placed on a par with Gérôme in a letter from Eakins to his mother of 1 April 1869 (Archives of American Art, Washington, D.C., microfilm, roll 640); I find this significant in that Couture seems to me a likely influence on the domestic interiors of the first half of the 1870s.

43. The use in the early stages of a work of a bright red accent (thereafter to be covered over) as a means of determining a picture's value structure is discussed by Eakins in notes in French written in Paris the summer of 1870 (Goodrich, *Thomas Eakins*, 1:63). The later history of the color red in his art would also be worth tracing.

44. Siegl emphasizes the absolute precision of Eakins's perspective system, in which each square in the "checkerboard" ground plan represents a square foot of reality; this enables Siegl to calculate "that the boat is 35 feet

long, that it is moving at an angle of 67 degrees away from the viewer, that its stern is 30 1/2 feet from the viewer and 5 1/2 feet to the right of center," etc. At the same time, he goes on to observe, "this drawing and the final painting are strangely flat because Eakins placed the point of distance (or vanishing point for the diagonals) unusually far from the center . . . with the result that the final painting appears condensed, as if it were the center of a much larger scene, or as if it were seen through a telescope" (*The Thomas Eakins Collection*, p. 56). As Siegl says elsewhere of these works, "the artist's knowledge of perspective was such that the distortion cannot be accidental" (in *Philadelphia: Three Centuries of American Art*, exhibition catalog, Philadelphia Museum of Art, 11 April – 10 Oct. 1976, p. 394). I take this up in n. 67 below.

45. Images of absorption and reflection also play a major role in Courbet's art, where they characteristically occur together; see my discussion of three related works in "Courbet's Metaphysics," pp. 801–2.

46. It remains a question to what extent the domestic interior scenes were preceded by detailed perspective constructions subsequently lost or lost to view. That at least sometimes they may have been so preceded is suggested by a perspective drawing for *The Chess Players*, which incidentally allows us to note an analogy between the "checkerboard" layout of the ground plane and the chessboard on the table. In view of the claims I have made for the possible relationship of *The Chess Players* to *The Gross Clinic*, this displacement of the schematized ground plane within the representational field of the finished painting will be pertinent to my reading of the patient and operating table in *The Gross Clinic* as analogous to the horizontal plane of writing/drawing as figured perspectively in the rowing pictures.

As for the pictures of sailboats on the Delaware of 1874–75, the rougher water sometimes rules out all systematic play of reflections, but the sailors in those works characteristically appear deeply absorbed in their tasks (enlarged details show this plainly). A further relation to writing/drawing may be implied by the densely painted pagelike whiteness of the four-sided sails, which in the fine *Sailboats Racing on the Delaware* (Fig. 16) contrasts strongly with the brownish underpainting.

47. On the Freudian concepts of *Nachträglichkeit* (or "deferred action") and "primal scene," see Laplanche and Pontalis, *The Language of Psycho-Analysis*, pp. 111–14, 335–36. The relation of the sort of fantasy of origination I have just posited to what I shall describe (in part V of this essay) as oedipal and "paranoiac" structures in *The Gross Clinic* seems to me an open question.

48. An earlier painting that bears on these issues is *Dr. John H. Brinton*, by virtue both of the depiction of writing materials and their reflection in the polished surface of the desk upon which Brinton rests his right elbow and forearm and of the illegibility of the pages open on the bookstand.

49. In *Kathrin* (a work that reproduces poorly, hence the absence of an illustration) the signature and date are enclosed in a T-shaped cartouche, a device Eakins subsequently abandoned.

50. Also relevant here are the painting *Hunting* (ca. 1874) and, especially, the preparatory drawing for it, both of which are reproduced in Sewell, *Thomas Eakins*, p. 26, figs. 23 and 24.

51. Siegl, *The Thomas Eakins Collection*, p. 64; the inverted X-ray is reproduced in "Appendix B," fig. 4, p. 173.

52. Clark's review is quoted in Hendricks, *The Life and Work of Thomas Eakins*, pp. 92–94. See also the negative review that appeared in the New York *Tribune*, ibid., pp. 97–98.

53. On Caravaggio's ambivalent attitude, at once aggressive and awestruck, toward the High Renaissance see S. J. Freedberg, *Circa 1600: A Revolution of Style in Italian Painting* (Cambridge, Mass., and London: Harvard University Press, 1983), pp. 59–64. See also Hibbard's discussion of two "Michelangelesque" pictures in *Caravaggio*, pp. 149–60, and Norman Bryson's remarks on iconoclasm in Caravaggio and Rembrandt in *Vision and Painting: The Logic of the Gaze* (New Haven and London: Yale University Press, 1983), p. 127. Louis Marin has an interesting discussion of Caravaggio's *Medusa* in *Détruire la peinture* (Paris: Editions Galilee, 1977), pp. 137–76. My understanding of Caravaggio has profited from looking at his works in the company of Charles Dempsey.

54. Edmund Burke, *A Philosophical Enquiry into the Origin of Our Ideas of the Sublime and Beautiful*, ed. J. T. Boulton (Notre Dame, Ind.: Notre Dame University Press, 1968), pp. 51–52 and *passim*. The risk of vitiation is emphasized by Frances Ferguson, "The Sublime of Edmund Burke, or the Bathos of Experience," *Glyph*, no. 8 (1981), pp. 70–71.

55. Thomas Weiskel, *The Romantic Sublime: Studies in the Structure and Psychology of Transcendence* (Baltimore and London: The Johns Hopkins University Press, 1976), pp. 93–94. Weiskel's oedipal reading of the Burkean or (Kantian) dynamic sublime is partly recast in Lacanian terms by Bryan Jay Wolf, *Romantic Re-Vision: Culture and Consciousness in Nineteenth-Century American Painting and Literature* (Chicago: The University of Chicago Press, 1982), chap. 5, "Thomas Cole and the Creation of a Romantic Sublime," pp. 177–236. As influential as they have been, Weiskel's views have received their share of criticism, both from psychoanalytic commentators who would challenge his emphasis on an oedipal as opposed to a pre-oedipal "moment" in the formation of the psyche, and from what might be called philosophical commentators for whom the translation of the dynamics of the sublime into the language of psychoanalysis inevitably obscures the precise issues at stake for Burke, Kant, and the later eighteenth century. The book by Wolf just cited is in effect an instance of a psychoanalytic critique, as is

Neil Hertz's essay, "The Notion of Blockage in the Literature of the Sublime," in Geoffrey H. Hartman, ed., *Psychoanalysis and the Question of the Text* (Baltimore and London: The Johns Hopkins University Press, 1978), pp. 62–85 (see n. 76 below). (Hertz's essay is republished in slightly revised form in *The End of the Line: Essays on Psychoanalysis and the Sublime* [New York: Columbia University Press, 1985], pp. 40–60; in that book see also the discussion of Weiskel in "Afterword: The End of the Line," pp. 230–39.) An exemplary instance of a philosophical critique is Steven Knapp, *Personification and the Sublime: Milton to Coleridge* (Cambridge, Mass., and London: Harvard University Press, 1985), especially pp. 74–82. My use of Weiskel at this juncture isn't intended to engage with the full range of questions his work raises; that there is an oedipal aspect to *The Gross Clinic* seems to me undeniable, and, partly on the strength of Wolf's discussion of Cole, I have found the analogy with the sublime instructive.

56. Freud, "Psychoanalytic Notes on an Autobiographical Account of a Case of Paranoia (Dementia Paranoides)," *Standard Edition,* 12:1–82. See also Laplanche and Pontalis, *The Language of Psycho-Analysis,* where it is stressed that throughout Freud's writing "paranoia is defined . . . whatever the variations in its delusional modes, as a defence against homosexuality" (p. 297).

57. Freud, *Standard Edition,* 12:44.

58. This is the obvious implication of Freud's suggestion that Schreber's images of "the *anterior* realms of God and the fore-courts of Heaven are to be regarded as a symbol of what is female, and the *posterior* realms of God as a symbol of what is male" (12:53, italics Freud's). "I feel confident," Freud adds in a "Postscript," "that every reader with a knowledge of psycho-analysis will have learned from the material which I presented more than was explicitly stated by me, and that he will have found no difficulty in drawing the threads closer and in reaching conclusions at which I no more than hinted" (12:80).

59. As Laplanche and Pontalis make clear, what I have been calling the oedipus complex and "paranoia" "are to be found in varying degrees in what is known as the *complete* form of the [oedipus] complex," understood as the "organised body of loving and hostile wishes which the child experiences towards its parents" (*The Language of Psycho-Analysis,* pp. 282–83, italics theirs). Another major painting by Eakins in which homoerotic fantasy would appear to be in play is of course *The Swimming Hole.*

60. Where it is closely juxtaposed with an image of writing; but is the latter "masculine" by contrast or "feminine" by association?

61. My discussion of the figure of the mother and more broadly my reading of "paranoiac" elements in *The Gross Clinic* are indebted to conversations with Peter Sacks and Edward Snow.

62. Weiskel, *The Romantic Sublime*, p. 5; in this connection Weiskel cites an essay by Neil Hertz, "A Reading of Longinus," now available in *The End of the Line*, pp. 1–20. See also Wolf, *Romantic Re-Vision*, pp. 178–80, 207–10; and, especially, Harold Bloom, *The Anxiety of Influence: A Theory of Poetry* (New York: Oxford University Press, 1973), *A Map of Misreading* (New York: Oxford University Press, 1975), and *Poetry and Repression: Revisionism from Blake to Stevens* (New Haven and London: Yale University Press, 1976).

63. Johns, *Thomas Eakins*, pp. 133–34. Johns goes on to discuss the vogue in Eakins's time for the "'pathetic song'—one that told a poignant tale of loss or regret" (pp. 134–35).

64. The aria is "O Rest in the Lord" from the oratorio *Elijah*. Weda Cook in 1930 recalled that "every day when she started posing Eakins asked her to sing 'O Rest in the Lord' so that he could observe the muscles of mouth and throat. 'I got to loathe it,' she said. But she spoke of how accurately he had caught the singer's action in producing the utmost fullness of tone. He would look at her 'as if through a microscope,' she said" (Goodrich, *Thomas Eakins*, 2:84). According to Siegl, Eakins "apparently decided to depict her at the very moment she sang the *e* sound in the word *rest*" (*The Thomas Eakins Collection*, p. 128). Hendricks for his part is convinced, on what evidence he doesn't say, that "the note Miss Cook is holding in her portrait is evidently the one 'for' in the phrase 'wait patiently for him'" (*The Life and Work of Thomas Eakins*, p. 193).

65. In a study for *William Rush* in the Yale University Art Gallery the chaperone has her back turned both to the viewer and to the figure of the model; the allegorical statue Rush is carving also faces away from the viewer; and the motif of the chair in the center foreground has not yet been invented. Subsequent changes in the composition mostly seem to have been designed to strengthen the painting as an object of "pictorial" seeing, and compared to the study the final version represents a stand-off between opposing forces.

66. It is as though the misalignment of Eakins's signatures in perspective with the principal axes of the carpets or floors on which they appear virtually to lie compels the recognition that the *implicit* ground plane of a given signature belongs to a separate "space" from that of the representation as a whole (or say from that of the *explicit* ground plane that we inevitably associate with the representation as such). Courbet's signatures too epitomize major aspects of his art but in an altogether different way; see Fried, "Painter into Painting," pp. 642–43.

67. The effect of shifting one's attention from the first "space" to the second is not unlike the experience of looking through a telescope or pair of binoculars at a distant portion of a scene that one has been viewing with the naked eye (the same effect can sometimes be found in paintings by George Stubbs). What makes this worth mentioning is Siegl's observation, cited in

n. 44 above, that the perspective system of *The Pair-Oared Shell* makes the painting "appear condensed, as if it were the center of a much larger scene, or as if it were seen through a telescope." This suggests that Eakins not only may have derived the motif of the Biglin brothers in *The Pair-Oared Shell* from the image of himself in *Max Schmitt* but also may have experimented with making the "telescopic" character of the latter image the basis for an entire painting, though to what end remains unclear.

68. The distinction developed in this essay between the horizontal "space" of writing/drawing and the vertical "space" of painting is partly anticipated in two short, posthumously published texts by Walter Benjamin, both apparently written in 1917, "Malerei and Graphik" and "Über die Malerei oder Zeichen und Mal," in *Gesammelte Schriften*, 6 vols., ed. Rolf Tiedemann and Hermann Schweppenhauser (Frankfurt am Main: Suhrkamp Verlag, 1977–85), 2:2, 602–7. In "Malerei und Graphik" Benjamin distinguishes between two possible "cuts" into the world, the longitudinal one of painting and the transverse one of certain drawings, and characterizes the first as "representative," in some sense capturing things themselves, and the second as "symbolic," containing signs. And in "Über die Malerei oder Zeichen und Mal" he constrasts the sign, which he takes to be not only linear but impressed (*aufgedrückt*) into surfaces where it is found, with the mark, which he conceives of as standing out from those surfaces (*hervortritt*) and thus as implying the concept of a medium. The second text begins by deferring consideration of the respective linear modalities of two classes of signs, those of geometry and of writing, both of which Benjamin would distinguish from that of drawing. In short Benjamin and I make somewhat different use of the same basic opposition between verticality and horizontality, but of course we are fundamentally concerned with different artistic phenomena, he with Cubism, I with Eakins. My thanks to Yve-Alain Bois for bringing Benjamin's texts to my attention.

A more recent essay that broaches the topic of a contrast between vertical and horizontal orientations in pictorial art (via the notion of the "flatbed picture plane") is Leo Steinberg, "Other Criteria," in *Other Criteria: Confrontations with Twentieth-Century Art* (New York: Oxford University Press, 1972), especially pp. 82–91.

69. Peale, *Graphics*, pp. 76–77, emphasis his.

70. Benjamin asks whether there is not a "primitive vertical position of writing, for example, writing graven in stone?" ("Malerei und Graphik," p. 603, my translation). I should add that part of the interest of the long passage from Peale's *Graphics* quoted in the text is that it seems to reveal a certain tension *between* writing and drawing, despite the author's express intention at least heuristically to identify them with one another. Indeed there is the suggestion of a similar tension in the perspective drawing for *John*

Biglin in a Single Scull, which includes, apparently as part of the representational field, Eakins's signature in script *but not in perspective.* (The signature, too faint to be made out easily, is to the right of the figure of Biglin, almost directly below the two-masted ship in the distance.)

71. Moore, "Henry A. Rowland," p. 150.

72. Goodrich, *Thomas Eakins,* 2:137–41.

73. See Siegl's discussion of *Mending the Net* in *The Thomas Eakins Collection,* p. 93.

74. Of *Shad Fishing* Siegl writes: "It is interesting to note that . . . [Eakins] first intended the family group [in the left foreground], without the dog, to stand behind a low sandbank that dominated the foreground. The bank, which is still visible, concealed the lower halves of these figures. Later he changed his mind and added the lower halves of the figures in a slightly different mixture of pigments and with slightly less care. The dog was also added at that time. A blurred foreground, in this case the sandbank, was to lead the eye of the viewer to the focal center, here Eakins's relatives, which are painted with surprising detail. The fishermen at mid-distance are less precisely rendered, while the far bank of the river is blurred as it would have appeared in an early photograph. Again, as in *Mending the Net,* Eakins seems to have experimented with camera vision; but then, as he made his changes in the family group, he softened the impact of his particular vision" (*The Thomas Eakins Collection,* p. 94). One motivation for those changes may have been a desire to counter the sense of remoteness and withdrawal to which I have just alluded.

75. No portrait by Eakins has been the object of more pointed scrutiny than *Addie.* In the late 1890s, Mary Adeline Williams (known as Addie), who had earlier been a friend of Eakins's favorite sister Margaret, returned to Philadelphia from Chicago, and in 1900, after Benjamin Eakins's death, she came to live with Eakins and his wife. *Addie* is the second of two portraits that Eakins painted of her and differs markedly in feeling from the first. "Why the difference?" Gordon Hendricks asks. "This question has vexed people for many years. Something happened to Addie or to Eakins' concept of her between the two portraits. Assuming that the first portrait was done shortly before she came to live with the Eakinses or soon thereafter, and that the second was done not long after the first—and that assumption appears to be correct—the difference is stunning. The natural thing to believe is that love came into Addie's life. That idea is taken for granted by one relative I met: 'You know, of course, that Uncle Tom made love to Addie Williams.' And this theory is not contradicted by the portrait Eakins made of his wife at about this time. The artist was a difficult man to live with at times, but he would have had to have been something more than just difficult to produce the effect shown in the portrait. It is painted with a love that neither of them

probably ever doubted, but that must have taken curious turns upon occasion" (*The Life and Work of Thomas Eakins*, p. 244). Hendricks's reading of *Addie,* for which no corroborating evidence whatever exists, is disputed by Goodrich, *Thomas Eakins,* 2:174.

That Eakins's chief concern as a portraitist was the representation of "character" is a *topos* of the literature on his art. "Like Rembrandt, Eakins loved old age, the marks of years and experience, the essential character that youth conceals but age reveals," Goodrich writes in a characteristic passage (*Thomas Eakins,* 2:59). "He often asked old people, including women, to pose. 'How beautiful an old woman's skin is—all those wrinkles!' he said to Mary Hallock Greenewalt. Helen Parker Evans wrote: 'I remember his telling me of an old model who came to see him and he found her whole body a net work of beautiful *fine* wrinkles.' Even when he painted a portrait of the deceased father of Dr. Henry Beates from a photograph, he was particular about getting a photo that showed all the wrinkles" (ibid.). Goodrich also suggests—not without reason—that "[Eakins's] sense of character extended also to clothes, which became an expression of individuality as much as the rest of the sitter's person" (*Thomas Eakins: His Life and Work,* p. 115). Thus Leslie W. Miller, principal of the School of Industrial Art and a close friend, was persuaded by the painter " 'to go and don a little old sack coat—hardly more than a blouse—that he remembered seeing me in in my bicycle days, and which I certainly never would have worn facing an audience, which the portrait represented me as doing' " (quoted in ibid.). As Miller also remarks: " '[Eakins] had a passion for the ultra informal which sometimes carried him so far as to lead him to prefer the unfit to the fit if it were only old, and worn and familiar enough' " (quoted in Siegl, *The Thomas Eakins Collection,* p. 156). The "graphic" basis of these predilections is self-evident.

Interestingly, the English word "character" derives ultimately from a Greek instrument for marking or incising; among the meanings of "character" in the *Oxford English Dictionary* are: "Writing, printing"; "The series of alphabetic signs, or elementary symbols, peculiar to any language; a set of letters"; and "The style of writing peculiar to any individual; handwriting." In this connection see Jonathan Goldberg's discussion of what he calls "the inscription of character" in Shakespeare in *Voice Terminal Echo: Postmodernism and English Renaissance Texts* (New York and London, Methuen, 1986), pp. 86–100; and David Marshall's analysis of the concept of character in the writings of the Third Earl of Shaftesbury in *The Figure of Theater: Shaftesbury, Defoe, Adam Smith, and George Eliot* (New York: Columbia University Press, 1986), pp. 7–70. My thanks to Stephen Greenblatt for alerting me to the Renaissance connotations of the term.

This is perhaps the place to remark that the nearest thing to a precedent in American painting that I have found for Eakins's preoccupation with images

of writing are the American portraits of John Singleton Copley, many of which also contain striking images of reflections.

76. One might say that the oedipal scenario that partly structures *The Gross Clinic* posits a one-to-one confrontation between the painter or viewer and the "paternal" figure of Gross, and by implication between the painter or viewer and the painting as a whole, and that because it does that structure is at odds with the (more fundamental) conflict between representational systems that I have tried to evoke. Put slightly differently, the oedipal scenario would allow the self to "read [in the painting] the confirmation of its own integrity, which is only legible in a specular structure, a structure in which the self can perform [a] supererogatory identification with [a] blocking agent" (adapted from Hertz, "The Notion of Blockage in the Literature of the Sublime," in Hartman, ed., *Psychoanalysis and the Question of the Text*, p. 78; see, however, the revision of this passage in *The End of the Line*, p. 53). But the obvious "blocking agent," the figure of Gross, is also the privileged site of an agon between representational systems that admits of no decisive outcome, while the fact that the "spaces" of writing/drawing and of painting coincide through and through and thus cannot be distinguished from one another in any simple way suggests that neither quite belongs to a specular structure in Hertz's sense of the term. There is thus a double division in *The Gross Clinic*, between oedipal and "paranoiac" structures on the one hand and between the systems of painting and of writing/drawing on the other. Although I have tentatively associated the fantasy of homosexual penetration with (an instance of) "graphic" seeing, I don't suggest that the two divisions are congruent; the truth is bound to be less tidy and more complex.

The image of a scalpel recurs in *The Agnew Clinic*, where however the blade is immaculate: Agnew apparently insisted that all traces of blood be removed from his hands and presumably from the scalpel as well (Goodrich, *Thomas Eakins*, 2:45). But note how one of the grooves in the wooden interior wall of the operating pit links up almost precisely with the point of Agnew's scalpel, a visual pun that can be read as implying that the groove was incised or even painted by that instrument. Still more telling in this connection is the preparatory portrait of Agnew in the Yale University Art Gallery, on which are painted directly below the blade of the scalpel and in pigment the color of dried blood the words "STUDY FOR THE / AGNEW POR / TRAIT / EAKINS." I think of this as the painter's revenge upon the surgeon for his fastidiousness, a suggestion independently made by David Lubin, *Act of Portrayal: Eakins, Sargent, James* (New Haven and London: Yale University Press, 1985), pp. 163–64, n. 28. Lubin also calls attention to the (headless) medical student at the upper left of *The Agnew Clinic* who has been depicted wielding a penknife "in the act of inscribing initials into the back of an upper row bench" (p. 39); it is hard to be sure that this is what the

student is doing, but in any case he is carving something into the back of the bench, an action that connects the later painting with the thematics of writing in *The Gross Clinic*. A further connection with that thematics is implied by the Latin text identifying Agnew as "SCRIPTOR ET DOCTOR CLARISSIMUS" that Eakins carved into the painting's frame.

Pursuing the metaphor of the scalpel as artist's tool would lead to a consideration of Eakins's production as a sculptor, including (or especially) his works in both deep and shallow relief, which in turn would complicate still further the account I have given of the unstable conjunction in his art of the systems of writing/drawing and of painting. But that too lies beyond the scope of this essay.

Finally, I offer the two extraordinary paragraphs that serve as an epigraph to this essay as evidence that at least one other person in Eakins's Philadelphia found the association of scalpel with pen literally inescapable (Samuel D. Gross, *Autobiography of Samuel D. Gross, M.D., with Sketches of His Contemporaries*, 2 vols. [Philadelphia: George Barrie, 1887], 1:176–77).

CHAPTER TWO

1. Stephen Crane, *Prose and Poetry*, ed. J. C. Levenson (New York: The Library of America, 1984), pp. 101–2. All subsequent references to texts by Crane by page numbers alone will be to this edition.

2. Cf. Neil Hertz, "Recognizing Casaubon," *The End of the Line: Essays on Psychoanalysis and the Sublime* (New York: Columbia University Press, 1985), pp. 75–96. The description of the dead soldier has been analyzed in the following terms by Frank Bergon:

> The movement of vision is from the general to the overwhelmingly particular; the words which bind the sentences together and intensify the focus are "corpse," "dead man," "ashen face," and finally "tawny beard." The wind raising the tawny beard is the contrasting detail which emphasizes the deadness of the man. Everything is cinematographic except the next sentence, which provides the scene with emotion; the beard "moved as if a hand were stroking it." Again, the inhuman is measured by the human, and this image of a living hand on a dead face only too poignantly accentuates the incomprehensible gulf that separates the living from the dead, the human from the nonhuman. The short, choppy sentences abruptly approximate the leaps by which a man grows in awareness. (*Stephen Crane's Artistry* [New York and London: Columbia University Press, 1975], pp. 13–14)

Bergon's assumption that Crane's prose proceeds by miming first perception and then growth of awareness exemplifies a central tradition in Crane criticism.

3. On the other hand, Johnson's death is erroneously announced in the next day's morning paper (p. 412); and when we are next shown him up close, being attended by Doctor Trescott in a bedroom at Judge Hagenthorpe's house where he was taken after the fire, his head is swathed in bandages that allow "only one thing to appear, an eye, which unwinkingly stared at the judge" (p. 413).

4. "The Upturned Face" is the fourth and incomparably the best of four short tales that relate the exploits of the Twelfth Regiment of the Line of the (imaginary) Spitzbergen army. According to R. W. Stallman, it is loosely based on an actual event, the burial under enemy fire of Marine surgeon John Blair Gibbs at Guantánamo on 10 June 1898 (*Stephen Crane: A Biography* [New York: George Braziller, 1968], pp. 362–64).

5. In Crane's letter of 4 November 1899 to his London literary agent, James B. Pinker, he characterizes the story he is sending him as "a double extra special good thing" and goes on to say, "I will not disguise from you that I am wonderfully keen on this small bit of 1500 words. It is so good—for me—that I would almost sacrifice it to the best magazine in England rather than see it appear in the best paying magazine" (R. W. Stallman and Lillian Gilkes, eds., *Stephen Crane: Letters* [New York: New York University Press, 1960], pp. 238–39; hereafter cited as *Letters*).

6. John Berryman discusses both the role of "Crane-masks" and Crane's peculiar practices of naming (and unnaming) characters in his fiction in *Stephen Crane: A Critical Biography* (1950; reprint, New York: Farrar, Straus, Giroux, 1977), pp. 193–94, 211–14, 309–13. Despite its somewhat reductive Freudian approach and although giving insufficient space to the interpretation of individual works, Berryman's book remains by far the most penetrating study of Crane to date. I might add that, as Berryman's study amply demonstrates, Crane's prose positively invites being understood psychoanalytically and that there will be moments in the present essay when my insistence on reading him in (ostensibly) quite other terms may strike some of my readers as willful if not perverse. Let me say, then, that I intend that insistence not as a refusal of psychoanalysis but as a means of focusing attention on a set of issues—the problematic of the materiality of writing alluded to in the preface to this book—that until now has had no place in Crane criticism. Nor do I doubt that it would be possible to reinterpret that problematic itself from a psychoanalytic perspective: indeed I more than once make explicit use of Freudian notions, and there is a sense in which a Lacanian emphasis on the materiality of the signifier is implicit in my entire approach (see n. 28 below). I am convinced, however, that a rigorously psychoanalytic—Freudian or Lacanian—reading of Crane's prose would have to take into account *all* the conclusions of this essay, conclusions such a reading could not arrive at strictly on its own.

Apropos of the name "Bill," the author-protagonist of "An Experiment in Misery," a text to be considered shortly, answers to the name "Willie," while the notion of will (in the sense of volition) figures prominently in a definition by Crane of the artist that I discuss toward the end of this essay.

7. In fact Crane often favored somewhat larger than usual sheets of writing paper, which nevertheless fall within the general parameters of face-likeness: for example, the final manuscript of *The Red Badge* is written on legal-cap paper measuring roughly thirteen inches by eight inches. Crane, *The Red Badge of Courage: A Facsimile Edition of the Manuscript*, 2 vols., ed. Fredson Bowers (Washington, D.C., 1973), 1:11.

8. The conclusion of the scene in the barbershop, with its moral reassurances crossed and in effect cancelled by Reifsnyder's fixation on Johnson's plight, sums up the remainder of the plot:

> The shaving of Bainbridge had arrived at a time of comparative liberty for him. "I wonder what the doctor says to himself?" he observed. "He may be sorry he made him live."
>
> "It was the only thing he could do," replied a man. The others seemed to agree with him.
>
> "Supposing you were in his place," said one, "and Johnson had saved your kid. What would you do?"
>
> "Certainly!"
>
> "Of course! You would do anything on earth for him. You'd take all the trouble in the world for him. And spend your last dollar on him. Well, then?"
>
> "I wonder how it feels to be without any face?" said Reifsnyder, musingly.
>
> The man who had previously spoken, feeling that he had expressed himself well, repeated the whole thing. "You would do anything on earth for him. You'd take all the trouble in the world for him. And spend your last dollar on him. Well, then?"
>
> "No, but look," said Reifsnyder; "supposing you don't got a face!" (pp. 423–24)

9. The pun on the verb "raised" in the passage from *The Red Badge* is doubled by the statement in the second paragraph that "the youth looked *keenly* at the ashen face" (italics mine). In this connection see Berryman's observations on what he takes to be Crane's oedipal imagery of knives, razors, and shaving (*Stephen Crane*, p. 313). Another knifelike instrument, a scalpel, turns up in a passage from "An Experiment in Misery" to be examined shortly.

10. Furthermore, Crane titled his first book of poems *The Black Riders, and Other Lines.* For reasons that will eventually become clear, Crane's poems lie beyond the scope of this essay (see n. 43 below); the principal study of the

poems remains Daniel G. Hoffman, *The Poetry of Stephen Crane* (New York and London: Columbia University Press, 1956).

11. "An Experiment in Misery" was published in the New York *Press*, 22 April 1894. Initially it had a framing narrative that explicitly alludes to issues of distance and point of view such as will become a concern of this essay. Levenson includes the framing narrative in the notes to his edition of Crane's writings (pp. 1366–68).

12. Streetcars in particular seem to have had this significance for Crane. For example, in one of his greatest stories, "The Blue Hotel," the hotel proprietor Pat Scully tries to reassure a seemingly demented Swede that he isn't about to be murdered by saying, "Why, man, we're going to have a line of ilictric street-cars in this town next spring"—this immediately after we are told that "as [the Swede] pulled on a strap [of his valise] his whole arm shook, the elbow wavering like a bit of paper" (p. 806). Scully's remarks might have proved more effective if lines in Crane weren't apt to encounter corpses: and in fact a moment later, still trying to pacify the Swede, Scully shows him a photograph of his dead daughter, Carrie (p. 807).

Returning to the passage just quoted from "An Experiment in Misery," a fifth image, that of the monstrous, crablike station squatting over the street, can be read as a (dis)figuration of the writer seated at a table and bent over the page.

A further point: the passage in question represents a revision of the original article on the occasion of the republication of "An Experiment in Misery" in a collection of 1898. For Alan Trachtenberg, the revisions add "a number of physical details that reinforce and particularize the sense of misery. Streetcars, which in the first version 'rumbled softly, as if going on carpet stretched in the aisle made by the pillars of the elevated road,' become a 'silent procession . . . moving with formidable power, calm and irresistible, dangerous [sic] and gloomy, breaking silence only by the loud fierce cry of the gong.' The elevated train station, now supported by 'leg-like pillars,' resembles 'some monstrous kind of crab squatting over the street.' These revisions and others suggest an intention more fully realized: the creation of physical equivalents to the inner experience of a 'moral region' of misery" ("Stephen Crane's City Sketches," in Eric J. Sundquist, ed., *American Realism: New Essays* [Baltimore and London: The Johns Hopkins University Press, 1982], pp. 150–51). I don't dispute Trachtenberg's conclusion, but would add that the revisions also suggest the fuller realization of an altogether different project.

13. The implicitly monstrous scale of the shadow fingers harks back also to the elevated station discussed in n. 12 (more on both further on).

14. The passage contains still another gerund, "mingling," that

eventually will also be associable with such a metaphorics. See my discussion of the becoming-visible and disappearing of thematizations of the scene of writing in the passage from *The Red Badge* beginning "The regiment slid down a bank and wallowed across a little stream" (pp. 128–30 below).

15. The title in question was given the sketch when it was published in the New York *Press,* but there is no evidence that it originated with Crane. On the other hand, the title "When Man Falls—" appears in the holograph inventory list of about July 1897, which suggests that Crane accepted it at least provisionally. See Crane, *Tales, Sketches, and Reports,* The University Press of Virginia Edition of the Works of Stephen Crane, ed. Fredson Bowers, 10 vols. (Charlottesville: The University Press of Virginia, 1969– 76), 8:868–70.

16. "When Man Falls" appeared 2 December 1894; *The Red Badge* began to be serialized the following day, first in the Philadelphia *Press* and then in the New York *Press* (9 December) as well as in several hundred smaller news- papers across the country (Stallman, *Stephen Crane,* p. 127). It is hard to know exactly what to make of the fact that the crucial word "battle" was introduced only in the process of revision; in a preliminary draft the sentence reads, "There were men who nearly created a riot in the madness of their desire to see the thing" (Crane, *Tales, Sketches, and Reports,* p. 351). Three years later, of course, the word "rioting" would itself contribute to a thematization of writing in the scene in the burning laboratory in *The Monster.*

17. As Crane himself recognized. Berryman quotes a letter of 1895 that takes issue with Henry James in the following terms: "What, though, does the man mean by disinterested contemplation? It won't wash. If you care enough about a thing to study it, you are interested and have stopped being disinterested. That's so, is it not? Well, Q.E.D. It clamours in my skull that there is no such thing as disinterested contemplation except that empty as a beerpail look that a babe turns on you and shrivels you to grass with. Does anybody know how a child thinks? The horrible thing about a kid is that it makes no excuses, none at all. They are much like breakers on a beach. They do something and that is all there is in it" (*Stephen Crane,* pp. 103–4). The remarks about how a child thinks and acts look forward to the representation of the abandoned peasant child in "Death and the Child," a story I discuss later in this essay. Even the figure of breakers on a beach and the association of being shamed by a child with the image of grass turn up again in that story. On the problematic nature of the concept of disinterest see also Stanley Cavell, *The Senses of 'Walden'* (New York: The Viking Press, 1972), pp. 115– 16.

18. Signs and legends of various sorts figure prominently in Crane's tales and sketches; no less than two signs—reading respectively "Free hot soup

tonight!" and "No mystery about our hash!"—appear in "An Experiment in Misery." It is striking too that "The Blue Hotel" climaxes (though it doesn't quite end) in the following short paragraph: "The corpse of the Swede, alone in the saloon, had its eyes fixed upon a dreadful legend that dwelt a-top of the cash-machine. 'This registers the amount of your purchase' " (p. 826). (The name of the easterner in that story is Mr. Blanc.) See also the treatment of signs in one of the Asbury Park sketches of the summer of 1892, "On the Boardwalk" (pp. 461–62). I owe to Mark Thistlethwaite the information that aspiring painters in the 1880s and 1890s (including Crane's friend Edgar Scudder Hamilton) often worked as sign painters, and that at that time sign painting was also referred to as sign writing.

19. "Death and the Child" is apparently set in the brief Greco-Turkish War in Crete of 1897. Crane, strongly sympathetic to the Greek cause, covered that war as a correspondent for the New York *Journal* (see Stallman, *Stephen Crane*, pp. 271–93).

20. As quoted for example by Milne Holton, *Cylinder of Vision: The Fiction and Journalistic Writings of Stephen Crane* (Baton Rouge: Louisiana State University Press, 1972), p. 10, and by Sergio Perosa, "Naturalism and Impressionism in Stephen Crane's Fiction," in *Stephen Crane: A Collection of Critical Essays,* ed. Maurice Bassan, Twentieth Century Views (Englewood Cliffs, N.J.: Prentice-Hall, Inc., 1967), p. 92. Also famous is Conrad's characterization of Crane to Edward Garnett as *"the only* impressionist and *only* an impressionist" (italics his; in *Letters,* p. 155). A useful collection of early reviews of Crane, which repeatedly characterize him as an impressionist, is *Stephen Crane: The Critical Heritage,* ed. Richard M. Weatherford (London and Boston: Routledge and Kegan Paul, 1973); see for example the article of 1898 by Edward Garnett, for whom Crane is "the chief impressionist of the age" (p. 228). Garnett also insists that Crane "keeps closer to the surface than any living writer" (p. 227), a feature of his manner that Garnett sees as both a strength and a limitation. According to R. G. Vosburgh, an illustrator with whom Crane shared a studio in 1893–94, "Impressionism was his faith. Impressionism, he said, was truth, and no man could be great who was not an impressionist, for greatness consisted in knowing truth. He said that he did not expect to be great himself, but he hoped to get near the truth" (quoted by Berryman, *Stephen Crane,* p. 73).

The remarks that immediately follow the characterization of Crane as *"only* an impressionist" in Conrad's letter to Garnett, self-serving though they may be, are of interest for the fully developed argument of this essay: "Why is [Crane] not immensely popular? With his strength, with his rapidity of action, with that amazing faculty of vision—why is he not? He has outline, he has color, he has movement, with that he ought to go very far. But—will he? I sometimes think he won't. It is not an opinion—it is a

feeling. I could not explain why he disappoints me—why my enthusiasm withers as soon as I close the book. While one reads, of course, he is not to be questioned. He is the master of his reader to the very last line—then—apparently for no reason at all—he seems to let go his hold" (*Letters*, p. 156). The preface to *The Nigger of the 'Narcissus'* is discussed by Ian Watt, *Conrad in the Nineteenth Century* (Berkeley and Los Angeles: The University of California Press, 1979), pp. 76–88.

21. Although I am following tradition in speaking of Crane as an "impressionist," by placing the term between quotation marks I mean to indicate that my use of it will be heuristic. Nothing could be more alien to the aims of this essay than to try to explain Crane's achievement by defining exactly the nature of his "impressionist" vision or technique, as for example James Nagel does when he claims that "what is unique about Crane's brand of Realism is his awareness that the apprehension of reality is limited to empirical data interpreted by a single human intelligence" (*Stephen Crane and Literary Impressionism* [University Park, Pa.: The Pennsylvania State University Press, 1980], p. 19).

22. That the "esthetic" point of view involves a failure of perspective is also implied by the statement that the stick in the child's hand "was much larger to him than was an army corps in the distance"—a disparity of scale that recalls the image of the corpselike sleeper's fingers lying full-length on the floor in "An Experiment in Misery." We might note too that the "calm interest" with which the child approaches Peza in the closing scene of the story isn't exactly the "empty as a beerpail look" that Crane equates with disinterested contemplation in n. 17 above.

23. It is as though the "journalistic" itself is divided between an aspiration to objectivity (the elevation of the sign in "When Man Falls," Peza feeling himself set on a pillar in "Death and the Child") and a desire for the ordinary (the legend on the sign, the deflation of the pillar image), which is to say that the "journalistic" contains within it a version of the larger conflict that I have described as one between "esthetic" and "journalistic" points of view. Put another way, the (heuristic) characterization of those points of view as "esthetic" and "journalistic" is less important by far than the recognition of the conflict they imply and indeed of their inherent instability. An earlier text by Crane that expresses a version of that conflict and instability is the last of the Sullivan County sketches, "The Mesmeric Mountain" (pp. 512–15).

24. Earlier in the story Peza is compared to "a corpse walking on the bottom of the sea, and finding there fields of grain, groves, weeds, the faces of men, voices" (p. 951). And a page or so later we read: "In the vale there was an effect as if one was then beneath the battle. It was going on above

somewhere. Alone, unguided, Peza felt like a man groping in a cellar" (p. 952). These are not exactly cheery sentences, but nor do they present Peza as terrified by his situation. His flight at the climactic moment must therefore be understood in the context of all the motifs that come together there, motifs that make the entire episode one that thematizes writing with a vengeance. An earlier text by Crane that has a bearing on the notion of a subterranean "space" of representation is "In the Depths of a Coal Mine"; see below, pp. 137–41.

25. "On Dreams," *The Standard Edition of the Complete Psychological Works of Sigmund Freud,* 24 vols., trans. James Strachey (London: Hogarth Press, 1953–74), 5:641 and *passim.*

26. Ibid., 5:678.

27. Ibid., 5:679–80.

28. Incontestably the most influential such developments are associated with the work of Jacques Derrida, from whom I have taken the phrase "scene of writing" (see his essay, "Freud and the Scene of Writing," *Writing and Difference,* trans. Alan Bass [Chicago: The University of Chicago Press, 1978], pp. 196–231), and Jacques Lacan (see, e.g., "The agency of the letter in the unconscious or reason since Freud," *Ecrits,* trans. Alan Sheridan [New York: W. W. Norton & Company, 1977], pp. 146–78). Equally relevant to the present essay is Cavell's *The Senses of 'Walden',* in which it is argued that "[while] we seem to be shown [the hero of *Walden*] doing everything under the sun but, except very infrequently, writing . . . [,] each of his actions is the act of a writer, . . . every word in which he identifies himself or describes his work and his world is the identification and description of what he understands his literary enterprise to require" (p. 5). Less vital to my argument, Paul de Man's essays "Autobiography as De-Facement" and "Wordsworth and the Victorians" (*The Rhetoric of Romanticism* [New York: Columbia University Press, 1984], pp. 67–92) pursue a complex thematics of facemaking and defacement keyed to issues not of writing as such but rather of language and rhetoric. However, the critique by Steven Knapp and Walter Benn Michaels of what they take to be de Man's view that "the material condition of language is not simply meaningless but is already 'linguistic,' that is, sounds are signifiers even before meanings (signifieds) are added to them" is pertinent to the fully developed argument of this essay. See Knapp and Michaels, "Against Theory," *Critical Inquiry* 8 (Summer 1982): 723–42; the remarks quoted are on p. 734. The essay by de Man they discuss is "The Purloined Ribbon," *Glyph,* no. 1 (1977): 28–49, reprinted as "Excuses (*Confessions*)" in *Allegories of Reading: Figural Language in Rousseau, Nietzsche, Rilke, and Proust* (New Haven and London: Yale University Press, 1979), pp. 278–301. Finally, the figure of the blank page has been exam-

ined from a feminist perspective by Susan Gubar in her article, "'The Blank Page' and the Issues of Female Creativity," *Critical Inquiry* 8 (Winter 1981): 243–63.

29. For example, there is the "ruby-red snakelike thing" in the passage from *The Monster;* in "The Upturned Face" the dead man's clothes are searched for "things" and the open grave is called (or addressed as) "poor little shallow thing"; and the man undergoing a seizure in "When Man Falls" is characterized both simply as a "thing" (in the sentence, "There were men who nearly created a battle in the madness of their desire to see the thing.") and more fully as "the inanimate thing on the pave" (in the astounding serpentine construction, "Through his pallid half-closed lids could be seen the steel-colored gleam of his eyes that were turned toward all the bending, swaying faces and in the inanimate thing upon the pave yet burned threateningly, dangerously, shining with a mystic light, as a corpse might glare at those live ones who seemed about to trample it under foot."). Closer in feeling to the "chapel" scene is the one-sentence paragraph in *The Monster* that recounts Johnson's removal from the burning house: "But a young man who was a brakeman on the railway, and lived in one of the streets near the Trescotts, had gone into the laboratory and brought forth a thing which he laid on the grass" (p. 408).

30. Berryman, *Stephen Crane*, p. 268.

31. These speculations recall Maurice Blanchot's essay, "Two Versions of the Imaginary," in which the peculiar sense in which a cadaver may be said to resemble the person who has died—"The cadaver is its own image" is Blanchot's formulation—becomes paradigmatic for representation as such (*The Gaze of Orpheus,* trans. Lydia Davis [Barrytown, N.Y.: Station Hill, 1983], pp. 79–89, esp. p. 83). That is, Blanchot takes the usual notion of an image "coming after" or "following" from the thing or object it images to mean that the thing or object must move away or even disappear (i.e., "die") in order to be grasped again in the relation of resemblance. "The thing was there," he writes, "we grasped it in the living motion of a comprehensive action—and once it has become an image it instantly becomes ungraspable, noncontemporary, impassive, not the same thing distanced, but that thing as distancing, the present thing in its absence, the thing graspable because ungraspable, appearing as something that has disappeared, the return of what does not come back, the strange heart of the distance as the life and unique heart of the thing" (pp. 80–81). Blanchot's not entirely perspicuous remarks are usefully glossed by Eugenio Donato in "The Crypt of Flaubert," in *Flaubert and Postmodernism,* ed. Naomi Schor and Henry F. Majewski (Lincoln, Neb., and London: University of Nebraska Press, 1984), pp. 32–34; see also the "Afterword" by P. Adams Sitney in *The Gaze of Orpheus,* pp. 182–83. My attention was first drawn to Blanchot's essay by Fred Maus.

Two powerful recent discussions of animism might also be mentioned in this connection: the first by Stanley Cavell in his unpublished Beckman Lectures on Romanticism and Skepticism, delivered under the auspices of the Department of English at the University of California, Berkeley, in February 1982; and the second by Elaine Scarry in the chapter called "The Interior Structure of the Artifact" in *The Body in Pain: The Making and Unmaking of the World* (New York and Oxford: Oxford University Press, 1985), pp. 278–326.

32. Thus for example it is said of Fleming in chapter one: "He had read of marches, sieges, conflicts, and he had longed to see it all. His busy mind had drawn for him large pictures extravagant in color, lurid with breathless deeds" (p. 83). The conjunction of reading, seeing, and drawing or picturing in these sentences is paradigmatic.

33. One attempt at explanation would have it that Fleming, guilt-ridden at having run from combat, is now in the grip of "an obscure but nevertheless powerful compulsion" that drives him to "go close and see [the battle] produce corpses" (Maxwell Geismar, "The Psychic Wound of Henry Fleming Crane," in Crane, *The Red Badge of Courage,* ed. Sculley Bradley, Richmond Croom Beatty, and E. Hudson Long, Norton Critical Editions [New York: W. W. Norton & Co., 1962], p. 260). (Hereafter cited as Norton Critical Edition.) But Fleming's obsession with seeing the battle at work precedes his running away, and in any case it would not be difficult to show that traditional psychological accounts of Fleming's actions and experiences fall far short of making coherent sense of the details of the narrative.

34. Cf. the following paragraph from the last chapter of *The Red Badge:* "[The youth] understood then that the existence of shot and countershot was in the past. He had dwelt in a land of strange, squalling upheavals and had come forth. He had been where there was red of blood and black of passion, and he was escaped. His first thoughts were given to rejoicings at this fact" (p. 210).

35. R. W. Stallman, "[Kipling's Wafer—and Crane's]," in Crane, *The Red Badge of Courage,* Norton Critical Edition, p. 165 (I have combined portions of two sentences). According to Edwin H. Cady: "As messy, expensive sealing wax passed out of use, it was replaced by a useful imitation of paper or other substance. Round, with neatly serrated edges stylizing the irregularities of a wax seal, often a deep, solid red as wax had been, these often gummed 'wafers' were used to seal letters, packages, documents, etc." (*Stephen Crane* [New York: Twayne Publishers, Inc., 1962], p. 137). Stallman nevertheless maintains that Crane's wafer image also represents the wafer of the Mass, a view that Cady persuasively contests.

36. For representative specimens of totalizing accounts of the novel see, for example, the excerpts from books or essays by Stallman, Geismar, Charles

C. Walcutt, M. Solomon, Stanley B. Greenfield, Eric Solomon, and James B. Colvert in Crane, *The Red Badge of Courage,* Norton Critical Edition; and by Mordecai Marcus, Edwin H. Cady, Kermit Vanderbilt and Daniel Weiss, John W. Rathburn, and Marston LaFrance in the second edition of the above, revised by Donald Pizer (New York, 1976). Some of these critics understand themselves to be refuting earlier commentators such as Edward Garnett and William Dean Howells who asserted the episodic, fragmentary, and repetitive (i.e., nontotalizable) character of the narrative in *The Red Badge.* More recently, Henry Binder has argued for the textual primacy of the handwritten manuscript of *The Red Badge* over the Appleton edition of 1895 largely on the basis of comparative totalizing psychological and moralistic readings of the two versions ("The *Red Badge of Courage* Nobody Knows," in *The Red Badge of Courage,* ed. Binder [New York: Avon Books, 1979, 1982], pp. 111–58, especially pp. 136–49). (For Binder, the overriding question is whether by the end of the novel Fleming has come to any real understanding of himself or compassion for others [p. 149]). See also Steven Mailloux, *Interpretive Conventions: The Reader in the Study of American Fiction* (Ithaca and London: Cornell University Press, 1982), pp. 160–65, 178–97; and Hershel Parker, "*The Red Badge of Courage:* the Private History of a Campaign that—Succeeded?," *Flawed Texts and Verbal Icons: Literary Authority in American Fiction* (Evanston, Ill.: Northwestern University Press, 1984), pp. 147–79.

Among previous commentators on *The Red Badge,* my views are closest to those of Warner Berthoff and Donald Pease regarding the question of the relation of the imagery (more broadly the prose) of *The Red Badge* to what I have been calling the novel's "manifest" content. Berthoff writes:

> . . . Crane's work presents itself not as a record of impressions and observations drawn from life but as a barrage of self-generating images and inward conceits whose essential function is to rival life, perhaps supplant it. He is, at his best, a visionary writer (Conrad is at the edge of saying so), and his authority is a visionary authority. It is visionary in a peculiar way, however, in that the images it presents refer to nothing equally authoritative beyond themselves, no clear pattern of understanding, no really coherent structure of imaginative experience. Except by a kind of parodic mimicry, they scarcely even refer to each other or to the narrative events they coexist with. *The Red Badge of Courage* is the fullest demonstration of Crane's special power; again and again particular gestures or moments of consciousness are given a dream-like authority. But these visionary flashes are as fleeting as they are brilliant. The emotions, the dramatic convergences, that contribute to their making somehow do not survive their crystallization in words. As they thus form no proper succession, neither can they be made to yield up a coherent narrative theme or argument. There is a gap between the story and the concrete demonstration that would be disastrous to the work as a whole if the story was anything more than a moving screen for the

author's vision-generating eye to project its inventions upon. . . . Nothing quite like this naked magic-lantern work exists elsewhere in our literature. Even Poe's inventions carry a more consistent reference to common experience or to some stable conception of it. (*The Ferment of Realism: American Literature, 1884–1919* [New York: The Free Press, 1965], pp. 231–32)

Obviously I don't agree that Crane's images refer to nothing outside themselves; but Berthoff's insistence on the essentially irruptive character of those images and his recognition that there exists "a gap between the story and the concrete demonstration" seem to me acute.

Recently, Pease (who doesn't cite Berthoff) has argued vigorously against the prevailing critical tendency to "[read] a coherent line of character development into the arbitrary incidents in Henry's life" ("Fear, Rage, and the Mistrials of Representation in *The Red Badge of Courage,*" in Sundquist, ed., *American Realism,* p. 157). Discussing a passage from chapter nineteen that I shall examine briefly in n. 44 (beginning "It seemed to the youth that he saw everything."), Pease remarks:

> In this description, each colorful image surges up all foreground, with a suddenness whose intensity is unmediated by a context capable of either subduing or containing it. Instead of settling into that relationship in which a figure is clearly contextualized within a stable ground and which a coherent picture is supposed to guarantee, these 'firm impressions' glare out as if in defiance of an implicit order to move into perspective. Not only the individual impressions fail to modify one another, however; so do the sentences in which they appear. These sentences do not describe a sequence in which new facts are 'comprehended' by an overall principle of coherence. Without any perspective capable of sorting out the relevant from the irrelevant, everything crowds into Henry's consciousness with all the force of confusion. (p. 158)

Pease goes on to argue that "Crane's text is remarkable for its refusal to favor the meaningful narrative. By persistently locating Henry in the space between unrelieved contingency and imposed narrative, Crane inveigles the arbitrariness usually associated with the chance event into the orderly narrative sequence" (pp. 159–60). Here too I would contend that the irruptiveness of the images, which is to say their refusal to submit to what Pease calls "the meaningful narrative," is itself grounded in the writer's relation to the scene of writing. But I am largely in agreement with Pease's evocation of the discontinuous texture of Crane's prose and of the consequences of that discontinuity for the meaningful (or "manifest") narrative.

37. Another preflight instance of Fleming's scopic compulsion that doesn't mention corpses but spectacularly figures writing comes at the end of chapter four (Fleming is witnessing a mass retreat from the scene of battle):

> The battle reflection that shone for an instant in the faces on the mad current

made the youth feel that forceful hands from heaven would not have been able to have held him in place if he could have got intelligent control of his legs.

There was an appalling imprint upon these faces. The struggle in the smoke had pictured an exaggeration of itself on the bleached cheeks and in the eyes wild with one desire.

The sight of this stampede exerted a floodlike force that seemed able to drag sticks and stones and men from the ground. They of the reserves had to hold on. They grew pale and firm, and red and quaking.

The youth achieved one little thought in the midst of this chaos. The composite monster which had caused the other troops to flee had not then appeared. He resolved to get a view of it, and then, he thought he might very likely run better than the best of them. (pp. 109–10)

In the bravura second paragraph, the "one desire" can logically be nothing other than a desire to flee, and yet the passage as a whole conveys the strong suggestion that the eyes are also wild with the desire to remain fixated upon that which has terrorized them. Indeed the imprinted faces read simultaneously as figures for the page being written and for the fixated attention of the writer, the two mirroring one another indistinguishably (cf. the image of "reflection" in the previous paragraph).

38. As if to downplay the significance of the encounter, however, Fleming's sense of disappointment at not discovering "an intense scene. . . as he came to the top of the bank" is insisted upon in the paragraph immediately following the description of the dead soldier (p. 102). But then as if to compensate for that, we are told a few paragraphs later that in Fleming's view "[t]here was but one pair of eyes in the corps" (p. 103), an assertion that recalls the encounter with the *corpse* that has just taken place and thereby invites speculation about exactly whose eyes have been doing the looking all along. (We might think of this as another "mirroring" effect, comparable to that discussed in n. 37.) The larger passage from which these quotations have been taken, which ends with Fleming's assuming "the demeanor of one who knows that he is doomed alone to unwritten responsibilities" (ibid.), is of considerable interest.

39. Here for example is the redoubtable Pete bragging to Maggie and her younger brother Jimmie:

"I met a chump deh odder day way up in deh city," he said. "I was goin' teh see a frien' of mine. When I was a-crossin' deh street deh chump runned plump inteh me, an' den he turns aroun' an' says, 'Yer insolen' ruffin,' he says, like dat. 'Oh, gee,' I says, 'oh, gee, go teh hell an' git off deh eart',' like dat. Den deh blokie he got wild. He says I was a contempt'ble scoun'el, er someting like dat, an' he says I was doom' teh everlastin' pe'dition an' all like dat. 'Gee,' I says, 'gee! Deh hell I am,' I says. 'Deh hell I am,' like dat. An' den I slugged 'im. See?" (p. 27)

40. See also the various instances of repetition in chapter four as the regiment prepares to take the brunt of an enemy charge. For example:

> A hatless general pulled his dripping horse to a stand near the colonel of the 304th. He shook his fist in the other's face. "You 've got to hold 'em back!" he shouted, savagely; "you 've got to hold 'em back!"
>
> In his agitation the colonel began to stammer. "A-all r-right, General, all right, by Gawd! We-we 'll do our—we-we 'll d-d-do—do our best, General." The general made a passionate gesture and galloped away. The colonel, perchance to relieve his feelings, began to scold like a wet parrot. The youth, turning swiftly to make sure that the rear was unmolested, saw the commander regarding his men in a highly resentful manner, as if he regretted above everything his association with them.
>
> The man at the youth's elbow was mumbling, as if to himself: "Oh, we 're in for it now! oh, we 're in for it now!" (pp. 111–12)

41. William James, *The Principles of Psychology* (1890; reprint, Cambridge, Mass., and London: Harvard University Press, 1983), p. 726. (Hereafter cited as *Principles.*)

42. Ibid., pp. 726–27.

43. Poetry, on the other hand, characteristically pursues effects of denaturalization, which is perhaps the main reason why the reading of Crane's prose I have been advancing doesn't readily cover his poems. In this connection it is striking that the poems in *The Black Riders, and Other Lines* were printed wholly in capitals, a typographic device plainly intended to call attention to their differentness from prose (see for example the contemporary review by T. W. Higginson, who remarks that "the capitalization of every word seems to imply that the author sought thus to emphasize his 'lines' . . . to express his sense of their value" [Weatherford, ed., *Stephen Crane: The Critical Heritage,* p. 68]).

44. For example, when Fleming first informed his mother that he planned to enlist, she told him not to be a fool and then "covered her face with her hands" (p. 84). A paragraph later there is this:

> When he had stood in the doorway with his soldier's clothes on his back, and with the light of excitement and expectancy in his eyes almost defeating the glow of regret for the home bonds, he had seen two tears leaving their trails on his mother's scarred cheeks.
>
> Still, she had disappointed him by saying nothing whatever about returning with his shield or on it. He had privately primed himself for a beautiful scene. He had prepared certain sentences which he thought could be used with touching effect. But her words destroyed his plans. (p. 84)

Finally, his departure for the war is recounted as follows:

> . . . when he had looked back from the gate, he had seen his mother kneeling

among the potato parings. Her brown face, upraised, was stained with tears, and her spare form was quivering. He bowed his head and went on, feeling suddenly ashamed of his purposes. (p. 85)

All this is suggestive, but it appears even more so when we consider certain brief passages present in the final manuscript but absent from the first published version, the Appleton & Co. edition of 1895. Specifically, the youth's mother urges him: "'Yeh aint never been used t' doin' fer yerself. So yeh must keep writin' t' me how yer clothes are lastin'" (Crane, *The Red Badge of Courage,* ed. Binder, p. 5). And a moment later she adds:

> "Don't fergit t' send yer socks t' me th' minute they git holes in'em an' here's a little bible I want yeh t' take along with yeh, Henry. I dont presume yeh'll be a-settin' readin' it all day long, child, ner nothin' like that. Many a time, yeh'll fergit yeh got it, I don't doubt. But there'll be many a time, too, Henry, when yeh'll be wantin' advice, boy, an' all like that, an' there'll be nobody round, p'rhaps, t' tell yeh things. Then if yeh take it out, boy, yeh'll find wisdom in it—wisdom in it, Henry—with little or no searchin'. (Ibid.)

I find it at least potentially significant that the deleted passages expressly present Fleming as a prospective writer and reader, as if they went too far in that direction and therefore had to be suppressed. In this connection see also the pages from an earlier draft of chapter twelve, one of which includes the following paragraph:

> He thought for a time of piercing orations starting multitudes and of books wrung from his heart. In the gloom of his misery, his eyesight proclaimed that mankind were bowing to wrong and ridiculous idols. He said that if some all-powerful joker should take them away in the night, and leave only manufactured shadows falling upon the bended heads, mankind would go on counting the hollow beads of their progress until the shriveling of the fingers. He was a-blaze with desire to change. He saw himself, a sun-lit figure upon a peak, pointing with true and unchangeable gesture. "There!" And all men could see and no man would falter. (Ibid., p. 55)

In addition to which there is this in the final manuscript:

> Some poets now received his scorn. Yesterday, in his misery, he had thought of certain persons who had written. Their remembered words, broken and detached, had come piece-meal to him. For these people he had then felt a glowing, brotherly regard. They had wandered in paths of pain and they had made pictures of the black landscape that others might enjoy it with them. He had, at that time, been sure that their wise, contemplating spirits had been in sympathy with him, had shed tears from the clouds. He had walked alone, but there had been pity, made before a reason for it.
>
> But he was now, in a measure, a successful man and he could no longer tolerate in himself a spirit of fellowship for poets. He abandoned them. Their

songs about black landscapes were of no importance to him since his new eyes said that his landscape was not black. People who called landscapes black were idiots. He achieved a mighty scorn for such a snivelling race. (Ibid., p. 72)

But of course scorn expressed in these terms foregrounds rather than suppresses a relation to literary writing, hence perhaps the disappearance of the passage from the Appleton edition.

Among the battle narratives in the last third of *The Red Badge,* virtually the whole of chapter nineteen, which narrates the regiment's charge into heavy fire and concludes with an account of Fleming and a friend seizing the Union flag from a dying color sergeant as he falls, is pertinent to my argument. There we encounter passages like:

Other men, punched by bullets, fell in grotesque agonies. The regiment left a coherent trail of bodies.

They had passed into a clearer atmosphere. There was an effect like a revelation in the new appearance of the landscape. Some men working madly at a battery were plain to them, and the opposing infantry's lines were defined by the gray walls and fringes of smoke.

It seemed to the youth that he saw everything. Each blade of the green grass was bold and clear. He thought that he was aware of every change in the thin, transparent vapor that floated idly in sheets. The brown or gray trunks of the trees showed each roughness of their surfaces. And the men of the regiment, with their starting eyes and sweating faces, running madly, or falling, as if thrown headlong, to queer, heaped-up corpses—all were comprehended. His mind took a mechanical but firm impression, so that afterward everything was pictured and explained to him, save why he himself was there. (p. 183)

And:

The command went painfully forward until an open space interposed between them and the lurid lines. Here, crouching and cowering behind some trees, the men clung with desperation, as if threatened by a wave. They looked wild-eyed, and as if amazed at this furious disturbance they had stirred. In the storm there was an ironical expression of their importance. The faces of the men, too, showed a lack of a certain feeling of responsibility for being there. It was as if they had been driven. It was the dominant animal failing to remember in the supreme moments the forceful causes of various superficial qualities. The whole affair seemed incomprehensible to many of them. (p. 185)

And at somewhat greater length:

Within him, as he hurled himself forward, was born a love, a despairing fondness for this flag which was near him. It was a creation of beauty and invulnerability. It was a goddess, radiant, that bended its form with an imperious gesture to him. It was a woman, red and white, hating and loving, that called him with the voice of his hopes. Because no harm could come to it he endowed it

with power. He kept near, as if it could be a saver of lives, and an imploring cry went from his mind.

In the mad scramble he was aware that the color sergeant flinched suddenly, as if struck by a bludgeon. He faltered, and then became motionless, save for his quivering knees.

He made a spring and a clutch at the pole. At the same instant his friend grabbed it from the other side. They jerked at it, stout and furious, but the color sergeant was dead, and the corpse would not relinquish its trust. For a moment there was a grim encounter. The dead man, swinging with bended back, seemed to be obstinately tugging, in ludicrous and awful ways, for the possession of the flag.

It was past in an instant of time. They wrenched the flag furiously from the dead man, and, as they turned again, the corpse swayed forward with bowed head. One arm swung high, and the curved hand fell with heavy protest on the friend's unheeding shoulder. (pp. 186–87)

In lieu of detailed commentary, I want to emphasize the relationship between the allusions to vapor floating in *sheets* and to rough *surfaces* of trees in the first quotation and an extraordinary sentence from the second in which what is figured, it seems to me, is precisely an obliviousness to the scene of writing imagined as an affair of surfaces: "It was the dominant animal failing to remember in the supreme moments the forceful causes of various *superficial* qualities" (italics mine). (Note, by the way, how difficult it is to integrate the phrase "superficial qualities" into a reading of the novel on what I have been calling the "manifest" level, at least without having recourse to a notion of irony that papers over that difficulty without in the least resolving it.) Similarly, I suggest that the first quotation's "mechanical but firm impression" of the scene of battle may be read as a figure for an automatic or unconscious mode of writing, and that, taking Fleming as a surrogate for the writer, as in this exact and fleeting context I believe we are justified in doing, the subsequent failure or inability of that impression to picture or explain "why he himself was there" becomes in turn a figure for the repression of the scene of writing and hence for the success of Crane's "impressionist" project. Finally, I want to call attention to the characteristic mobility with which, in the third quotation, the flag that Fleming is said to endow with power participates in a thematization of the written page under opposing aspects: the first attractive or narcissistic ("It was a woman, red and white, hating and loving, that called him with the voice of his hopes."), the second repulsive or at least agonistic in the sense of having to be wrested from the dead color sergeant's grasp (and note how Fleming's friend grabbing the flagpole "from the other side" further complicates this image, as does the action of the corpse's arm and hand in the last sentence).

All this scarcely exhausts the interest of these passages and doesn't begin

to evoke the all but continuous relevance of chapter nineteen to our inquiry, but it perhaps gives some idea of the terms in which that relevance contends for our alerted attention with the "manifest" subject of the narrative. Cf. the brief account in chapter twenty-three of the last moments of the mortally wounded enemy color-bearer, whose face is described as marked both by "the bleach of death" and by "dark and hard lines of desperate purpose" (p. 206). The account concludes: "The youth's friend went over the obstruction in a tumbling heap and sprang at the flag as a panther at prey. He pulled at it and, wrenching it free, swung up its red brilliancy with a mad cry of exultation even as the color bearer, gasping, lurched over in a final throe and, stiffening convulsively, turned his dead face to the ground. There was much blood upon the grass blades" (p. 207). Here the mobility just referred to involves successive thematizations of the written page via images of the flag, of the dead face of the slain color bearer now turned to the ground (like a page added face down to a pile of sheets already filled with words), and of the grass blades covered with blood.

45. Some of these connections are remarked by Berryman, *Stephen Crane*, pp. 192–93, and by James Hafley, "'The Monster' and the Art of Stephen Crane," originally published 1959, reprinted in Thomas A. Gullason, ed., *Stephen Crane's Career: Perspective and Evaluations* (New York: New York University Press, 1972). Hafley, however, interprets *The Monster* as thematically unified around the idiom "to lose face," which obviously won't do; Max Westbrook argues that it won't, but his preferred solution, a "dualistic" reading that holds that Crane's subject is guilt and responsibility, is scarcely an improvement ("Whilomville: The Coherence of Radical Language," in Joseph Katz, ed., *Stephen Crane in Transition: Centenary Essays* [DeKalb, Ill.: Northern Illinois University Press, 1972], pp. 86–105).

Significantly, the railroad imagery of the opening is twice underscored in the pages that follow: the man being shaved by Reifsnyder when the latter asks, "How would you like to be with no face?" is Bainbridge, a railway engineer (pp. 422–24); and the young man who carries Johnson out of the burning laboratory and lays him on the grass is identified simply as a brakeman on the railway (p. 408).

46. Not surprisingly, such interpretations have dominated the critical literature, the articles by Hafley and Westbrook cited in n. 45 being cases in point. See also Marston LaFrance, *A Reading of Stephen Crane* (Oxford: Clarendon Press, 1971), p. 207. On the other hand, the resistance of *The Monster* to being understood solely in terms of its "heroic narrative"—"a black man risks his life for a boy, is saved by the moral courage of the boy's father, and then is made a martyr, together with the boy's father, by the social hypocrisy of the townsfolk"—is stressed in a recent article by Michael D. Warner, who sees that narrative as contravened by another, antipathetic one and the reader

therefore as suspended between the two ("Value, Agency, and Stephen Crane's 'The Monster,'" *Nineteenth-Century Fiction* 40 [June 1985]: 76–93). Berthoff too stresses disjunction, though of a different sort: "[T]he conventional village ironies in 'The Monster' about the practice of charity and common decency draw what force they have from the strange, self-animating flame-blossoms and chemical serpents in the burning laboratory where the Negro stableman saves his employer's son and is himself deformed; without these actual terrors we are left with a sentimental parable more outlined (though it is brilliantly outlined) than told" (*The Ferment of Realism*, p. 233).

47. For Crane's concern with word counts and fees see, for example, his letters to his literary agents, Paul Revere Reynolds and James B. Pinker, in *Letters*. The following excerpt is representative: "My dear Pinker: I am sending you another of the Whilomville stories for Harper and Bros. It is 4095 words and for it they will pay you (at $50 per thousand) something over forty pounds. Please send me £30 by next post. I need it badly" (p. 214). See also the letter to Reynolds mentioning *The Monster* and giving its length as 21,000 words (p. 144). A three-page inventory list of titles plus word counts is illustrated in Crane, *Tales, Sketches, and Reports* (between pp. xxxii and xxxiii).

The two pages I have chosen to illustrate are from the original manuscript of *The Red Badge*. Unfortunately, there is extant today only a single leaf of manuscript of *The Monster*, neither side of which (there is text on both sides) shows Crane doing sums of words. However, on the recto of the leaf, in addition to the foliation "64" and the section heading "XXXIII," we find "[p]arallel with the long side of the paper and written in black ink . . . the number 70, circled, and below this the number 400 with a short rule beneath it. These appear to be in Crane's hand. About halfway down the page and parallel with the short side of the paper, double circled, is the pencil figure 102, also probably in Crane's hand" (Fredson Bowers, ed., Crane, *Tales of Whilomville*, The University of Virginia Edition of the Works of Stephen Crane, 7:5).

48. Crane, *Tales, Sketches, and Reports*, pp. 512–13; the piece appeared in the New York *Tribune*, 17 July 1892.

49. A passage in Crane's *War Memories*, his memoir of the Spanish-American War, combines both terms of the opposition in a single mysterious figure:

> On top of the hill one had a fine view of the Spanish lines. We started across almost a mile of jungle to ash-colored trenches on the military crest of a ridge. A goodly distance back of this position were white buildings, all flying great red-cross flags. The jungle beneath us rattled with firing and the Spanish trenches cracked out regular volleys, but all this time there was nothing to indicate a tangible enemy. In truth, there was a man in a Panama hat strolling to and fro

behind one of the Spanish trenches, gesticulating at times with a walking-stick. A man in a Panama hat, walking with a stick! That was the strangest sight of my life—that symbol, that quaint figure of Mars. The battle, the thunderous row, was his possession. He was the master. He mystified us all with his infernal Panama hat and his wretched walking-stick. From near his feet came volleys and from near his side came roaring shells, but he stood there alone, visible, the one tangible thing. He was a Colossus and he was half as high as a pin, this being. Always somebody would be saying: "Who *can* that fellow be?" (Crane, *Tales of War*, ed. Bowers, The University of Virginia Edition of the Works of Stephen Crane, 6:244–45)

If one thinks of the stick as a version of the writer's pen or pencil, the last question all but answers itself. Cf. the sentence with which Crane in the final manuscript initially ended *The Red Badge:* "Yet the youth smiled, for he saw that the world was a world for him, though many discovered it to be made of oaths and walking sticks" (p. 212), as well as the brief account of Judge Hagenthorpe's psychic dependence on his cane in *The Monster* (pp. 412–13).

50. The conviction that the last scene is one of reading painfully that which has already (painfully) been written is sharpened for me by the recognition that Trescott's helpless "There, there" to his wife repeats Jimmie's repeated "There!"—pointing at the destroyed flower—in the novella's opening pages (pp. 391–92). Cf. the exclamation "There!"—pointing at what exactly?—in the paragraph from an early draft of *The Red Badge,* quoted in n. 44 above.

51. However, there is in Crane's oeuvre a still later story, "Manacled," in which defeat triumphs unconditionally. Its bizarre plot is this: the hero of a play, having been victimized by his enemies and unjustly sent to prison, stands panting with rage as two brutal warders fasten real handcuffs on his wrists and real anklets on his ankles (this closely reproduces the actual text [p. 1291]); just then a fire breaks out in the theater, and the actor playing the hero is abandoned by the rest of the cast; his face turns chalk color beneath his makeup as he takes in the dangerousness of his situation; he struggles desperately to make his way down one flight of steps and up another (we are told that each step "arose eight inches from its fellow" [p. 1293]); but in the end, having fallen to the foot of the ascending flight, he realizes that there is no escape. The last paragraphs read:

He lay there whispering. "They all got out but I. All but I." Beautiful flames flashed above him, some were crimson, some were orange, and here and there were tongues of purple, blue, green.

A curiously calm thought came into his head. "What a fool I was not to foresee this! I shall have Rogers furnish manacles of papier-mâché to-morrow."

The thunder of the fire-lions made the theatre have a palsy.

Suddenly the hero beat his handcuffs against the wall, cursing them in a loud

wail. Blood started from under his finger-nails. Soon he began to bite the hot steel, and blood fell from his blistered mouth. He raved like a wolf.

Peace came to him again. There were charming effects amid the flames. . . . He felt very cool, delightfully cool. . . . "They've left me chained up." (p. 1293)

It is as though Crane, who when he wrote these paragraphs surely knew he was dying, figures his own death through that of a surrogate who cannot use his hands (hence cannot write) even as he is about to be consumed by a conflagration that here as elsewhere in Crane's work may be read as representing writing ("There were charming effects amid the flames."). There is even, near the beginning of the story, a posthumous perspective on the scene of writing (and reading): "Most of the people who were killed on the stairs still clutched their play-bills in their hands as if they had resolved to save them at all costs" (p. 1291).

52. The phrase "exquisite legibility" comes from a reminiscence of Crane by Frank W. Noxon, a former classmate at Syracuse University (*Letters*, p. 334).

53. Joseph Conrad, "Introduction," in Thomas Beer, *Stephen Crane: A Study in American Letters* (Garden City, N.Y.: Garden City Publishing Co., 1927), p. 27.

54. Hamlin Garland, "Stephen Crane as I Knew Him," originally published Spring 1914, *Yale Review* 75 (Autumn 1985): 7–8. According to Garland, Crane said of his poems that they needed only to be "drawn off" (p. 8). In an article published shortly after Crane's death Garland writes: "I can see the initial poem now, exactly as it was then written, without a blot or erasure—almost without punctuation—in blue ink. It was beautifully legible and clean of outline" ("Stephen Crane: A Soldier of Fortune," *Letters*, p. 302).

55. *Letters*, p. 342.

56. Ford Madox Ford, "[Crane's Life in England]," in Crane, *The Red Badge of Courage*, Norton Critical Edition, p. 230. Ford's description is confirmed in turn by Cora Crane, who comments in a note made after Stephen Crane's death: "Handwriting had a tendency to grow microscopic—ms. seldom corrected even punctuation & penmanship wonderfully neat x Sometimes misspelled & never kept papers neat—never cared for ms until married—wrote slowly forming each letter with greatest care" (in Crane, *Poems and Literary Remains*, ed. Bowers, The University of Virginia Edition of the Works of Stephen Crane, 10:345).

57. James, *Principles*, p. 741; quoted (in translation) from M. Lazarus, *Das Leben der Seele*. The passage continues: "More than half of the words come out of their mind, and hardly half from the printed page. Were this not so, did we perceive each letter by itself, typographic errors in well-known words would never be overlooked. . . . In a foreign language, although it may be printed with the same letters, we read by so much the more slowly as we do

not understand, or are unable promptly to perceive, the words. But we notice misprints all the more readily."

58. Ibid., n. 19. James's argument here is framed in terms of hearing rather than reading, but the same general considerations are in force in the two cases:

> In the ordinary hearing of speech half the words we seem to hear are supplied out of our own head. A language with which we are perfectly familiar is understood, even when spoken in low tones and far off. An unfamiliar language is unintelligible under these conditions. If we do not get a very good seat at a foreign theatre, we fail to follow the dialogue; and what gives trouble to most of us when abroad is not only that the natives speak so fast, but that they speak so indistinctly and so low. The verbal objects for interpreting the sounds by are not alert and ready-made in our minds, as they are in our familiar mother-tongue, and do not start up at so faint a cue.

Elsewhere in the *Principles* James writes:

> How comes it about that a man reading something aloud for the first time is able immediately to emphasize all his words aright, unless from the very first he have a sense of at least the form of the sentence yet to come, which sense is fused with his consciousness of the present word, and modifies its emphasis in his mind so as to make him give it the proper accent as he utters it? Emphasis of this kind is almost altogether a matter of grammatical construction. If we read "no more" we expect presently to come upon a "than"; if we read "however" at the outset of a sentence it is a "yet," a "still," or a "nevertheless," that we expect. A noun in a certain position demands a verb in a certain mood and number, in another position it expects a relative pronoun. Adjectives call for nouns, verbs for adverbs, etc., etc. And this foreboding of the coming grammatical scheme combined with each successive uttered word is so practically accurate that a reader incapable of understanding four ideas of the book he is reading aloud, can nevertheless read it with the most delicately modulated expression of intelligence. (p. 245)

59. Thus James: "As I write, I have no anticipation, as a thing distinct from my sensation, of either the look or the digital feel of the letters which flow from my pen. The words chime on my mental *ear,* as it were, before I write them, but not on my mental eye or hand. This comes from the rapidity with which often-repeated movements follow on their mental cue. An end consented to as soon as conceived innervates directly the centre of the first movement of the chain which leads to its accomplishment, and then the whole chain rattles off *quasi*-reflexly . . ." (ibid., p. 1128). A few pages later James quotes Lotze to the same effect: "We see in writing or piano-playing a great number of very complicated movements following quickly one upon the other, the instigative representations of which remained scarcely a second in consciousness, certainly not long enough to awaken any other volition than the general one of resigning one's self without reserve to the passing over of representation into action" (p. 1131).

60. Or consider this from the end of chapter sixteen: "In the regiment there was a peculiar kind of hesitation denoted in the attitudes of the men. They were worn, exhausted, having slept but little and labored much. They rolled their eyes toward the advancing battle as they stood awaiting the shock. Some shrank and flinched. They stood as men tied to stakes" (p. 171).

61. Berryman, aware that names in Crane's work bear a special charge, associates Scully's dead daughter Carrie with the woman Crane met in Jacksonville in late 1896 and lived with as man and wife until his death, Cora Howarth Stewart (*Stephen Crane,* p. 212); but of course Cora Stewart herself bore Crane's initials in reverse. It is Berryman too who sees versions of the names Corwin Linson and Acton Davies in Corinson and Shackles respectively (p. 309). Berryman's general view is this: "Some inhibition affecting the name 'Crane' and then names in general must be at work, and we may suppose it a consequence of the Oedipal guilt-sense toward the father, whose place he wishes to take with the mother. But there is probably some self-consolation present also ("If I am not a Crane, my desire is not forbidden"), and some *defiance* (obliteration of the father's sign in him, the patronym). . . . He thought no doubt that he was picking names at random, but I am speaking of what his imagination learned and did" (pp. 310–11).

Two quotations from stories that have just been cited but are not discussed elsewhere in this essay provide further evidence of the various things I have been claiming Crane's imagination learned and did. The first, of several not quite consecutive paragraphs, is from "The Five White Mice" and comes at a moment of extreme crisis as three Americans and three Mexicans stand facing each other about to fight (the New York Kid, a perfect moniker for Crane, has just been described as "transfixed as if he was already seeing lightning ripples on the knife-blade" [p. 766]):

> But the Mexican's hand did not move at that time. His face went still further forward and he whispered: "So?" The sober Kid [the New York Kid] saw this face as if he and it were alone in space—a yellow mask smiling in eager cruelty, in satisfaction, and above all it was lit with sinister decision. As for the features they were reminiscent of an unplaced, a forgotten type which really resembled with precision those of a man who had shaved him three times in Boston in 1888. But the expression burned his mind as sealing-wax burns the palm and fascinated, stupefied, he actually watched the progress of the man's thought toward the point where a knife would be wrenched from its sheath. The emotion, a sort of mechanical fury, a breeze made by electric fans, a rage made by vanity, smote the dark countenance in wave after wave.
>
> Then the New York Kid took a sudden step forward. His hand was also at his hip. He was gripping there a revolver of robust size. He recalled that upon its black handle was stamped a hunting scene in which a sportsman in fine leggings and a peaked hat was taking aim at a stag less than one eighth of an inch away. . . .

He was aware that the third Mexican was over on the left fronting Benson and he was aware that Benson was leaning against the wall sleepily and peacefully eyeing the convention. So it happened that these six men stood, side fronting side, five of them with their right hands at their hips and with their bodies lifted nervously while the central pair [the drunken 'Frisco Kid and the Mexican opposite him] exchanged a crescendo of provocations. The meaning of their words rose and rose. They were travelling in a straight line toward collision. . . .

The Eastern lad suddenly decided that he was going to be killed. His mind leaped forward and studied the aftermath. The story would be a marvel of brevity when first it reached the far New York home, written in a careful hand on a bit of cheap paper topped and footed and backed by the printed fortifications of the cable company. But they are often as stones flung into mirrors, these bits of paper upon which are laconically written all the most terrible chronicles of the times. He witnessed the uprising of his mother and sister and the invincible calm of his hard-mouthed old father who would probably shut himself in his library and smoke alone. Then his father would come and they would bring him here and say: "This is the place." Then, very likely, each would remove his hat. They would stand quietly with their hats in their hands for a decent minute. He pitied his old financing father, unyielding and millioned, a man who commonly spoke twenty-two words a year to his beloved son. The Kid understood it at this time. If his fate was not impregnable, he might have turned out to be a man and have been liked by his father. (pp. 766–68)

A few moments later the New York Kid resolves the situation by actually drawing his revolver, at which point the Mexicans give ground; one of them cries out like "a man who suddenly sees a poisonous snake" (p. 770), a figure the interest of which for my argument is about to be developed. The entire story repays close attention.

The second, briefer quotation, from "His New Mittens," provides our first view of the butcher Stickney, who will shortly return the runaway Horace to his family. The first sentence in particular seems to me a *tour de force* of compulsive thematic recapitulation:

Stickney, hale and smiling, was bantering with a woman in a cloak, who, with a monster basket on her arm, was dickering for eight cents' worth of something. Horace watched them through a crusted pane. When the woman came out and passed him, he went toward the door. He touched the latch with his finger, but withdrew again suddenly to the sidewalk. Inside Stickney was whistling cheerily and assorting his knives. (p. 1166)

62. Cf. the following from near the start of chapter eleven:

Presently the calm head of a forward-going column of infantry appeared in the road. It came swiftly on. Avoiding the obstructions gave it the sinuous movement of a serpent. The men at the head butted mules with their musket stocks.

They prodded teamsters indifferent to all howls. The men forced their way through parts of the dense mass by strength. The blunt head of the column pushed. The raving teamsters swore many strange oaths. (p. 142)

63. Crane, *'The Third Violet' and 'Active Service'*, ed. Bowers, The University of Virginia Edition of the Works of Stephen Crane, 3:168.

64. Ibid.

65. Ibid. Apropos of the word "sketch," which turns up here so unexpectedly, Crane's predilection for the sketch as a literary genre has important precedents in the work of earlier American writers, notably Washington Irving and Nathaniel Hawthorne, who found a representational ideal in the artist's sketchbook and who tended to privilege pencil or crayon as the designating tool. Crane, we might say, takes that pictorial genre and makes it writerly, or at any rate thematizes paper, ink, and pen in ways that ground the pictorialness of the sketch in the scene of writing. I am indebted to Larzer Ziff for pointing out this implication of my reading of Crane.

66. Accordingly, the next paragraph but one (the first paragraph of chapter ten) begins: "On a spread of plain they saw a force drawn up in long line. It was a flagrant inky streak on the verdant prairie" (p. 170). A similar relaxation of defenses occurs in Crane's first-person account of his experiences covering the conflict in Cuba, *War Memories*. "It was Jimmie's first action," Crane writes (Jimmie was a photographer), "and, as we cautiously were making our way to the right of our lines, the crash of the Spanish fire became uproarious, and the air simply whistled. I heard a quavering voice near my shoulder, and, turning, I beheld Jimmie—Jimmie—with a face bloodless, white as paper" (*Tales of War,* p. 246).

Also pertinent is an early manuscript (probably composed in early to mid-1892, but possibly in late 1891) that begins: "Little Mary Laughter went to sleep upon the grass under the peach-tree in her mother's garden. When she awoke, the world had changed. She lay on paper ground under a paper tree while a brook of ink babbled noisily at her feet" (Crane, *Poems and Literary Remains,* p. 100). Obviously the allegorization of writing here is perfectly conscious; equally obviously that consciousness inhabits a prose that couldn't be recognized as Crane's if the manuscript weren't in his hand. It may be, though, that Little Mary Laughter's brook of ink is the "original" of numerous rivers, streams, and the like in Crane's mature work.

67. Stephen Crane, "The Snake," in *The Works of Stephen Crane,* Fredson Bowers, ed., vol. 8, *Tales, Sketches, and Reports* (Charlottesville: University Press of Virginia, 1973), pp. 65–68; the passages quoted in the body of the essay are taken from pp. 65–67. According to Bowers, "The Snake" appears to have been written in 1894 (p. 786). This may be the most important single omission from the Library of America edition.

68. The rest of the sketch reads:

The man made a preliminary feint with his stick. Instantly the snake's heavy head and neck was bended back on the double curve and instantly the snake's body shot forward in a low straight hard spring. The man jumped backward with a convulsive chatter and swung his stick. The blind, sweeping blow fell upon the snake's head and hurled him so that steel-colored plates were for a moment uppermost. But he rallied swiftly, agilely, and again the head and neck bended back to the double curve and the steaming wide-open mouth made its desperate effort to reach its enemy. This attack, it could be seen, was despairing but it was nevertheless impetuous, gallant, ferocious, of the same quality as the charge of the lone chief when the walls of white faces close upon him in the mountains. The stick swung unerringly again and the snake, mutilated, torn, whirled himself into the last coil.

And now the man went sheer raving mad from the emotions of his fore-fathers and from his own. He came to close quarters. He gripped the stick with his two hands and made it speed like a flail. The snake, tumbling in the anguish of final despair, fought, bit, flung itself upon this stick which was taking its life.

At the end, the man clutched his stick and stood watching in silence. The dog came slowly and with infinite caution stretched his nose forward, sniffing. The hair upon his neck and back moved and ruffled as if a sharp wind was blowing. The last muscular quivers of the snake were causing the rattles to still sound their treble cry, the shrill, ringing war-chant and hymn of the grave of the thing that faces foes at once countless, implacable, and superior.

"Well, Rover," said the man, turning to the dog with a grin of victory, "we'll carry Mr. Snake home to show the girls."

His hands still strembled from the strain of the encounter but he pried with his stick under the body of the snake and hoisted the limp thing upon it. He resumed his march along the path and the dog walked, tranquilly meditative, at his master's heels. (Ibid., pp. 67–68)

Cf. the passage in chapter ten of *The Red Badge* in which Fleming, uninjured, cries out in exasperation when asked by the tattered man where his wound is located. "'Oh, don't bother me!' he said. He was enraged against the tattered man and could have strangled him. His companions seemed ever to play intolerable parts. They were ever upraising the ghost of shame on the stick of their curiosity. He turned toward the tattered man as one at bay. 'Now, don't bother me,' he repeated with desperate menace" (p. 140).

69. Quoted by Berryman, *Stephen Crane*, p. 6.

70. I have reserved until now a further ramification of my insistence that Crane throughout his career was wholly unaware of the extent to which his "impressionist" style had as its implicit agenda the figuring and foregrounding but also, simultaneously, the repressing of multifarious aspects of the scene of writing. In the late nineteenth and early twentieth century, psychologists in both Europe and America (e.g., Alfred Binet, Josef Breuer, Jean-Marc Charcot, Max Dessoir, Sigmund Freud, Pierre Janet, F. W. H. Myers, Morton Prince, and of course William James) were greatly interested in a

range of phenomena that included partial aphasias and anaesthesias, auto-matic writing, and split consciousness. For example, James in the *Principles* cites the work of Bernheim and Pitres as proving

> that the hysterical blindness is no real blindness at all. The eye of an hysteric which is totally blind when the other or seeing eye is shut, will do its share of vision perfectly well when *both* eyes are open together. But even where both eyes are semi-blind from hysterical disease, the method of automatic writing [having the patient respond to questions in writing, often while distracting him or her by conversation] proves that their perceptions exist, only cut off from communica-tion with the upper consciousness. M. Binet has found the hand of his patients unconsciously writing down words which their eyes were vainly endeavoring to "see," i.e., to bring to the upper consciousness. Their submerged consciousness was of course seeing them, or the hand couldn't have written as it did. . . . It must be admitted therefore that, *in certain persons*, at least, *the total possible con-sciousness may be split into parts which coexist but mutually ignore each other*, and share the objects of knowledge between them. More remarkable still, they are *comple-mentary*. Give an object to one of the consciousnesses, and by that fact you remove it from the other or others. Barring a certain common fund of information, like the command of language, etc., what the upper self knows the under self is ignorant of, and *vice versa*. (*Principles*, pp. 203–4, italics James's; see also idem, "The Hidden Self," *Scribner's Magazine* 7 [1890]: 369.)

Elsewhere James emphasizes the importance of cases in which "an active dissociation or shutting out of certain feelings and objects from the field of consciousness" reaches the point that "the subject's mind loses its quality of unity, and lapses into a polypsychism of fields that genuinely co-exist and yet are outside of each other's ken and dissociated functionally" (quoted by Eu-gene Taylor, *William James on Exceptional Mental States: The 1896 Lowell Lec-tures* [Amherst: The University of Massachusetts Press, 1984], pp. 36–37). Characteristically, however, James found unpersuasive Janet's view that the secondary consciousness is in all cases a permanently inferior derivative of the primary one; instead he favored F. W. H. Myers's idea of the subliminal— "that each person has within him a simultaneous double consciousness. Above the threshold is everyday waking awareness, while below it are innu-merable streams of consciousness. Some of these streams Myers called dis-solutive, others he called evolutive. But regardless of their nature—James tells his audience—the operation of such streams distinctly 'beyond the mar-gin' points to the reality of a subliminal consciousness" (Taylor, p. 53). Myers's notion, James argued, "fits both the cases described by Janet as pathological, and also the more exceptional instances that suggest the pos-sibility of a transcendent dimension in the spectrum of subconscious states— the presence just below the threshold of a domain far wiser than and superior to that of normal, waking, rational awareness" (Taylor, p. 91). (The investi-

gation of that possibly transcendental dimension belonged to psychical research.)

My point in introducing this material (as regards James alone I have barely scratched the surface) is not quite to insist that Crane's literary practice proves the operation in him of a double consciousness in the Myers-James sense of the term. It *is* to suggest that between Crane's enterprise as interpreted in these pages and the general class of phenomena that James and his contemporaries found so arresting certain strong analogies may be drawn, analogies that at the very least help us see Crane's uniqueness as a writer in a somewhat broader context. Even the psychologists' interest in cases of hysteria in which the secondary consciousness is hyperesthetic, that is, endowed with perceptual powers far exceeding those of ordinary waking awareness (see Taylor, pp. 60–61), recalls highly cathected moments in Crane—the ant trundling its bundle along the upper lip of the corpse in the "chapel" scene in *The Red Badge,* for example, or the image of the definition of Peza's misery being written on a wee blade of grass at the end of "Death and the Child." Perhaps the closest Crane comes to acknowledging a version of the dividedness of mind that was of such intense contemporary concern is in Rufus Coleman's musings immediately after the encounter with the corpse and snake in *Active Service,* a novel in which, as we have seen, the flatness of Crane's prose is correlated with a relaxation of the defenses that usually keep thematizations of writing at a metaphorical remove. The passage reads:

> And now he interwove his memory of Marjory [the woman Coleman loves] with a dead man and with a snake in the throes of the end of life. They crossed, intersected, tangled, these two thoughts. He perceived it clearly, the incongruity of it. He academically reflected upon the mysteries of the human mind, this homeless machine which lives here and then there and often lives in two or three opposing places at the same instant. He decided that the incident of the snake and the dead man had no more meaning than the greater number of the things which happen to us in our daily lives. Nevertheless it bore upon him. (*'The Third Violet' and 'Active Service'*, p. 169)

Finally, some remarks by Hamlin Garland may be pertinent here. "The fact of the matter seems to be this," Garland writes. "Crane's mind was more largely subconscious in its workings than that of most men. He did not understand his own mental processes or resources. When he put pen to paper he found marvelous words, images, sentences, pictures already [*sic*] to be drawn off and fixed upon paper. His pen was 'a spout,' as he says" ("Stephen Crane: A Soldier of Fortune," *Letters,* p. 305). In the same article Garland remarks of Crane: "I have never known a man whose source of power was so unaccounted for" (ibid.). And in "Stephen Crane as I Knew Him," Garland says that according to Crane himself the composition of his poems

was an entirely automatic, subconscious process; and being keenly interested at this time in super-normal psychical phenomena, I was, naturally, much impressed by the poet's air of detachment. *It was precisely as if some alien spirit were delivering these lines through his hand as a medium.*

"There is a ghost at your shoulder," I said in mock seriousness, "but not the ghost who gave you 'The Red Badge of Courage.' This is the ghost of militant agnosticism—a satirical ghost."

Of course I was only half in earnest as I said this; but at the same time it was evident that his composition (even to the process of punctuation) went on beneath consciousness, and that setting his poems down was for him a kind of transcribing as from a printed page. He told me that the first pages of 'The Red Badge of Courage' came to him in just that way, every word in place, every comma, every period fixed. (p. 9; italics Garland's)

On the concept of the unconscious during this period see Henri Ellenberger, *The Discovery of the Unconscious* (New York: Basic Books, 1970). Taylor's book cited earlier in this note, which attempts to reconstitute William James's Lowell Lectures of 1896, is also indispensable. Another major American psychologist concerned with these issues was Morton Prince; see for example "Some of the Revelations of Hypnotism" (1890) in Prince, *Psychotherapy and Multiple Personality: Selected Essays,* ed. Nathan G. Hale, Jr. (Cambridge, Mass.: Harvard University Press, 1975), pp. 37–60; and idem, *The Dissociation of a Personality: The Hunt for the Real Miss Beauchamp* (1905; reprint, Oxford, New York, Melbourne: Oxford University Press, 1978). My thanks to Ruth Leys for sharing with me her knowledge of late nineteenth- and early twentieth-century psychology.

71. Stephen Crane, "The Veteran," in *The Works of Stephen Crane,* Fredson Bowers, ed., vol. 6, *Tales of War* (Charlottesville: University Press of Virginia, 1970), pp. 82–86. "The Veteran" was first published in August 1896; chronologically, it falls between *The Red Badge* and *The Monster* (James B. Colvert, "Introduction," in Crane, *Tales of War,* p. lxxvii).

72. From my perspective on Crane, of course, the statement that Jim Conklin's father was named Si is almost too good to be true. Note too how the cow that "had so fastened herself that she could not be moved an inch" and therefore must be left to perish in the flames prefigures the fate of the protagonist and obvious writer-surrogate of "Manacled" (see n. 51 above). What makes this all the more uncanny is the near-conjunction in "The Veteran" of two parallel constructions involving the phrase "save one" (in the paragraphs beginning "Here as at the well . . ." and "Old Fleming took a fork . . ."), referring respectively to Fleming and the cow. I read the parallelism as implicitly aligning *their* fates in a manner that establishes a three-term analogy—Fleming-cow-protagonist of "Manacled"—which in turn reinforces the suggestion that the old Fleming functions in "The Veteran" as a surrogate for the author.

Index